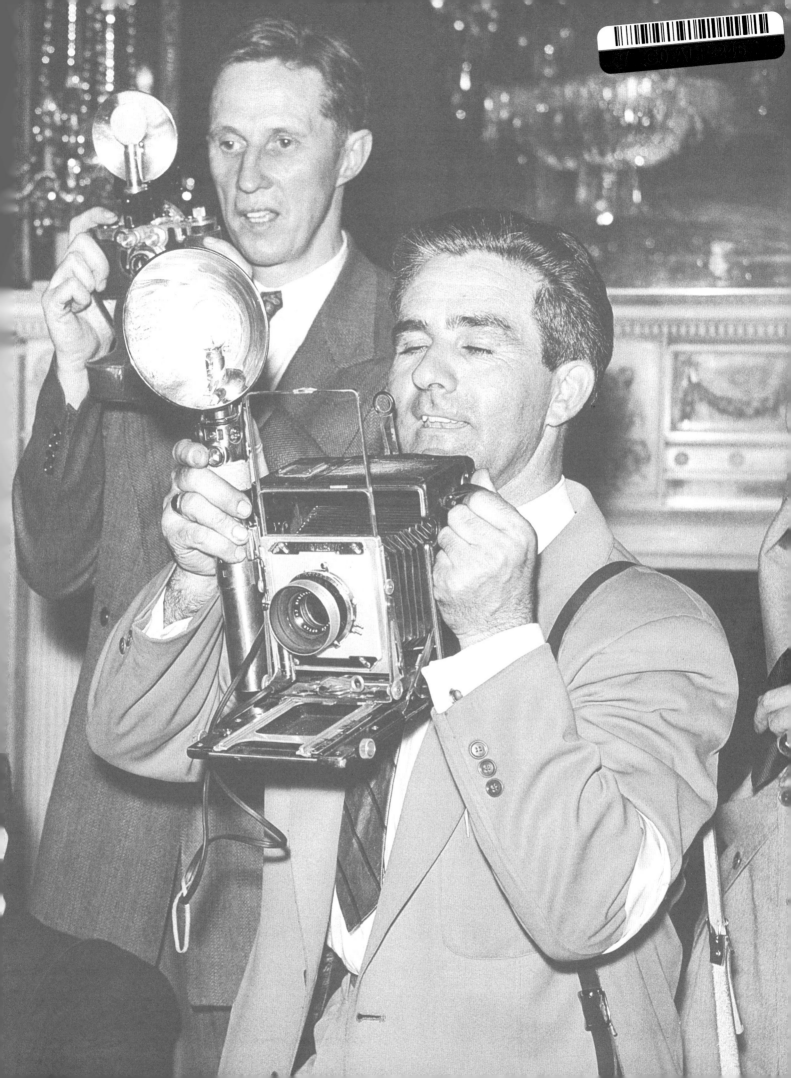

# ONLY IN NEW YORK

## PHOTOGRAPHS FROM LOOK MAGAZINE

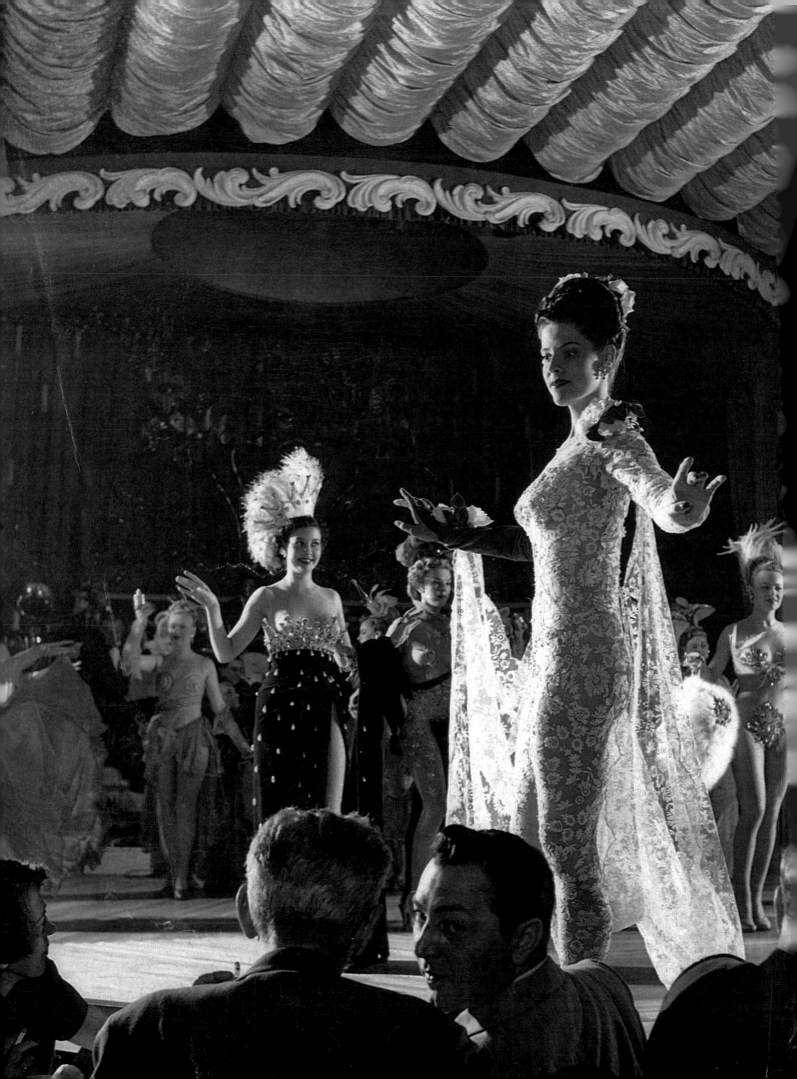

DONALD ALBRECHT
THOMAS MELLINS

PHOTOGRAPHS FROM
LOOK MAGAZINE

ONLY
IN
NEW
YORK

MUSEUM OF THE CITY OF NEW YORK
THE MONACELLI PRESS

Copyright © 2009 The Monacelli Press and
the Museum of the City of New York

Published in the United States by The Monacelli Press,
a division of Random House, Inc., New York

The Monacelli Press and colophon are trademarks of
Random House, Inc.

Library of Congress Cataloging-in-Publication Data
Albrecht, Donald.
Only in New York : photographs from Look magazine /
Donald Albrecht and Thomas Mellins.
p. cm.
Includes index.
ISBN 978-1-58093-248-6 (alk. paper)
1. New York (N.Y.)—History—20th century—
Pictorial works. 2. New York (N.Y.)—Social life and
customs—20th century—Pictorial works. 3. New York
(N.Y.)—Biography—Pictorial works. 4. City and town
life—New York (State)—New York—History—
20th century—Pictorial works. I. Mellins, Thomas.
II. Look. III. Title.
F128.37.A52 2009
974.7'10430222—dc22

2009012389

Printed and bound in China

10 9 8 7 6 5 4 3 2 1
First Edition

Designed by Pure+Applied

www.monacellipress.com

ENDPAPERS:
Art Students League, April 1952
Photographers: Phillip Harrington and Arthur Rothstein.
Credit for the specific images of this shoot is not identified
in the *Look* collection. See pages 198–199.

TITLE PAGE:
Copacabana, December 1948
Photographer: Stanley Kubrick. See pages 194–195.

# CONTENTS

# LOOK

20¢ FEBRUARY 18, 1958

On February 18, 1958, *Look* published a special issue devoted to New York City, with a cover image by Emil Schulthess. Supporting the magazine's eclectic take on the city, this issue featured profiles on Florida newlyweds spending four days on the town, an editor who lived with his family on Park Avenue and was characterized as a "real New Yorker," three boys growing up in Greenwich Village, the director of the Museum of Modern Art, six smartly dressed women, Episcopalian minister Norman Vincent Peale, a foreman for the city's electrical utility, a midtown Manhattan restaurateur, a Catholic nun (and surprisingly a surgeon) who served the medical needs of the needy, and a Dalmatian named Butch. Rounding out this kaleidoscopic coverage of the city's citizens, *Look* highlighted the dramatic architectural changes reshaping the city's financial district and Park Avenue, and also went "behind New York's facade" to examine segregation and life in

## THIS IS NEW YORK

40 pages on the world's most exciting island

# PREFACE

Among the many treasures in the collections of the Museum of the City of New York is a vast archive of photographs taken for *Look* magazine. *Only in New York: Photographs from Look Magazine* is the first publication to be devoted to this great resource, which was donated by Cowles Magazines beginning in the 1950s. It numbers some 200,000 images — negatives, contact sheets, transparencies, and prints — and comprises most of the magazine's New York assignments made between 1938 and 1961. From this huge collection, *Only in New York* focuses on the immediate post–World War II years; during these years, the magazine's zesty photojournalism captured a broad swath of New Yorkers and the city's changing streets and neighborhoods. In the pages of *Look*, New York appears sophisticated, exciting, dense with activity, and populated by all sort of players — businessmen, models, commuters, prizefighters, artists, entrepreneurs, and more.

A number of funders have helped the Museum with important, behind-the-scenes work on this collection, and I thank them all. I am particularly grateful to the William E. Weiss Foundation and its President, Daryl Brown Uber, for the Foundation's early support. It enabled us to attract additional funding, which came from Save America's Treasures, a public-private partnership between the National Trust for Historic Preservation and the National Park Service; The Cowles Charitable Trust; and *Vanity Fair*. These gifts enabled us to catalog and re-house the collection and to create a finding aid.

*Only in New York* specifically grew out of the exhibition *Willing to Be Lucky: Ambitious New Yorkers from the Pages of Look Magazine*, which was presented at the Museum from October 21, 2006 through January 3, 2007, and supported by The Marlene Nathan Meyerson Family Foundation. The exhibition was organized by this book's authors, Donald Albrecht, the Museum's Curator of Architecture and Design, and Thomas Mellins. I am very grateful to them for bringing this marvelous collection to public view. Additional and hearty thanks go to Dan Leers for cataloging the collection; to Susan Johnson and Melanie Bower for the their work in assembling the images; and to Sarah Henry, the Museum's Deputy Director and Chief Curator, for overseeing the project.

Finally, we are all happy to have had the opportunity to work with Elizabeth White of The Monacelli Press. We were gratified by her responsiveness to the lively quality of the images in the collection. I also want to recognize Rebecca McNamara at Monacelli, Ken Allen of Ken Allen Studios for producing the prints used in the book, and Urshula Barbour, Paul Carlos, and Isaac Gertman of Pure+Applied, for their book design that captures the spirit and verve of New York City.

Susan Henshaw Jones
*Ronay Menschel Director of the*
*Museum of the City of New York*

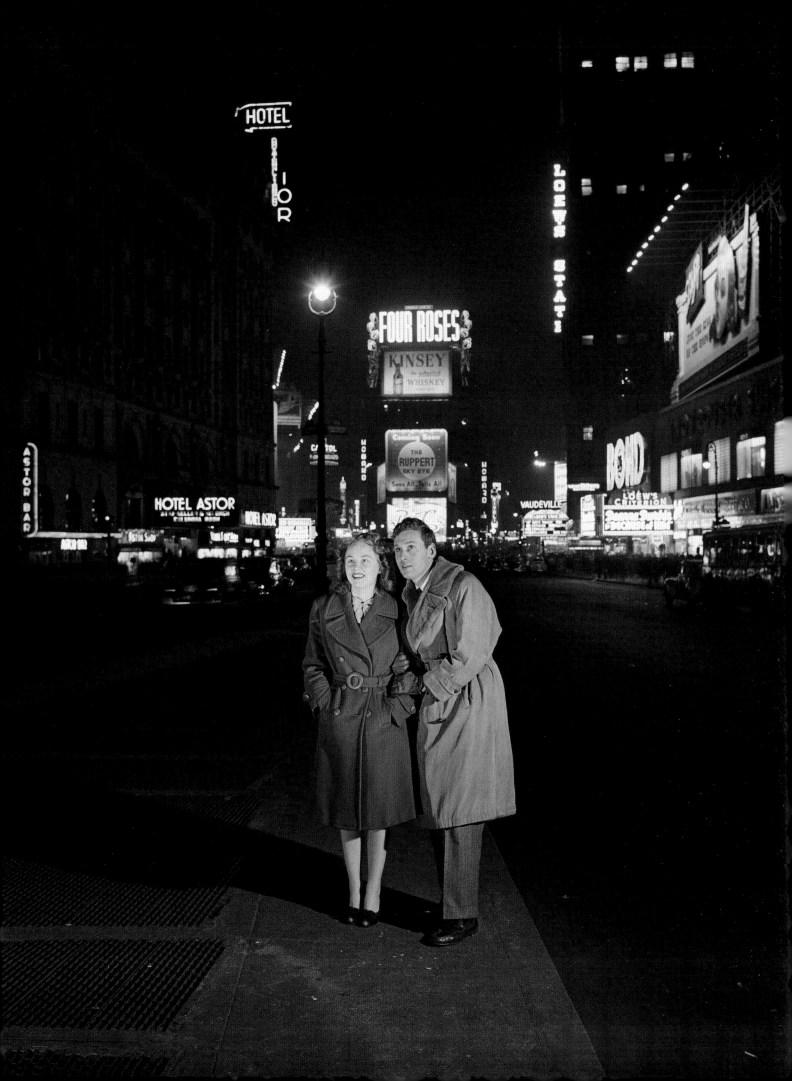

# ONLY IN NEW YORK

*Look* magazine had a long love affair with New York City, bringing its people, places, events, and ever-changing social scene to the attention of the magazine's national audience. Stressing human warmth over journalistic objectivity, the magazine's New York–based editors, writers, and photographers scoured their city for stories on a kaleidoscopic range of subjects. On *Look*'s pages, readers learned about Broadway personalities, kids in slums, tastemakers and eccentric artists, sports heroes, developers of gleaming new skyscrapers, and Brooklyn's so-called "thrill killers." Throughout this diversity, however, one message remained clear. New York was both a big city, unlike any other in the nation, and a small town, where everyday life progressed much as it did elsewhere. "Behind the facade of this pushing, friendly, cruel, cultured, rich and ragged city," wrote Patricia Coffin (d. 1974), one of the magazine's longtime editors, "there is another town, a 'small' town . . . Mine includes a grocer who delivers my order to the corner liquor store if I'm home late from the office. There is also the Italian shoemaker who chalks '5-A' on the soles of my shoes without asking where I live. 'Tomarra,' he says."

As this observation underscores, *Look*'s coverage of New York had a distinctive tone, rejecting an icy, at-arms-length view in favor of one that was close-up and finely grained. The magazine's portrayal of New York was candid, humorous, and always emphasized the story of individuals over societal documentation. Ira Mothner (b. 1932), who served as a *Look* editor beginning in 1957, has noted that the magazine "was always more about fun" than its celebrated rival *Life*. Mothner has

also contended that while *Life*'s staff was more highly paid, the work atmosphere at *Look* was more spirited and free-wheeling.

*Look* was founded, published, and edited by Gardner Cowles (1903–1985, known as Mike Cowles). Its first issue was published in early 1937, a few months after the launch of Henry R. Luce's *Life*. Both *Look* and *Life* brought to America the style of lively photojournalism already apparent in such European magazines as the German *Berliner Illustrirte Zeitung* and the French *VU*. *Look*'s mission was to meet "the tremendous unfilled demand for extraordinary news and feature pictures" and sought to appeal to a broad readership. As the editors promised potential advertisers, *Look* would have "reader interest for yourself, for your wife, for your private secretary, for your office boy." Though the postwar growth of the magazine was dramatic—9,270,830 copies of its March 7, 1967, issue were sold—*Look*'s demise resulted from many forces, including the shift of advertising dollars to television and the rising costs of paper, printing, and mailing. After publishing 903 issues with 180,000 pictures, *Look* printed its last issue on October 19, 1971.

In the postwar period, numerous stories about New York conveyed the magazine's defining character. *Look* celebrated New York as a place in which to realize the American ideal of self-invention, publishing articles on fashion models, boxers, artists, and entertainers, both striving and established. In this respect, *Look*'s editors concurred with E. B. White who, in his 1947 essay, "Here is New York," stated that the city "can destroy an individual, or it can fulfill him, depending a good deal on luck. No

one should come to New York to live unless he is willing to be lucky." Ambushing expectations that the big city was a place of anonymous crowds, *Look*'s photographic essay "Life and Love on the New York Subway" (see pages 118–127) depicted the nation's largest mass-transit system as a kind of subterranean town square. An opening panoramic view of the Grand Central Terminal subway station at the peak of the evening rush hour was followed by numerous, smaller portraits of "subway characters," from college students to nighttime revelers and Talmudic scholars, whose "actions and dreams pull them out of the crowd."

A darker and more disturbing side of New York was revealed in a 1946 four-page photo spread by Weegee, identified by *Look* as "one of the world's most publicized photographers." Titled "New York Off Guard," this group of images was culled from the photographer's latest book, *Weegee's People*.

Like the magazine itself, "Weegee's themes are New York and its people — the poor and the rich, the clean and the dirty, the respectable ones and the outcasts." Amid portraits of a colorful cast of characters, one image stood out: an elegant blond and her tuxedo-clad friends sit adjacent to a disheveled woman. The caption read, "A derelict rubs elbows with an expensive beauty out slumming," and while only the beauty is enjoying herself, the caption sarcastically concluded, "both smile."

Negative depictions of New York were, during this period, relatively rare. One notable exception was a 1954 story about a series of senseless crimes committed in Brooklyn, which had shocked the country and grabbed headlines nationwide (see pages 178–181). *Look* presented a pictorial essay, which, consistent with the magazine's overall approach to the city, highlighted not only the accused young men, but also included portraits of

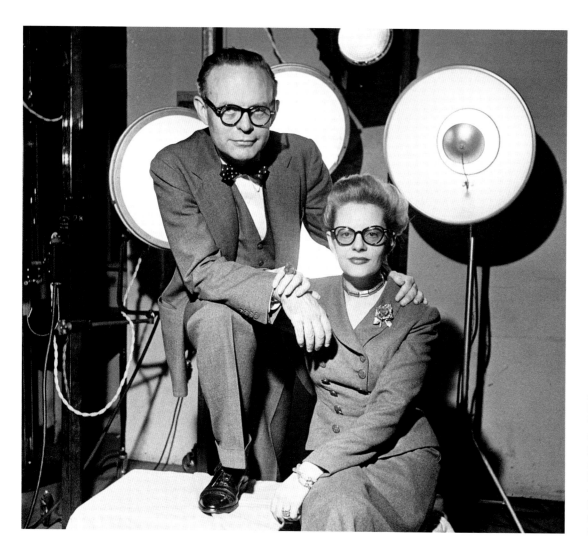

**GARDNER AND FLEUR COWLES**
JANUARY 1950
PHOTOGRAPHER
UNKNOWN

Gardner Cowles is here photographed in *Look*'s editorial offices in midtown Manhattan with his wife Fleur Cowles (1910–2009), who was at the time the magazine's associate editor.

nearly a dozen neighbors, giving the lurid story recognizable human faces.

*Look*'s success in telling rich stories about New York was due in part to Daniel D. Mich (1905–1965), who served in a variety of executive positions between the magazine's founding in 1937 and his death. Mich fostered a work environment that was especially open to a variety of story ideas, whether generated by staff employees or freelancers. Once editors gave an initial green light, a give-and-take process followed, involving picture editors, writers, and photographers. Working with the art department, editors created and displayed elaborate storyboards of articles for discussion. Ultimately, the decision to publish an article belonged to Mich, who deemed its timeliness and its relevance to *Look*'s audience. (As a result, many assignments were never published.) Throughout this process, successful photographers understood that it was advantageous to shoot liberally, in order to give the magazine's art department a wide range of choices in laying out stories. Successful editors and writers understood that in order to remain competitive it was necessary for *Look*, a bi-weekly magazine, to scoop its chief rival, *Life*, which was published weekly.

Among the longest standing staff members of Mich's outstanding photographic team was Arthur Rothstein (1915–1985), who joined the magazine in 1940 and remained its photographic technical director until the magazine's close in 1971. Rothstein had been employed by the Farm Security Administration, established by President Franklin D. Roosevelt, to document the abject living conditions of the rural poor during the Great Depression. For Rothstein, this proved to be ideal training for *Look*'s focus on individuals, as it also would for Charlotte Brooks (b. 1918) and John Vachon (1914–1975), other FSA veterans. The first woman to be hired by *Look* as a staff photographer, Brooks worked for the magazine from 1952 until 1971. Vachon, in addition to working with Rothstein, had been mentored by the socially committed artist Ben Shahn and photographer Walker Evans. Other *Look* staff photographers included: Michael A. Vaccaro (b. 1922), who specialized in celebrity coverage and fashion; Paul Fusco (b. 1930), who started at *Look* in 1957 and went on to be part of the celebrated Magnum photographic collective;

and James Karales (1930–2002), whose photographs documenting racial integration in America brought him to the attention of the magazine in 1960. While these and other staff photographers, such as Frank Bauman, James Hansen (1921–1999), Phillip Harrington (1920–2009), Robert Lerner (b. 1926), and Bob Sandberg were expected by their editors to cover a broad range of subject matter, sometimes a freelancer with special expertise would be hired, such as Marvin E. Newman (b. 1927) for sports coverage.

Perhaps the most surprising name on the magazine's masthead was Stanley Kubrick (1928–1999), who from 1945 to 1950, before launching his career as the director of such films as *Doctor Strangelove* and *2001: A Space Odyssey*, worked as a *Look* photographer. Kubrick grew up in the Bronx and at the age of sixteen sold his first photograph to *Look* — an image of a newsstand announcing the death of President Roosevelt. Over the next five years, Kubrick completed numerous assignments, but of special interest were his photographs of showgirls and boxers. Kubrick elevated individuals to the status of archetypes, telling mythic stories about contemporary urban society and the roles men and women played in it.

Most of these photographers took part in producing the February 18, 1958, issue of *Look*, which featured the largest photographic essay to date in the magazine's two-decade history: forty pages, fourteen articles, and ninety-eight photographs devoted to the city, with Manhattan described on the cover as "the world's most exciting island." Among the wealth of stories in the special issue, a trio offered a particularly trenchant picture of the city's highs and lows. Two presented the city as an international capital, a status achieved only after World War II. In 1945, America, largely physically unscathed by the just-ended war, emerged militarily and economically triumphant and New York, the beneficiary of homegrown talent, as well as émigrés from Europe's artistic elites, was culturally vibrant as never before. A key player in the transformation of New York into a glittering monument to modern art and architecture was the Museum of Modern Art. The title of *Look*'s 1958 profile of MoMA director René d'Harnoncourt (1901–1968) boldly and succinctly asserted "New York: The Taste Shaper." The editors noted that

The article "Prizefighter" was published at the start of the tenure of Merle Armitage (1893–1975) as *Look*'s art director and demonstrates his talent for visually sophisticated layouts juxtaposing small and full-page images in lively, asymmetrical patterns. Armitage, who pursued several distinct career paths, including designer, writer, and impresario, and had once served as the American publicist for Sergei Diaghilev's Ballets Russes, worked for *Look* from 1949 until 1954. Armitage's crisp graphic design perfectly complemented Stanley Kubrick's striking photography, with its dramatic contrasts of light and dark. See pages 150–153.

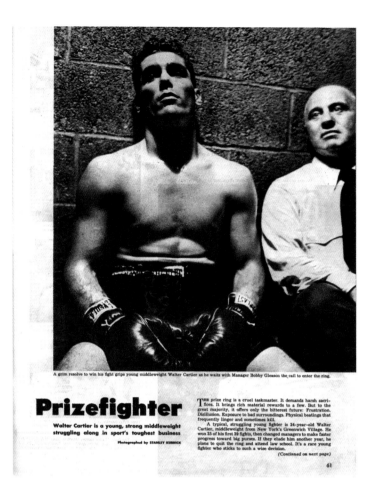

A grim resolve to win his fight grips young middleweight Walter Cartier as he waits with Manager Bobby Gleason the call to enter the ring.

# Prizefighter

Walter Cartier is a young, strong middleweight struggling along in sport's toughest business

Photographed by STANLEY KUBRICK

THE prize ring is a cruel taskmaster. It demands harsh sacrifices. It brings rich material rewards to a few. But to the great majority, it offers only the bitterest future: Frustration. Disillusion. Exposure to bad surroundings. Physical beatings that frequently linger and sometimes kill.

A typical, struggling young fighter is 24-year-old Walter Cartier, middleweight from New York's Greenwich Village. He won 25 of his first 29 fights, then changed managers to make faster progress toward big purses. If they elude him another year, he plans to quit the ring and attend law school. It's a rare young fighter who sticks to such a wise decision.

(Continued on next page)

61

Walter sleeps until 9:30 on a day he's going to fight. In training, he gets up at 5:30, runs four miles. Twin brother Vincent sleeps on.

Vince helps train Walter, serves him breakfast of orange juice, three soft-boiled eggs, toast and coffee. Their Aunt Eva oversees the meal.

## THE DAY OF A FIGHT

Cartier sleeps late, eats carefully, gets a physical check-up —and goes to church.

On way to fight, Walter stops at church, prays that he escape serious injury.

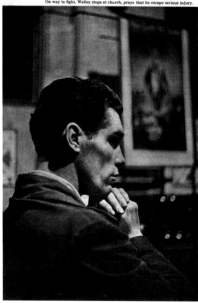

Cartier weighs in at N. Y. State Athletic Commission around noon. An official checks him on the scales.

Doctor carefully examines eyes. Eye cuts, an occupational hazard, often impair vision, sometimes bring blindness.

Time drags heavily until evening and the hour of battle. Walter sits it out on front steps with brother, neighbor.

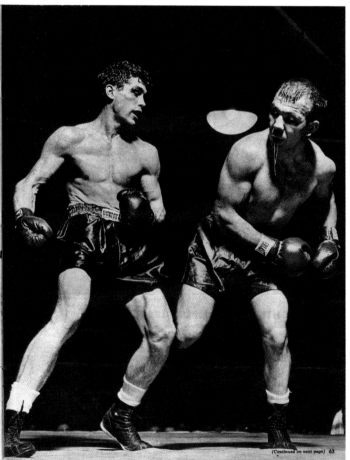

The fight: Walter carries attack to Tony D'Amico at Jerome Stadium, drives spittle from Tony's mouth. He led until head butt cut his right eye, gave Tony technical KO.

(Continued on next page) 63

PRIZEFIGHTER *continued*

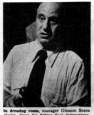
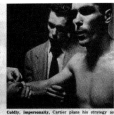
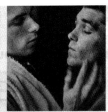

In dressing room, manager Gleason flexes gloves, gives his fighter final instructions.

Coldly, impersonally, Cartier plans his strategy as Vincent holds his arm and Gleason adjusts right glove.

Vincent rubs Vaseline on Walter. His expression reveals depth of fondness he has for his brother.

## ...AND HIS WORK IS BRUTAL

**Boxing's atmosphere discourages gaiety and lightheartedness. The scenes
are grim, filled with slashing blows of leather on flesh**

Between rounds, Gleason removes mouthpiece, then works furiously to stanch blood from old eye cut. Calculating foes always seek to open old cuts.

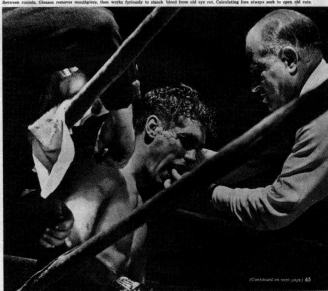

Radio music and the sun put Walter to sleep on the beach at Staten Island, where he enjoys day's outing with Dolores Germaine. But he has no No. 1 girl friend.

## THE FIGHTER HAS SIMPLE PLEASURES...

**Between matches, Cartier keeps himself in top shape, takes some relaxation
on the beach, at the baseball game and with his family**

Rowing out to a friend's sailboat emphasizes long, powerful muscles that give him punching power.

Unemotional most of the time, Walter breaks loose at Yankee Stadium. He's a Boston Red Sox rooter.

At home, he fixes a toy sailboat for his little nephew and leading rooter, Charlie Cartier, III.

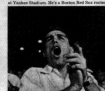
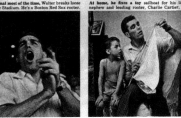

(Continued on next page) 65

PRIZEFIGHTER *continued*

## SKILL IS NOT ENOUGH

**Ability alone cannot carry a fighter into the big
money and a chance at the championship. His
manager must be able to cope with the intrigues
and connivings of the ring—a business in which no
blows are barred**

Cartier looks on anxiously as Gleason palavers over the telephone about an important match. Getting the right kind of fight is a manager's big job.

Walter works out. Boxing follows calisthenics, rope-skipping, shadow-boxing, bag-punching.

After a fight, it takes Walter hours to relax. Late into the night, he walks Greenwich Village streets with Vincent, wonders if he'll ever get a crack at the championship

He gets a break. At Jersey City's Roosevelt Stadium, in prelim to Zale-Cerdan championship, he knocks out Jimmy Mangia in first round with right to the jaw.

This fight earned Walter biggest net purse: $700.

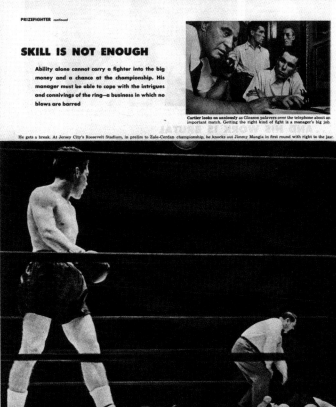
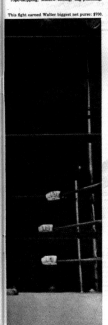
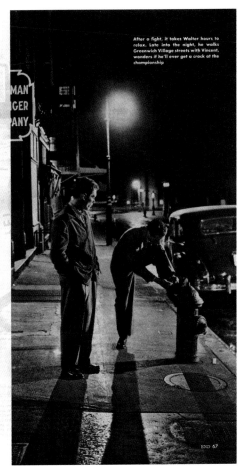

END 67

while the museum had only been in existence since 1929, it had already had broad impact, from making "Picasso a household word" to influencing "the very shape of the chairs that we sit on." D'Harnoncourt was born in Vienna, but "now like so many New Yorkers who were born elsewhere, he 'wouldn't live anywhere else.'" The Museum of Modern Art also helped establish the International Style of modern architecture, which was the look of a wholesale transformation of the city's physical fabric, as well as a style disseminated throughout the world. This was the subject of another article in the issue, "The Changing Face of New York," (see pages 74–79) which explored midtown Manhattan's "new horizons," including such recently completed steel-and-glass towers as Lever House and the Seagram Building.

"Manhattan's glitter conceals an ugly streak that runs the length of the island" began a third article in the issue entitled "Behind New York's Facade: Slums and Segregation" (see pages 136–139). While the article broke with the magazine's usual approach, presenting a wealth of statistical information rather than focusing on individuals' stories, its text invited the reader to identify with slum dwellers and the problem of racial segregation: "Say you are a Puerto Rican arriving in New York—as some 40,000 do every year . . . You don't want to live in a slum. You didn't make it—you inherited it. But you'll find all the exits barred by the invisible barrier." A caption accompanying a full-page photograph of kids playing in an empty lot spoke of "Manhattan's patterns of racial segregation that keeps minority groups confined to certain neighborhoods."

The issue's photography was distinctive as well. In addition to primarily black-and-white photographs by the magazine's staff photographers, the issue included a small selection of color images by well-known Swiss photographer Emil Schulthess (1913–1996). Schulthess had recently done a series of photographic essays on the United States for the pioneering Swiss journal *Du*. In contrast to *Look*'s typical focus on people, these shots represented the city's bridges, skyscrapers, streets—and even the famous Radio City Music Hall Rockettes—as abstract compositions. These images continued a great tradition of Europeans using New York, the paradigmatic modern city, to create a new vision of twentieth-century life. At the same time, just as the opening page of the magazine quoted avant-garde architect Le Corbusier, who was infatuated with "the Manhattan of vehement silhouettes . . . the vertical city with its unimaginable diamonds," Schulthess's provocative images underscored how, even in the late 1950s, Americans looked to Europeans for self-definition.

This unprecedented issue was the brainchild of Patricia Coffin, a former society columnist, publicist, and model who worked at the magazine for twenty-five years and beginning in 1955, served as its editor of special departments. In her self-described capacity as the project's "mother hen," Coffin oversaw eight writers and seven photographers who fleshed out, in words and pictures, the city's unsurpassed creativity and cosmopolitanism. To this, Coffin added her own confirmation of the city's character: "Here is a city that encompasses the excitement of the world. I can imagine anything happening in New York—except my not living here." (Coffin went on to supervise a second special issue devoted to New York that was published on March 26, 1963. In that issue, acknowledging that a distinct era in the city's history had closed and another had begun, Coffin wrote, "New York is still a thrill to me, but it is also a slap in the face. It's as though someone I love had gone berserk, bent on self-destruction—with a glittering audacity.)"

Coffin's assurance that she could live nowhere else, as well as her magazine's infatuation with the city as a place of larger-than-life personalities, one-of-a-kind events, and unforgettable places, inspired the title of this book. In writing it we have allowed ourselves the freedom to draw from all the *Look* images in the Museum of the City of New York's collection, which represent entire assignments that go far beyond those published in the magazine. This larger group of images represents the full picture of what *Look*'s photographers chose to focus upon when capturing the essence of the city. It is itself a hidden treasure, an unprecedented resource, found "only in New York."

Note: *The photographs in the* Look *collection at the Museum of the City of New York are identified by the titles assigned by the magazine's editors; those titles are listed on page 207. Captions include dates that assignments were executed, not publication dates, which are provided in the text when known.*

The *Look* collection housed at the Museum of the City of New York not only features singular photographs, but also contact sheets recording the full extent of an assignment. These images are from a shoot titled "Nightclubs: Copacabana Girl," taken by Stanley Kubrick in December 1948.

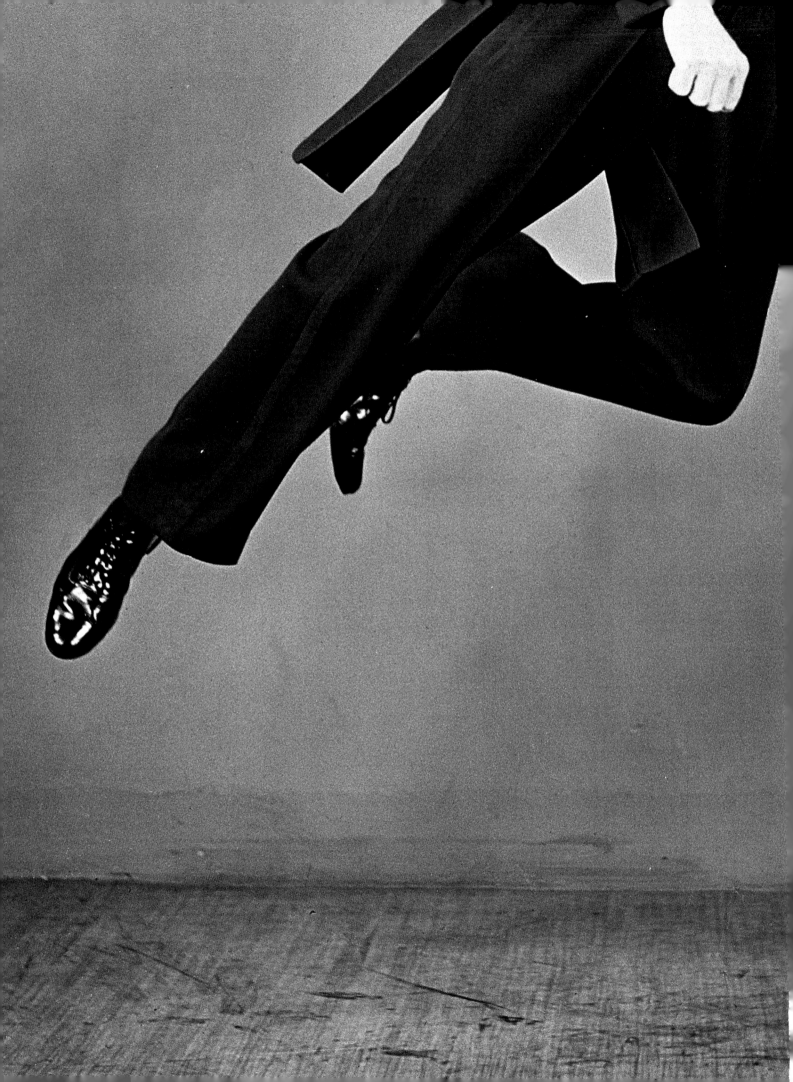

# ENTERTAINERS

Postwar New York remained the nation's entertainment capital. Broadway produced the country's song standards and turned unknowns into overnight sensations. A thriving nightclub scene offered stages to international performers and purveyors of strange stunts. Even department stores got into the act, entertaining shoppers with such novelties as trained dogs. At this time, Broadway and Hollywood still dominated America's popular culture, as shown in assignments on Marlon Brando, Katherine Dunham, and Eric Victor, a Broadway choreographer and dancer who taught actors to be light on their feet.

## ERIC VICTOR

**FEBRUARY 1949 / PHOTOGRAPHER: PHILLIP HARRINGTON**

Eric Victor danced in the Broadway revue
*Inside U.S.A.* in 1948–49 and choreographed
two other Broadway productions, *You'll See
Stars* in 1942–43 and *All for Love* in 1949.
Victor is seen instructing Patrice Wymore
(b. 1926). Wymore, a child actor from
Miltonval, Kansas, who had been dubbed
the "Shirley Temple of the Midwest," moved
to New York in 1944 at the age of eighteen
and began a successful Broadway career,
appearing in numerous shows, including a
Mike Todd production. Victor is also seen
with film actor Steve Cochran (1917–1965).
The profile on Victor ran as "Broadway
Dance Master" in the June 7, 1949, issue
of the magazine.

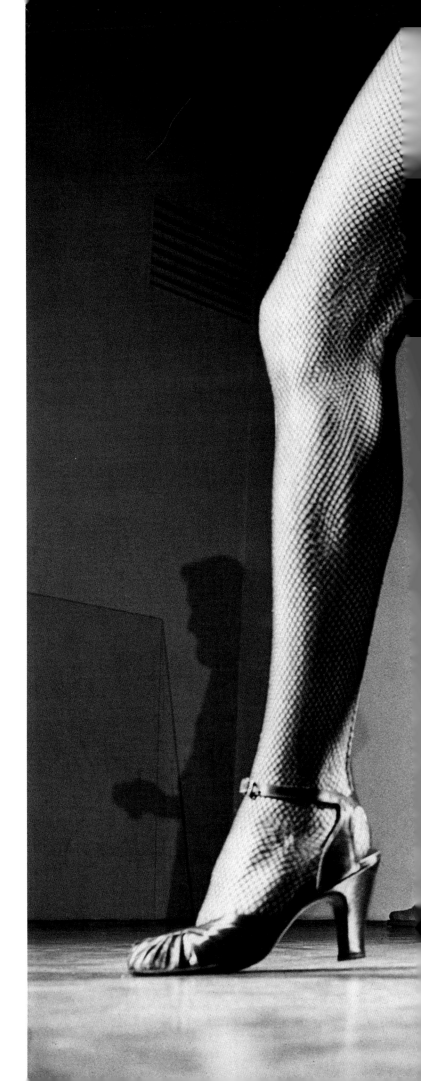

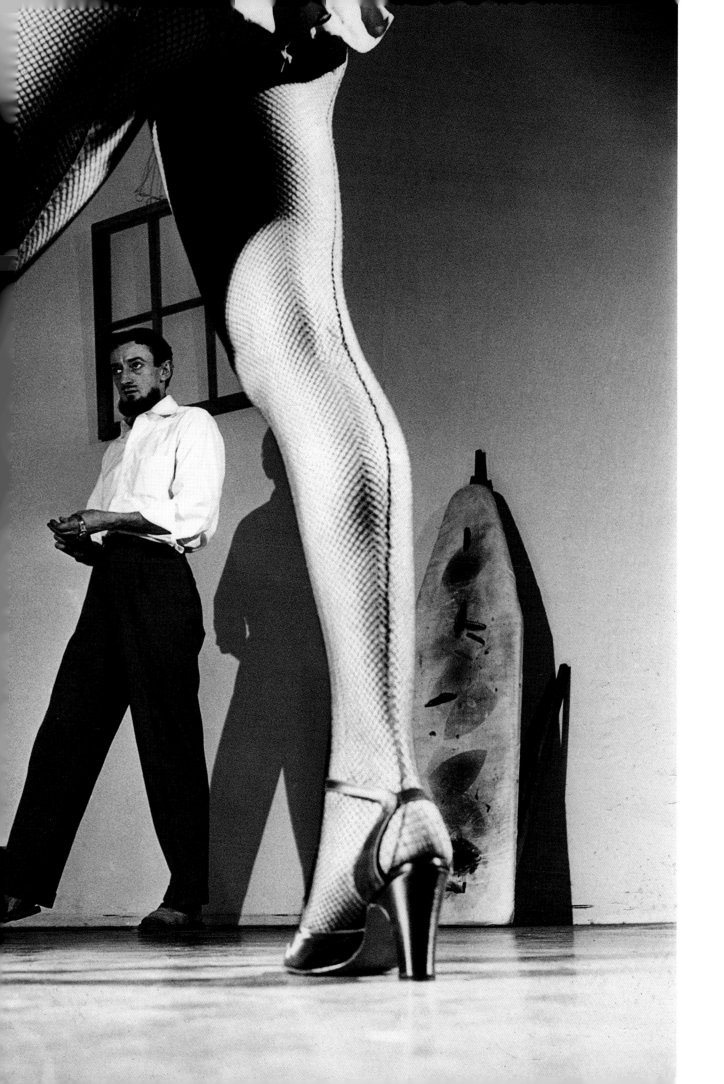

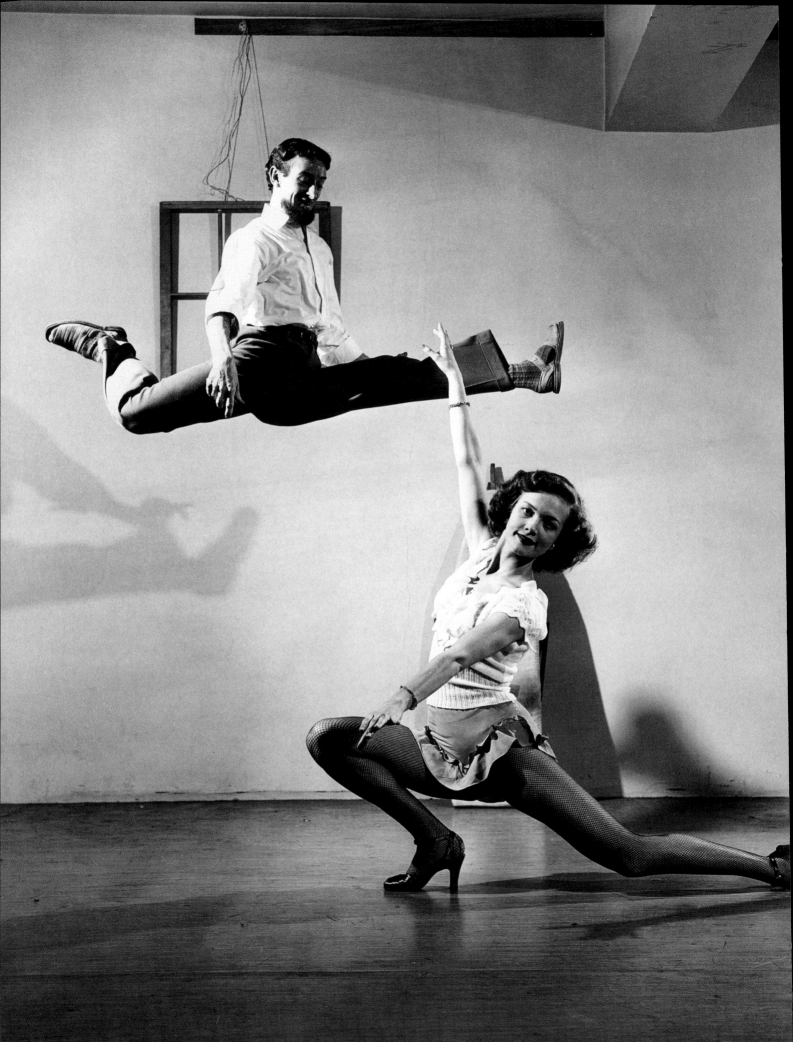

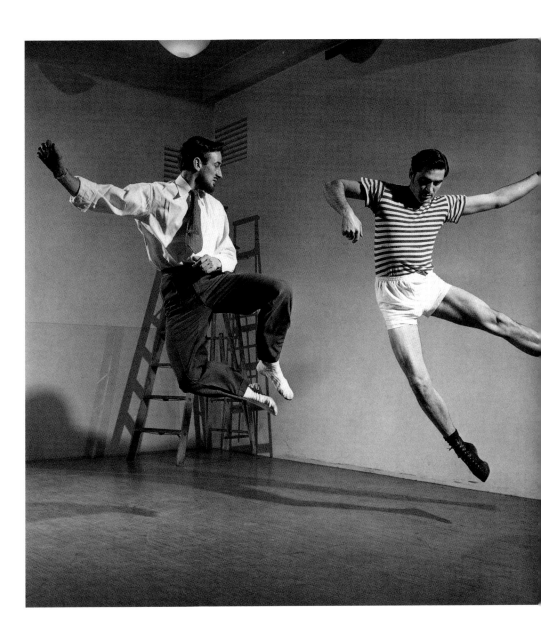

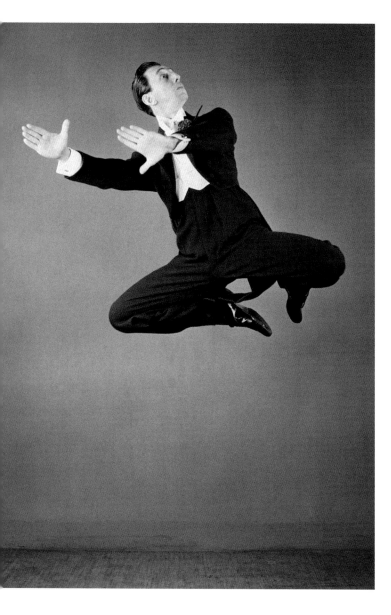

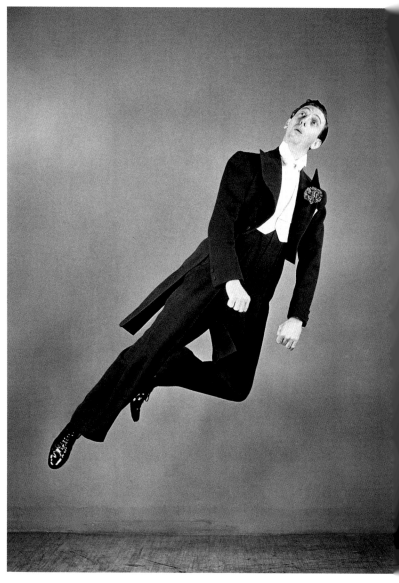

## RAY BOLGER

**JULY 1946 / PHOTOGRAPHER: HY PESKIN (1915–2005)**

Ray Bolger (1904–1987), reputedly fired from an
early job at a Boston bank for tap-dancing down
the hallways, first attracted broad attention in
George White's Broadway revue *Scandals* of
1931. Eight years later he attained Hollywood
immortality for his performance as the Scarecrow
(and a farm hand named Hunk) in *The Wizard of
Oz*. He returned to Broadway in 1946 for a star
turn in the musical revue *Three to Get Ready*,
which showcased his perfectly timed comedy and
gravity-defying dance. *Look* ran photographs from
this assignment in its July 23, 1946, issue.

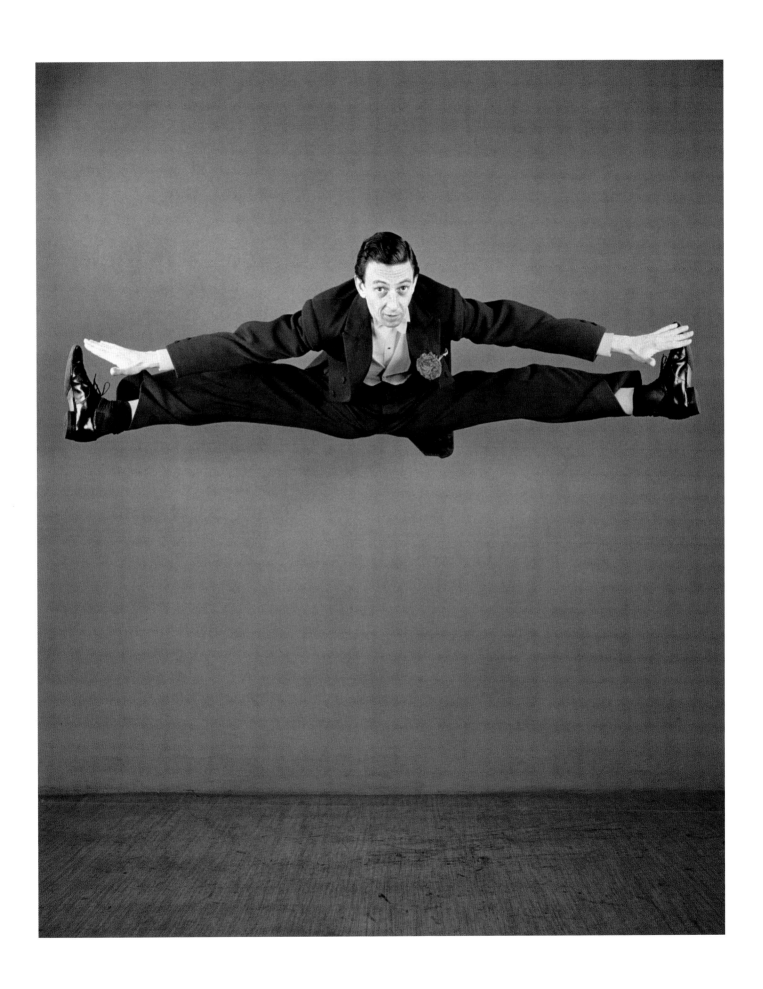

# KATHERINE DUNHAM

**SEPTEMBER 1946 / PHOTOGRAPHER: BOB SANDBERG**

In 1945, shortly before these photographs were taken, Katherine Dunham (1909–2006) had opened the Dunham School of Dance and Theater in Manhattan. As run by Dunham, who had a master's degree in anthropology, the school specialized in dance but offered courses in the humanities. Six years earlier, as dance director of the New York Labor Stage, Dunham choreographed the musical *Pins and Needles* and in 1940 appeared with her company in the hit Broadway musical *Cabin in the Sky*.

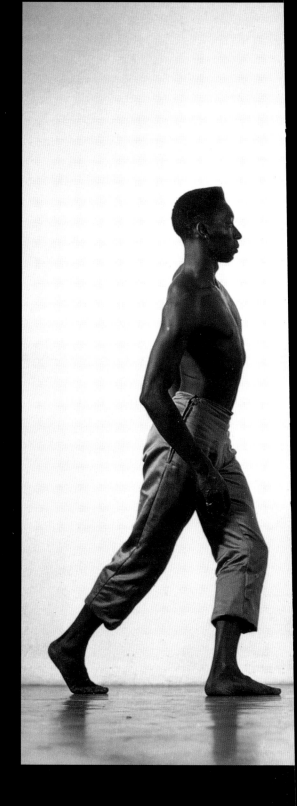

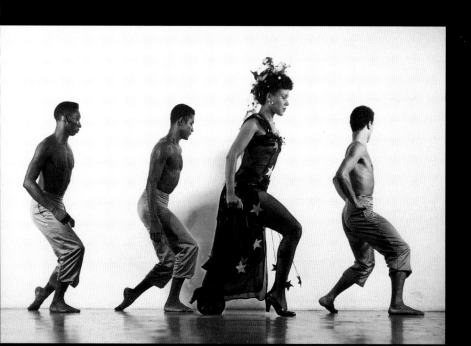

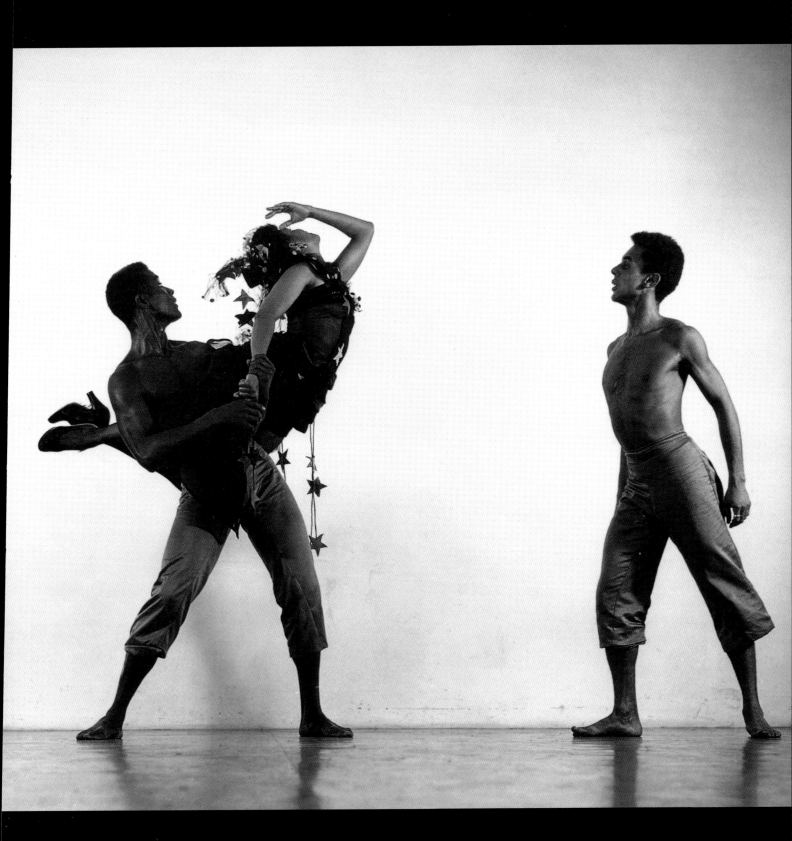

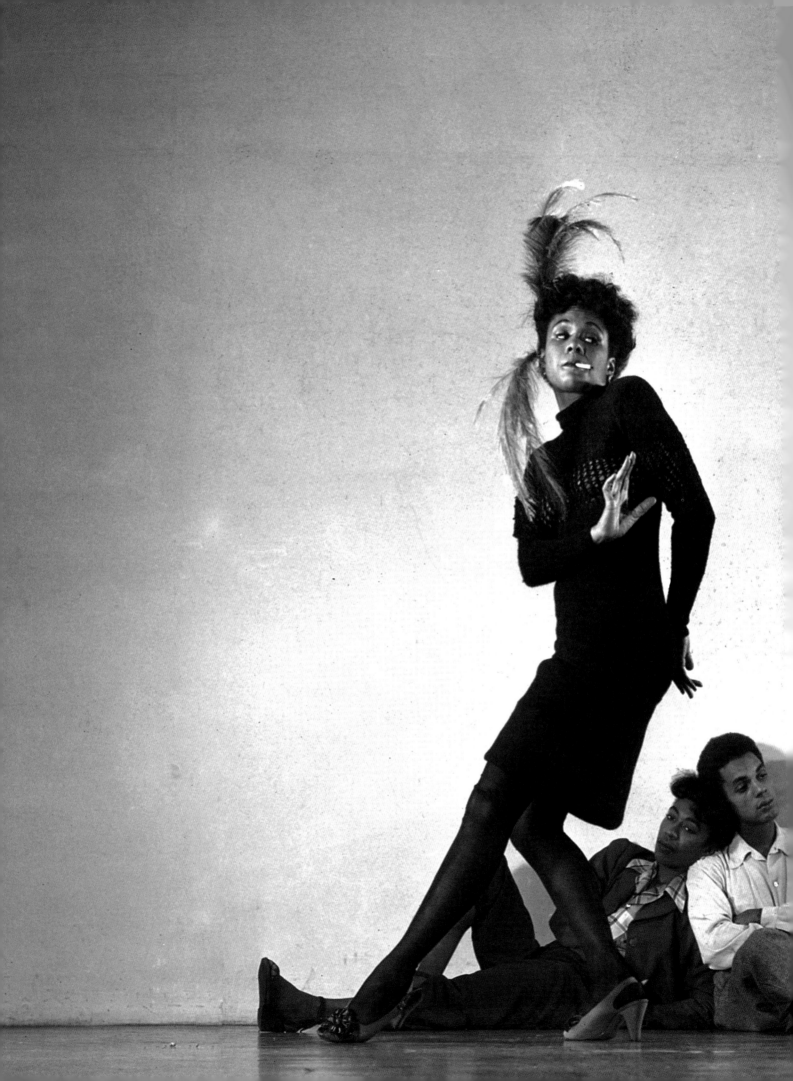

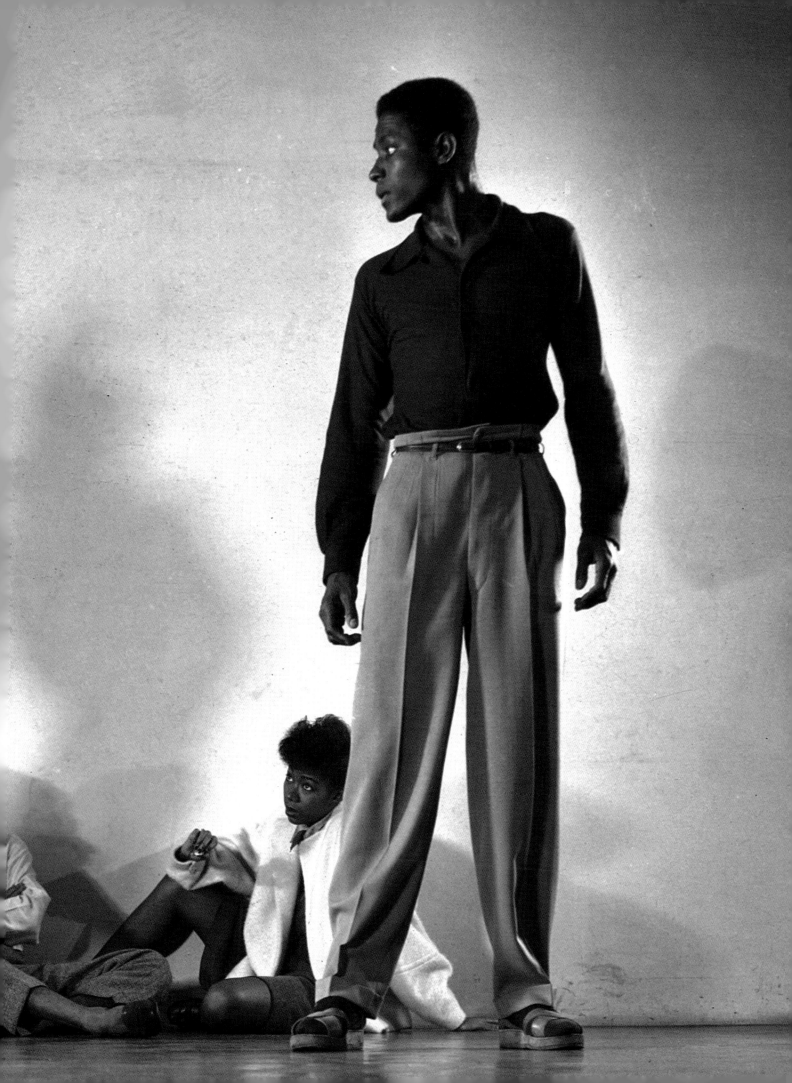

## KNIFE THROWER
**FEBRUARY 1948**
**PHOTOGRAPHER: FRANK BAUMAN**

## FLAME EATER
**MAY 1948 / PHOTOGRAPHER UNKNOWN**
Wolodia Lasareff was famous for performing
a fire-eating act at the Waldorf-Astoria Hotel.

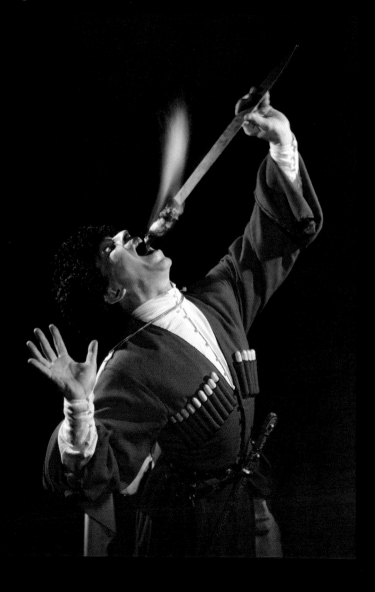

# SALVADOR DALÍ

**JANUARY 1947 / PHOTOGRAPHER: BOB SANDBERG**

Salvador Dalí (1904–1989), one of the twentieth century's most famous and instantly recognized artists, and the creator of such iconic Surrealist paintings as *The Persistence of Memory*, pioneered what would later become known as performance art. In 1939, Dalí entertained New Yorkers when he crashed through the window of Fifth Avenue's Bonwit Teller, which had staged a controversial Surrealist display of his own design. This photograph captures a "performance" staged for *Look* in which a bizarre office environment is equipped with a water cooler, a telephone, and a human desk.

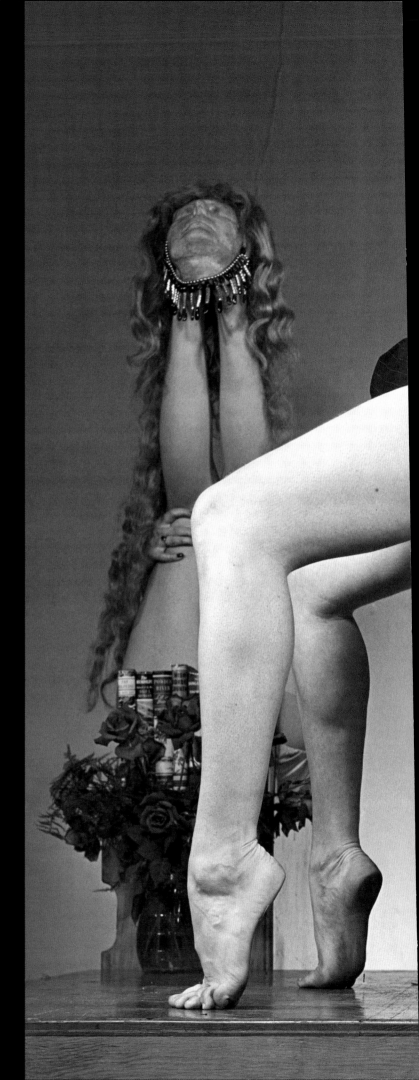

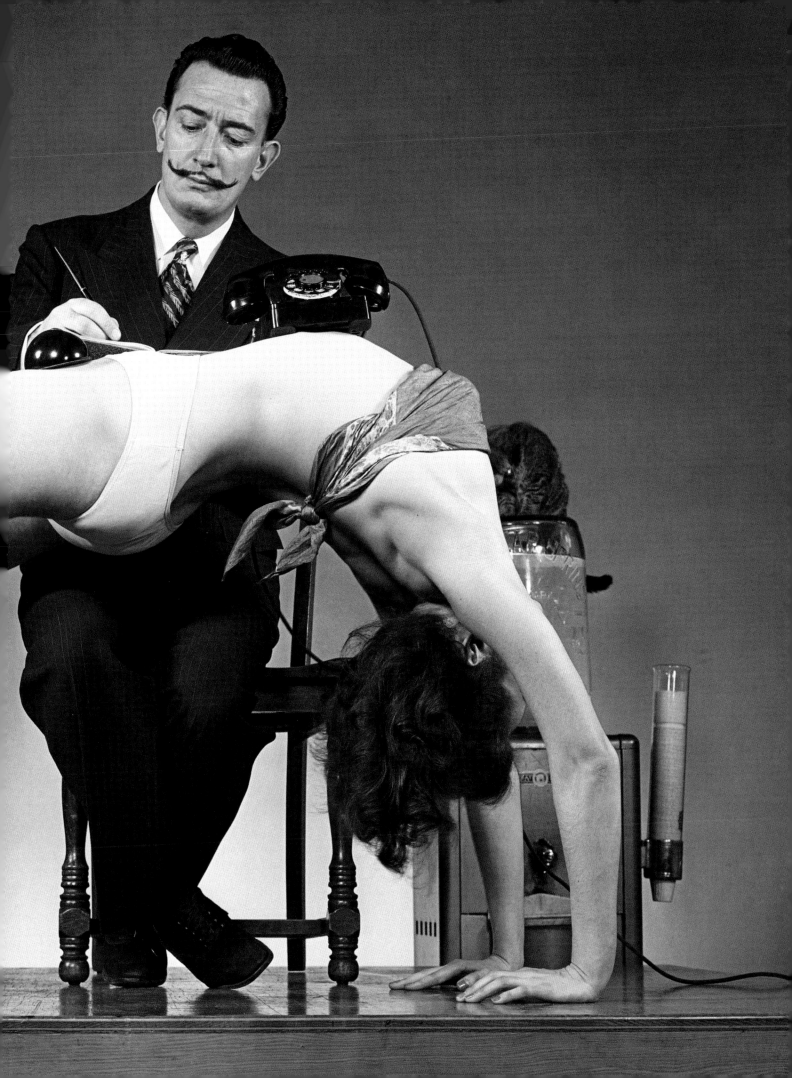

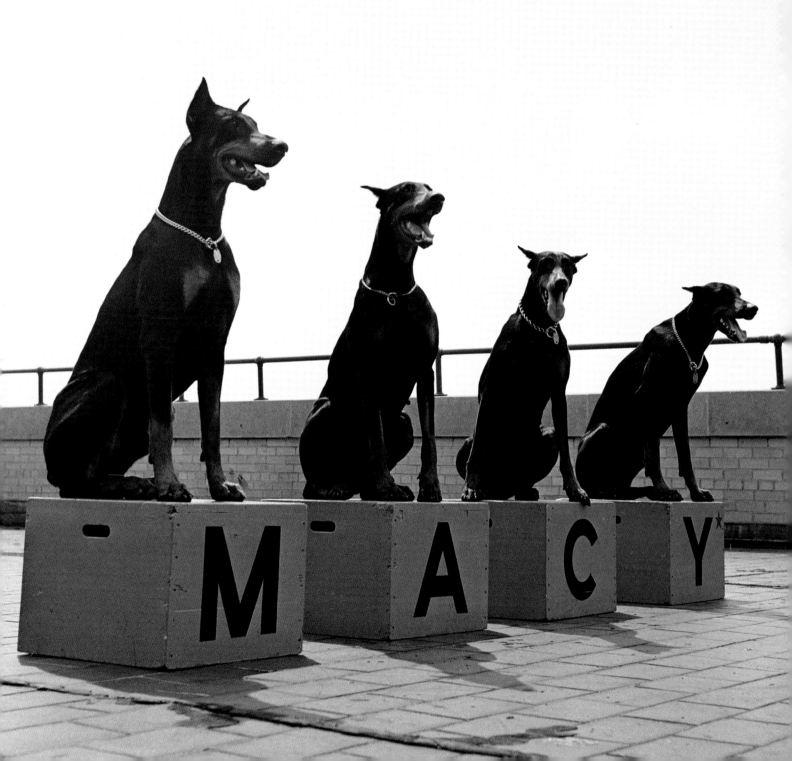

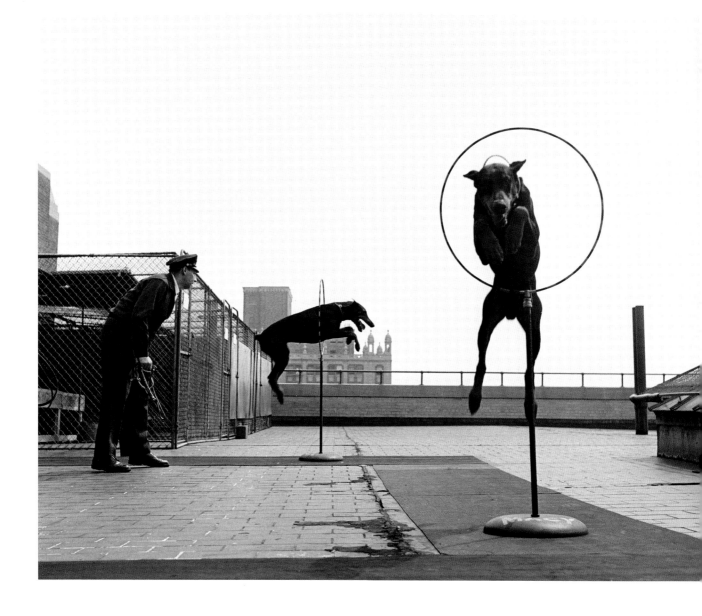

## MACY'S DOGS

**JULY 1954 / PHOTOGRAPHER: ROBERT LERNER**

In New York, dogs can be celebrities. Macy's, the famous Manhattan department store, trained these Doberman pinschers to perform various tricks, among them striking elegant poses on wooden crates spelling MACY. As the company's mascots, the dogs traveled and entertained people at different stores and hotels.

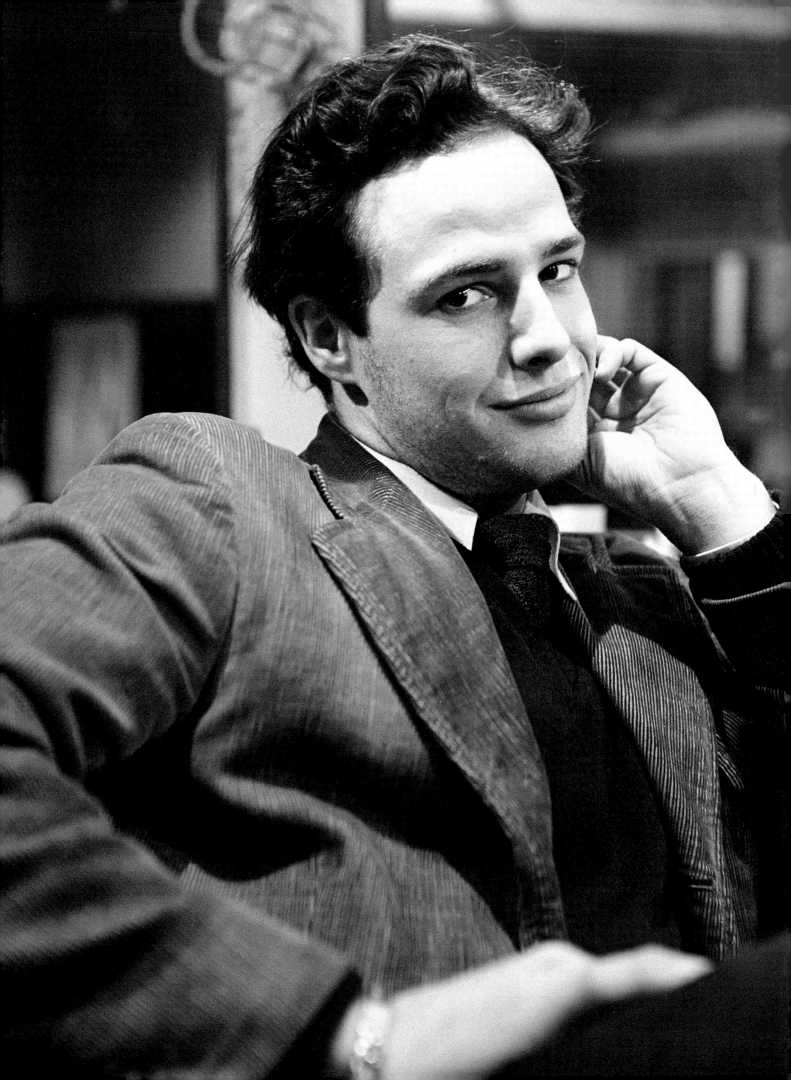

## MARLON BRANDO

**MARCH 1948 / PHOTOGRAPHER UNKNOWN**

This assignment was sparked by the performance of Marlon Brando (1924–2004) as Stanley Kowalski in Tennessee Williams's *A Streetcar Named Desire*, which had opened on Broadway the preceding December. The play made the twenty-three-year-old, Omaha-born Brando an overnight New York sensation. Brando studied with Stella Adler, a member of a famous family of Yiddish theater actors, in the Dramatic Workshop of the New School in Greenwich Village, where so-called "method acting," which drew directly on an actor's personal experience, was pioneered.

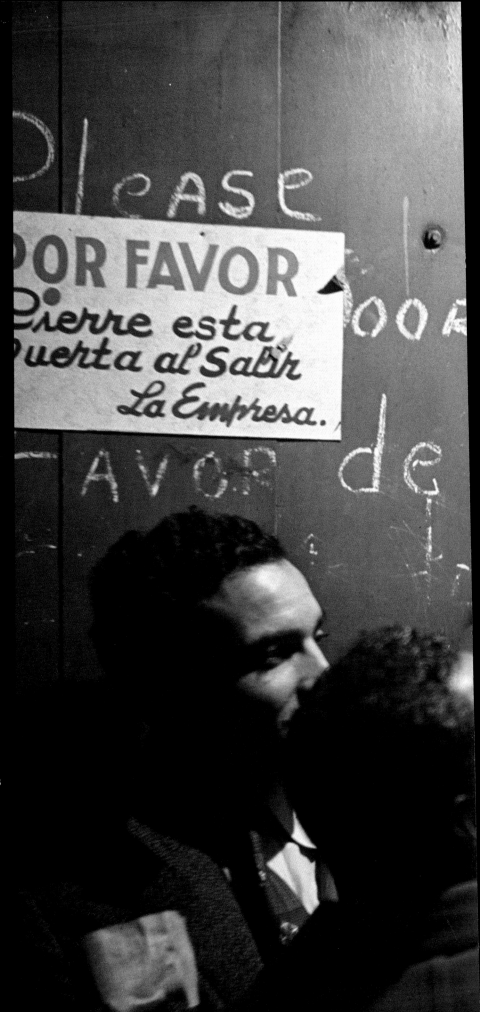

# CÉSAR ROMERO

**FEBRUARY–MARCH 1950**
**PHOTOGRAPHER: JANET MEVI (1922–1976)**

After World War II, as the city's demographics changed, with a dramatic increase in the number of Spanish-speaking New Yorkers, theaters followed suit. Here César Romero (1907–1994) signs autographs for his fans at the stage door of the Puerto Rico Theater in East Harlem. The debonair, Cuban-born actor had a flourishing Hollywood film career in the 1930s and 1940s, but is perhaps best known for portraying the character of The Joker in the popular 1960s television program *Batman*.

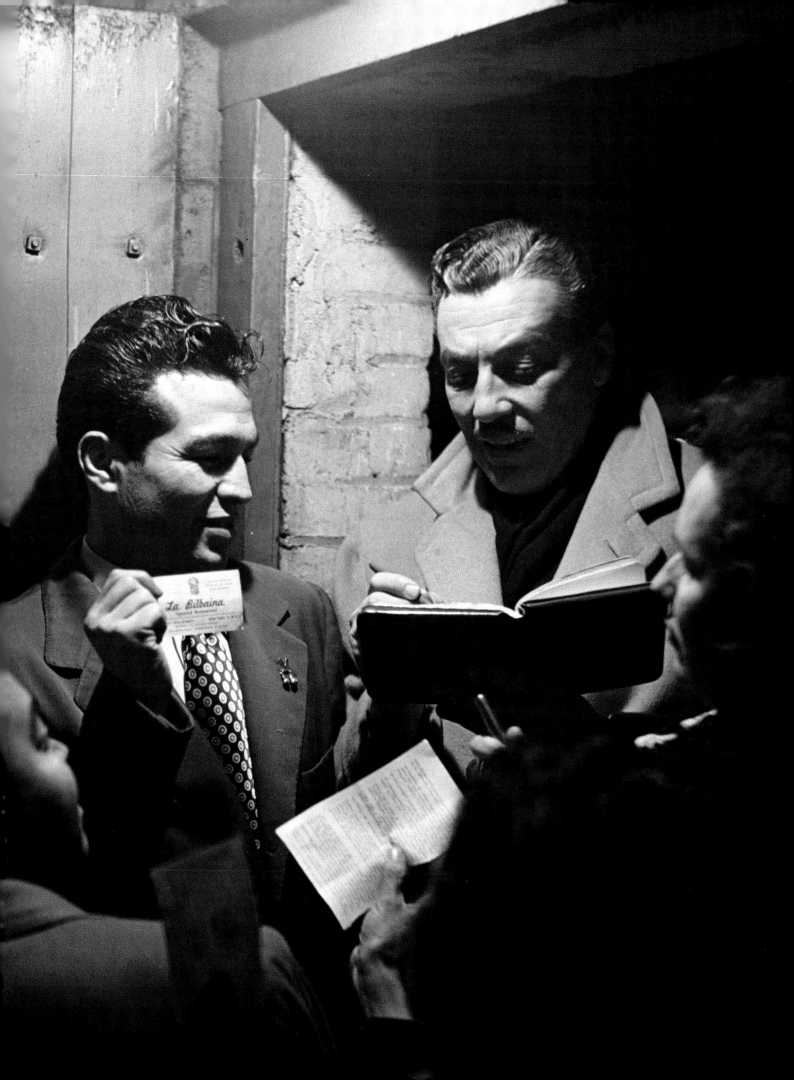

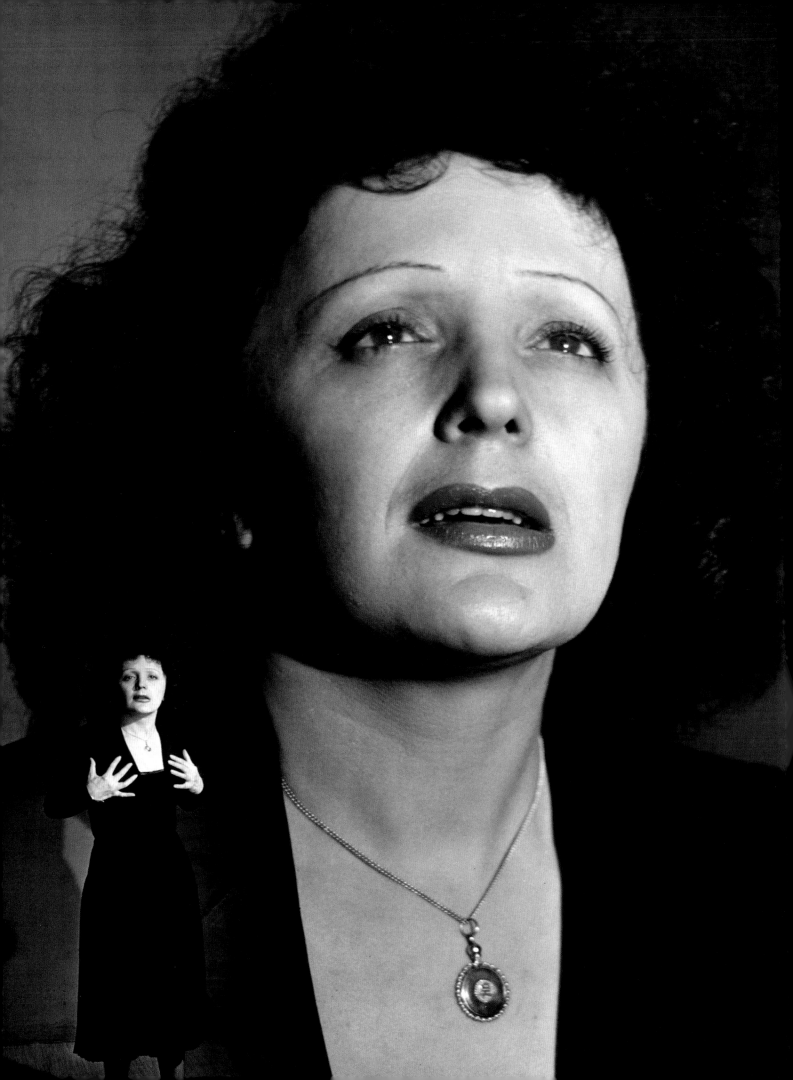

## EDITH PIAF

**FEBRUARY AND APRIL 1948**
**PHOTOGRAPHER: GEORGE HEYER**

Edith Gassion (1915–1963) was dubbed La
Mome Piaf—the Little Sparrow—at the
outset of her singing career and subsequently
identified herself as Edith Piaf. First spotted
performing on the streets of Paris, Piaf
gained a devoted club following during World
War II, but her New York debut in 1947
received lukewarm reviews. She returned
to New York the following year, performing
at the fashionable Versailles nightclub,
where she was a huge hit and set attendance
records. She performed regularly at the club
until 1955.

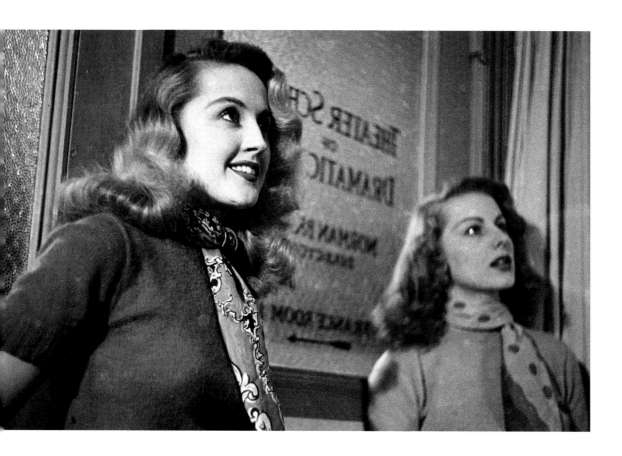

## ASPIRING ACTRESSES

**DATE AND PHOTOGRAPHER UNKNOWN**

Sometimes *Look* offered its readers day-by-day, even hour-by-hour, chronicles of young hopefuls as they made their arduous rounds in search of fame and fortune. In the shoot seen on these pages, the Struck sisters (identified as such in the original assignment's title) visit a drama school, participate in a reading, and pose at the stage door of Broadway's Shubert Theater. This rather sunny portrayal of youthful ambition stood in contrast with the darker images of showgirl Rosemary Williams, taken by Stanley Kubrick, which follow on pages 42 through 47. In the final image, the twenty-year-old photographer is reflected in the mirror of Williams's dressing room.

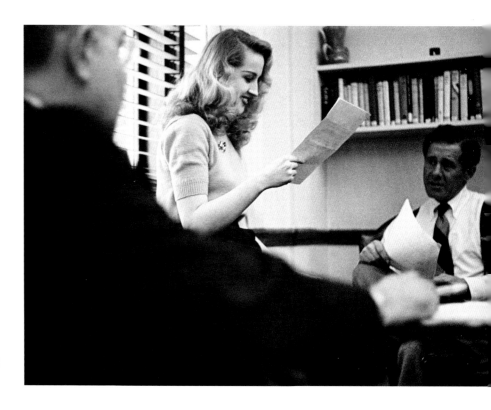

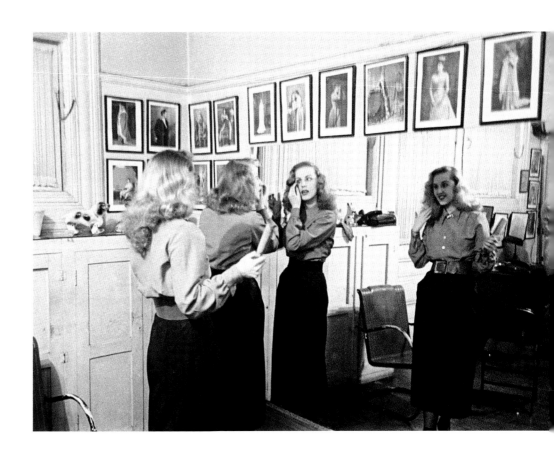

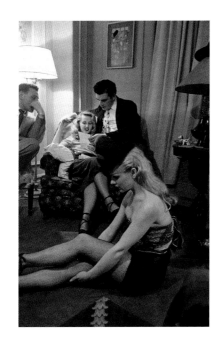

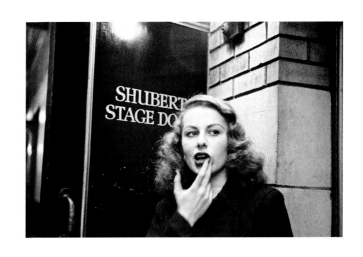

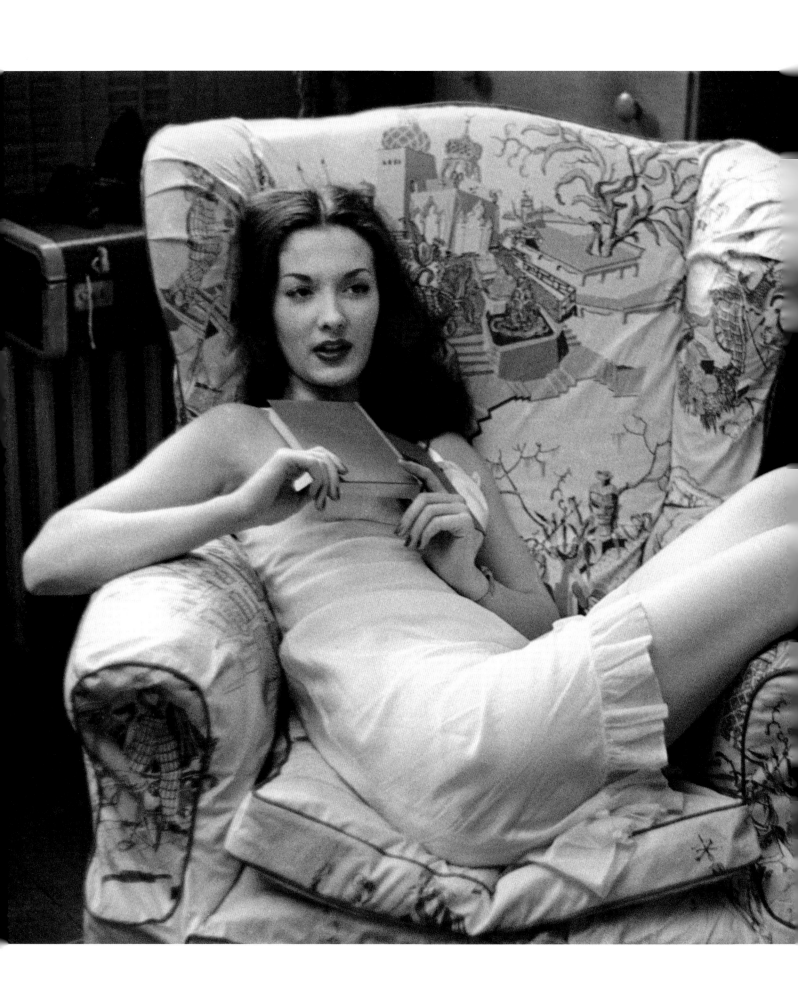

**ROSEMARY WILLIAMS**
MARCH–APRIL 1949 / PHOTOGRAPHER: STANLEY KUBRICK

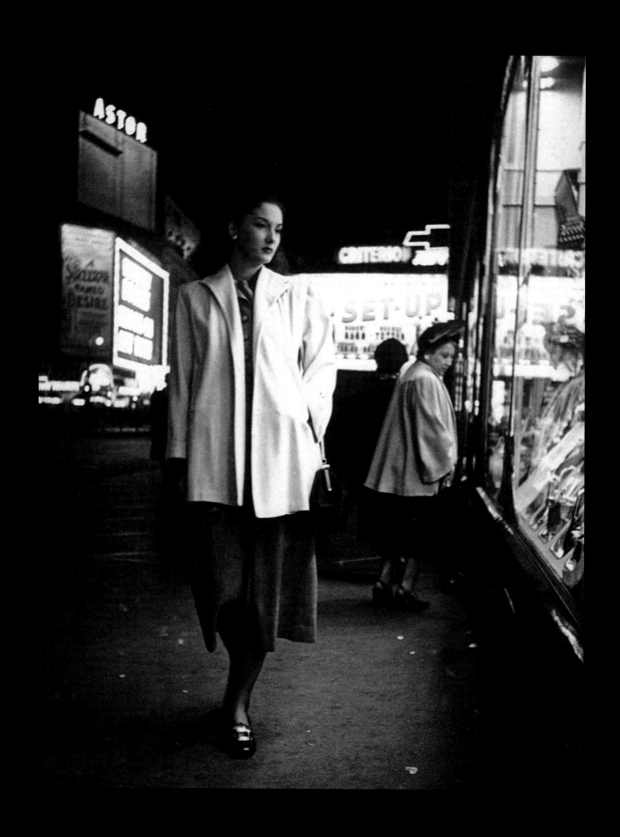

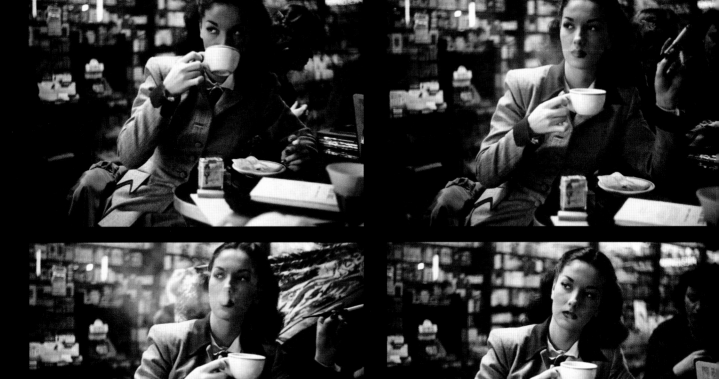

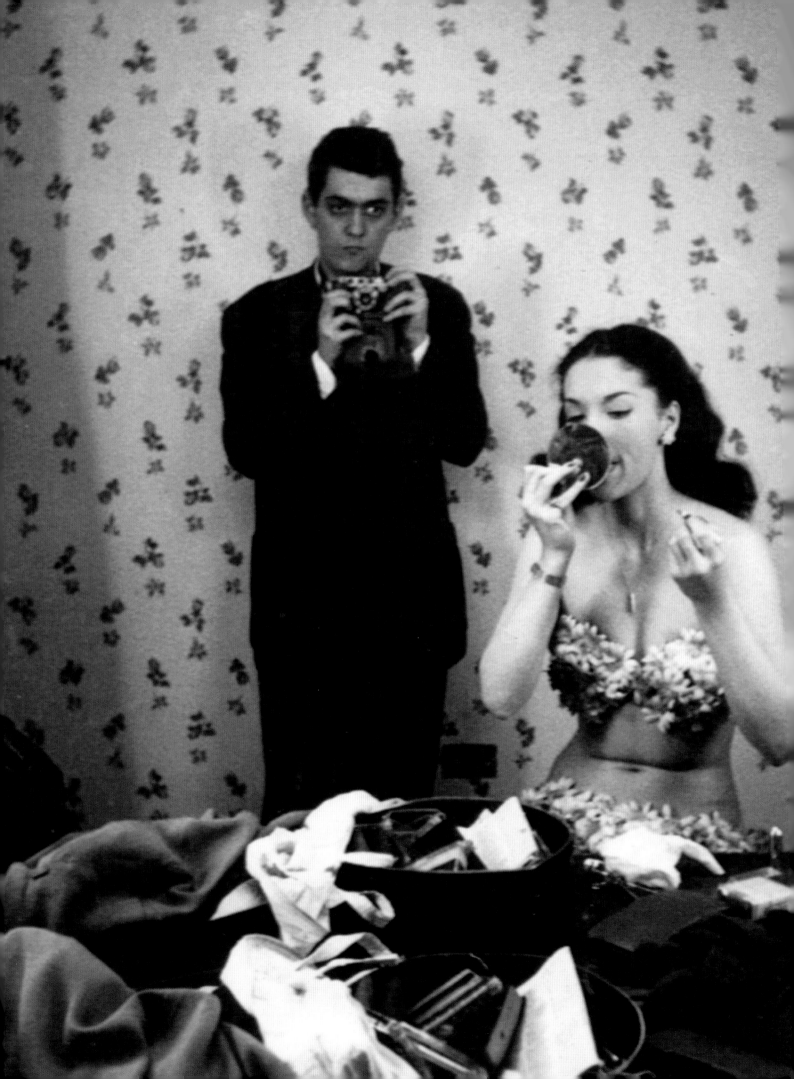

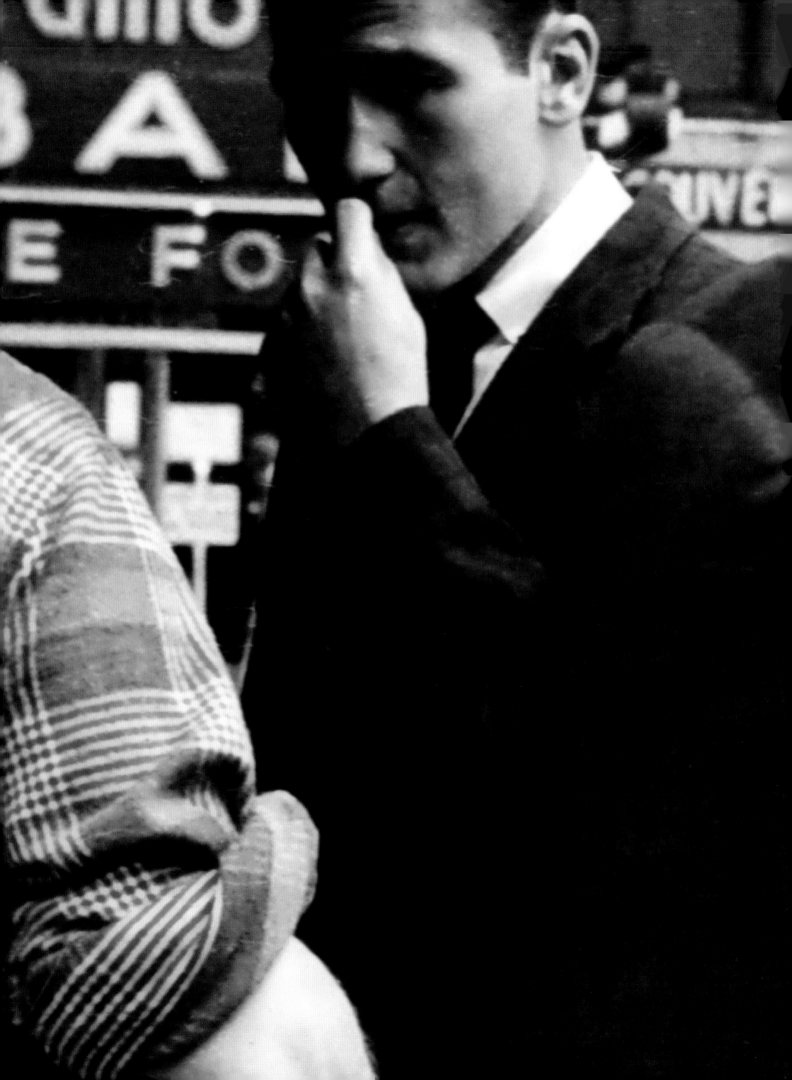

# TIMES SQUARE

Times Square, so named in 1904 in honor of the *New York Times*, which moved to the area that year, has gone through numerous transformations. In the 1910s and 1920s, Times Square was home to the city's burgeoning theater district dominated by stars like Fred Astaire, Tin Pan Alley composers, and bigger-than-life producers. By the 1960s and 1970s, the area's decline into porn theaters and street crime came to symbolize the city's own dwindling fortunes. *Look* magazine's 1952/53 photo shoot, shown here, straddles these two periods in the life of the "crossroads of the world." As seen through the lens of Charlotte Brooks's camera, Times Square by night still glows in high-contrast black and white through its bright signs advertising that this playland is "always open." By day, this area turns gray and washed out. Tourists also seem oddly missing as showgirls and street-smart men populate the area and give it an edge of menace.

APRIL 1952–FEBRUARY 1953 / PHOTOGRAPHERS: JOSEPH MORSCHAUSER (1924–1993, PAGES 50–51) AND CHARLOTTE BROOKS (PAGES 52–57)

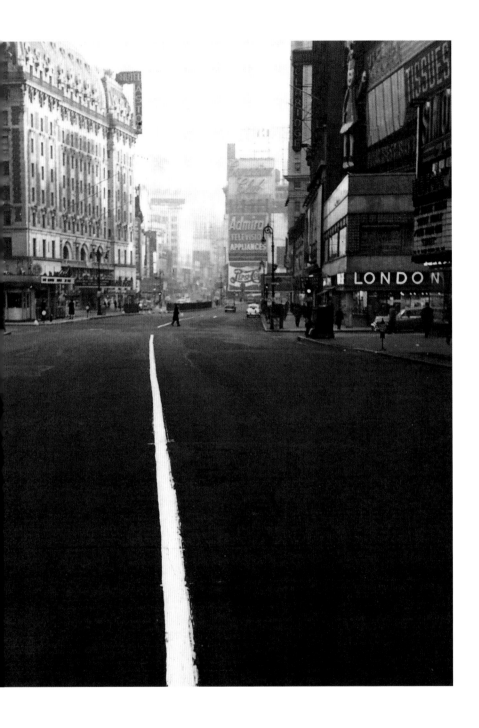

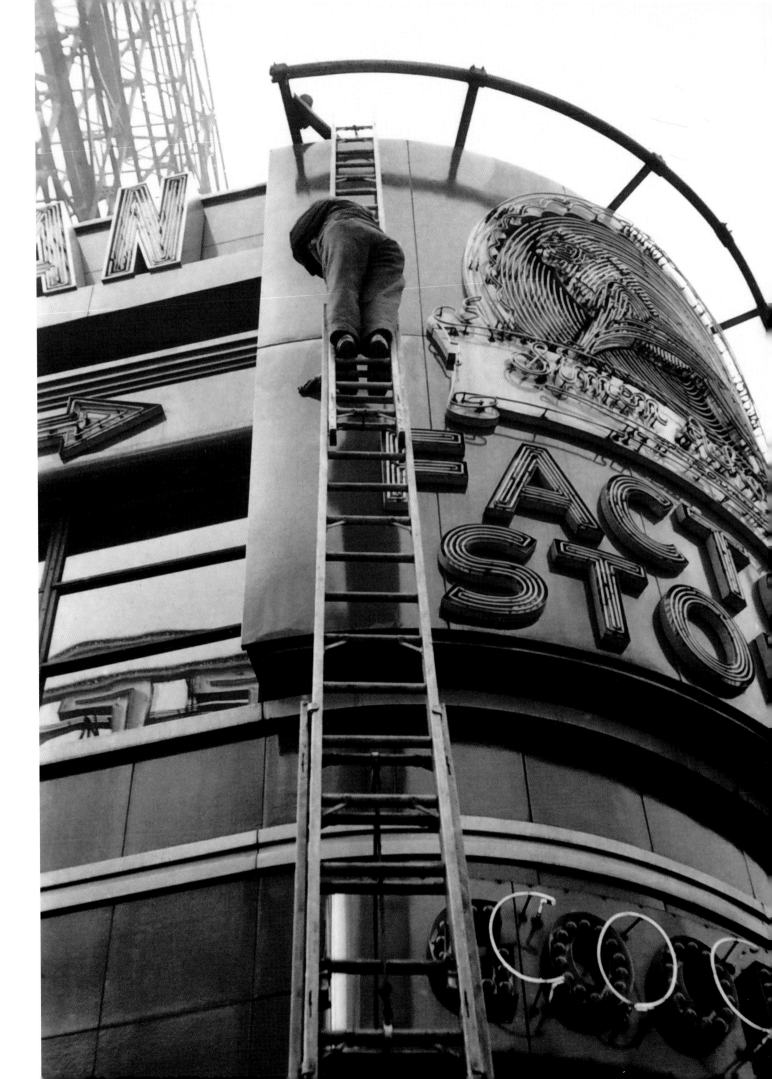

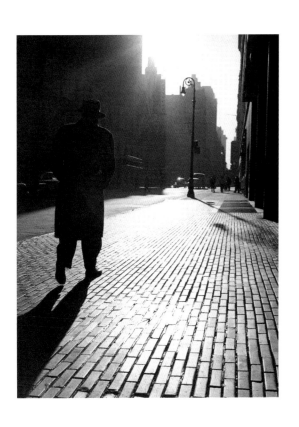

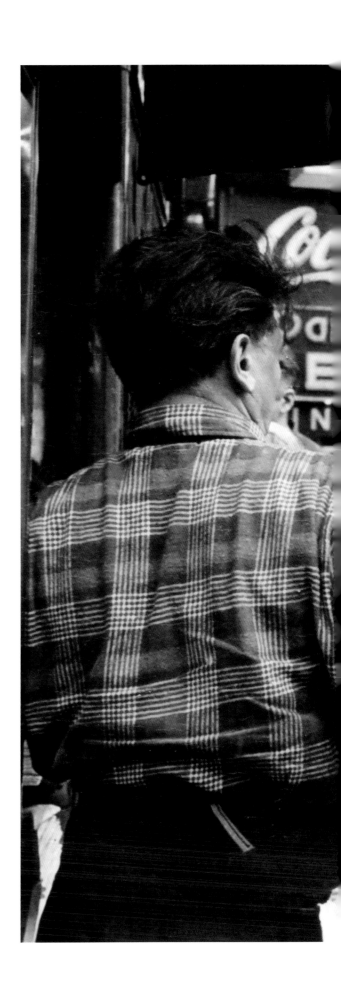

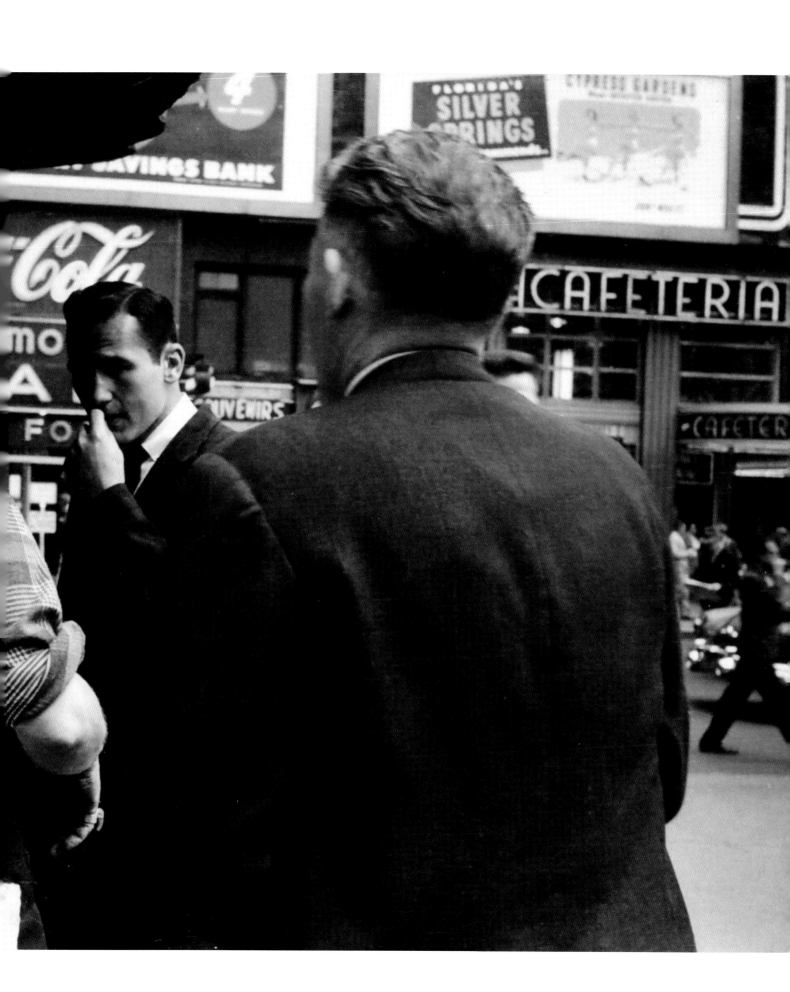

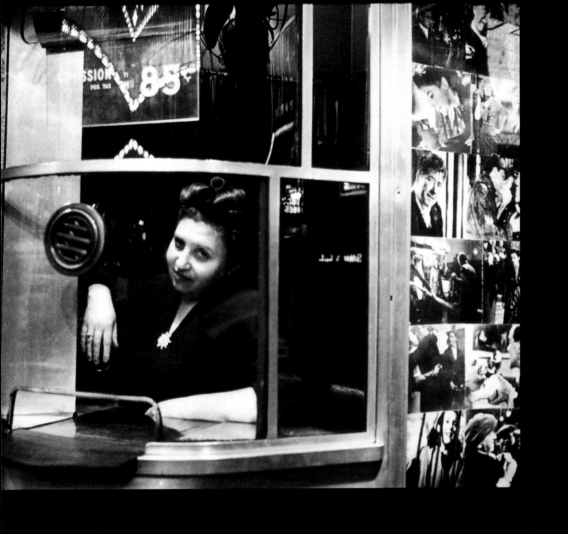

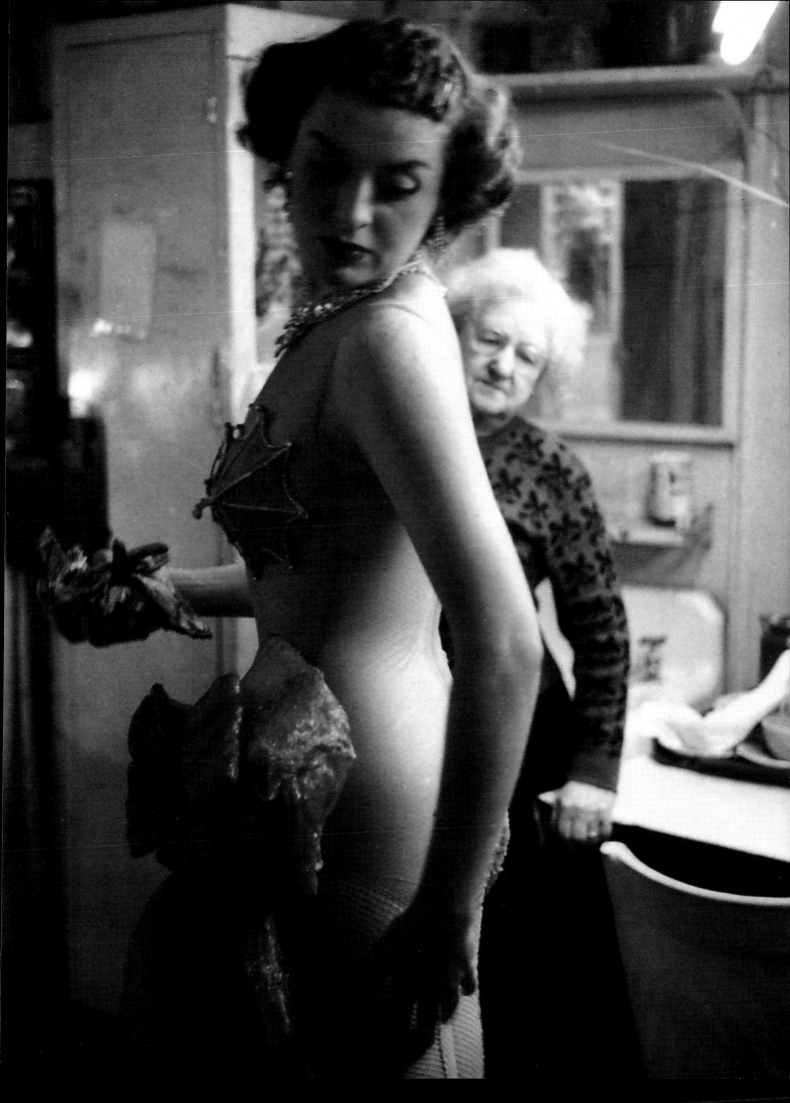

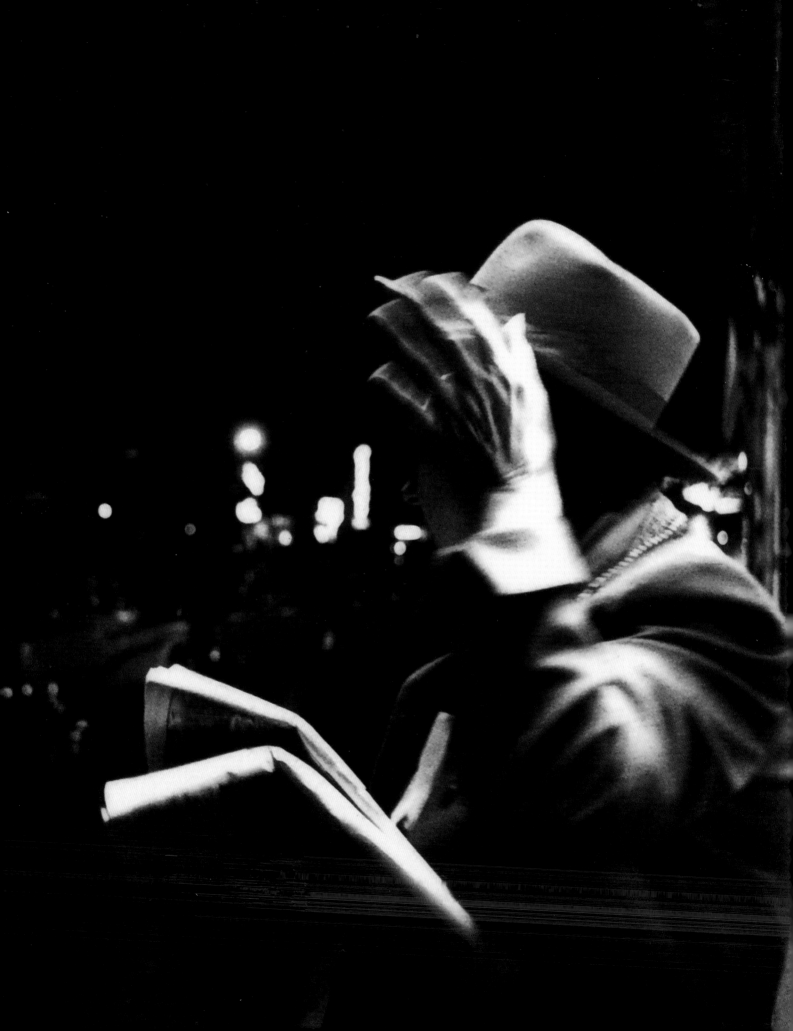

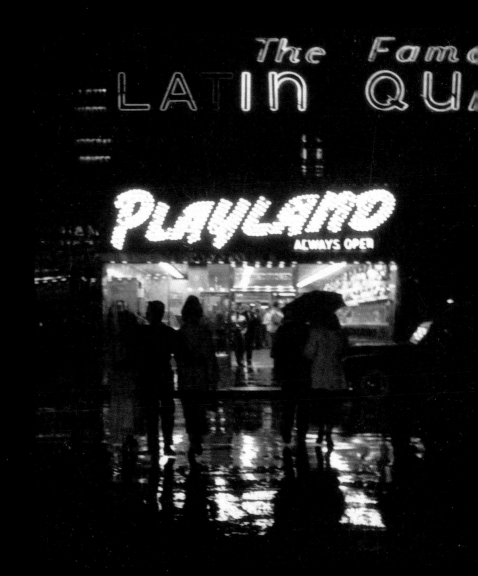

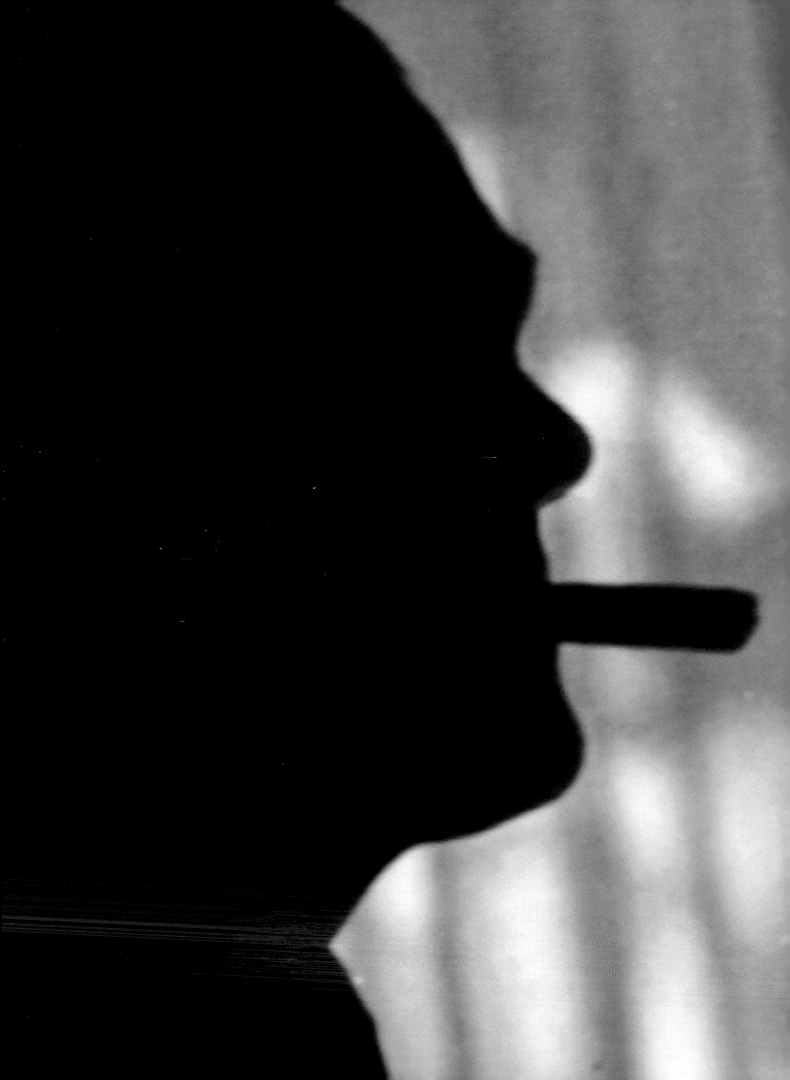

# PROMOTERS

Promoters serve as the city's catalysts. From the
Broadway stage to the galleries of the Museum
of Modern Art and the swankiest nightclubs,
post–World War II New York offered ample places
for strivers to get attention. Many, in fact, moved
to New York from small towns all over America for
just that reason. Risking their reputations—and
sometimes their money—the city's promoters
spotted the new talent, served as social magnets,
built a new skyline, and created the institutions
that defined New York for the nation and the world.
These people also had a genius for self-promotion;
whatever the outcome of their endeavors, they
grabbed attention and the headlines.

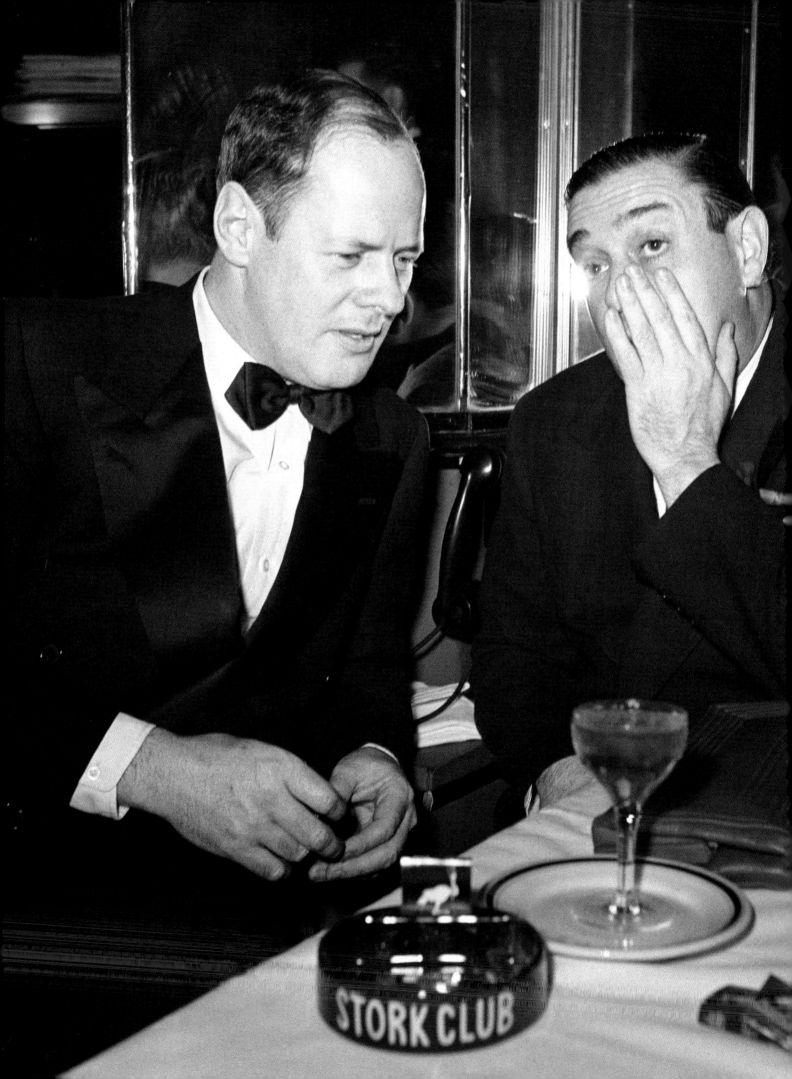

# SHERMAN BILLINGSLEY

**DATE UNKNOWN / PHOTOGRAPHER: FRANK BAUMAN**

From 1929 to 1965, Oklahoma-born Sherman Billingsley (1900–1966) owned the Stork Club, located after 1934 at 3 East Fifty-third Street, where he held court at table Number One. Crowning himself the city's leading nightlife impresario, Billingsley (left) used the club to promote the careers of established stars, as well as wannabes seeking celebrity. Widely covered in the press, the club was a not-to-be-missed destination for those able to get in and a symbol of New York's mythic glamour to the excluded. A year after the club closed, Billingsley died in a small apartment on Manhattan's East Side, his fortune squandered.

## ELSA MAXWELL

**DATE UNKNOWN / PHOTOGRAPHER: MAURICE TERRELL**

Elsa Maxwell (1883–1963) became New York's most famous hostess in the 1920s and 1930s. Attendance at her parties was de rigueur for all those interested in self-promotion. Additionally a gossip columnist, songwriter, author, and publisher of her own magazine, Maxwell claimed her achievement was "not bad, for a short, fat, homely piano player from Keokuk, Iowa, with no money or background, who decided to become a legend and did just that."

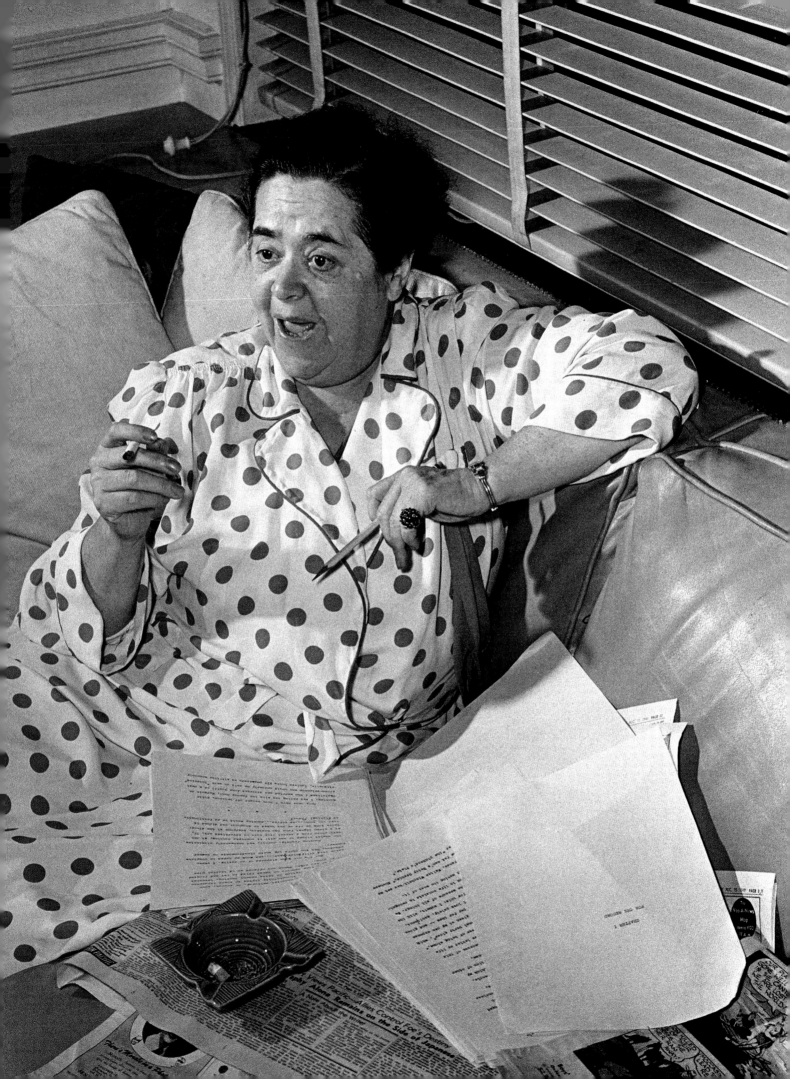

# MIKE TODD

**OCTOBER 1950 / PHOTOGRAPHER: MICHAEL A. VACCARO**

Mike Todd (1909–1958), born Avrom Hirsch Goldbogen in Minneapolis, burst onto the New York entertainment world with his successful production of *The Hot Mikado* at the 1939/40 New York World's Fair. With two telephones and a copy of *Variety* at his ready, the cigar-chomping Todd is shown on the terrace of his Manhattan penthouse, seemingly in complete control of his expanding entertainment empire. Throughout a tumultuous career of hits and flops, Todd produced thirty Broadway shows. He married Elizabeth Taylor in 1957 and died in a plane crash the following year at the age of forty-nine.

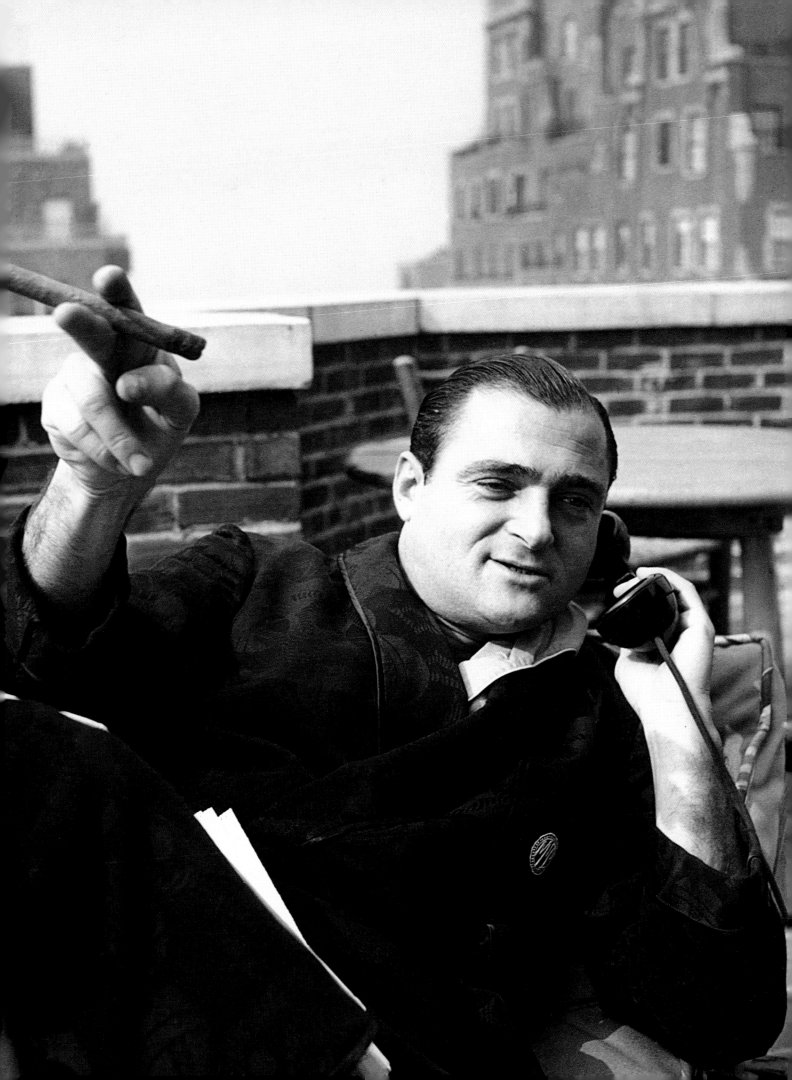

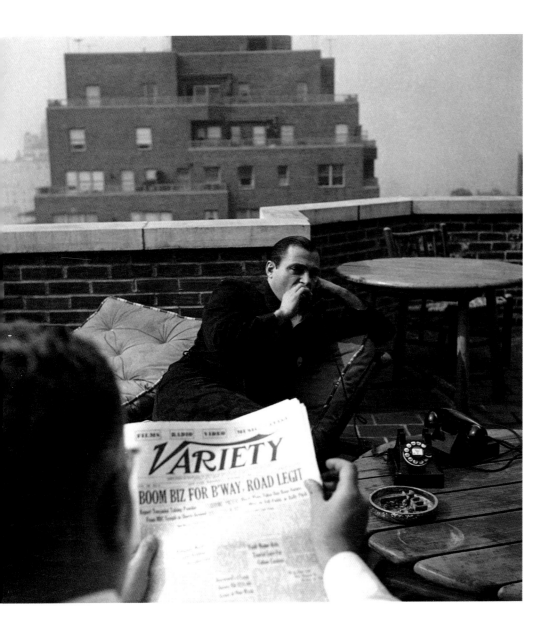

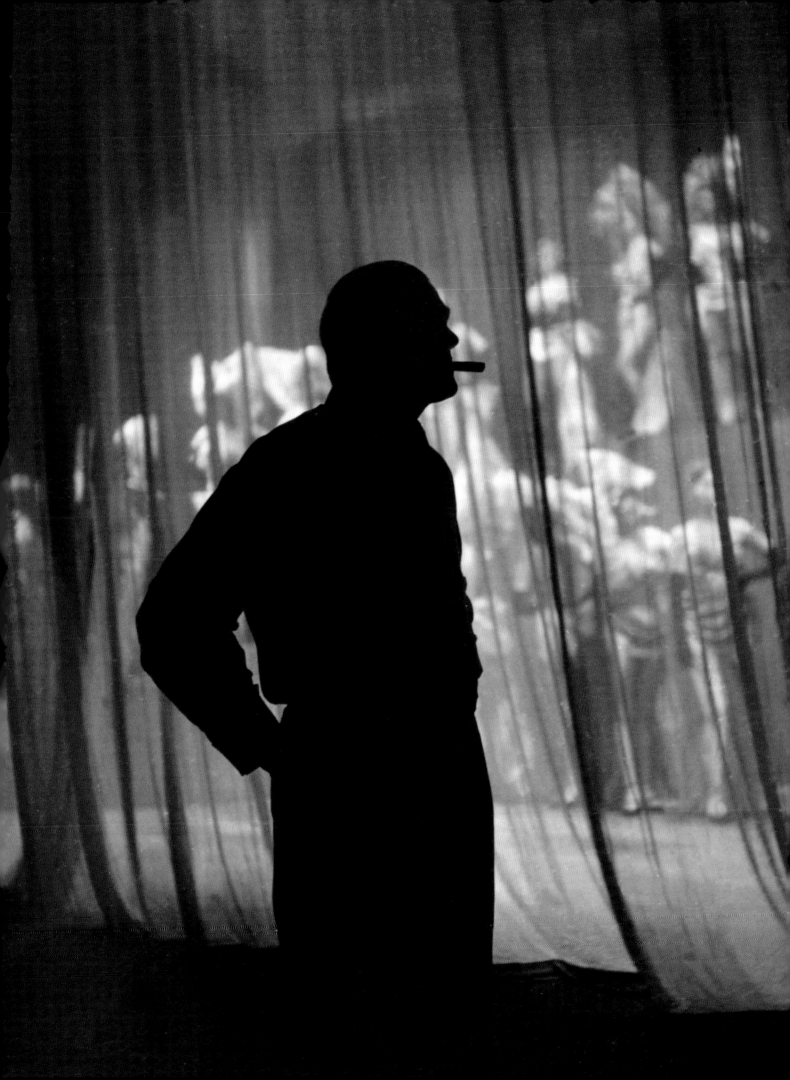

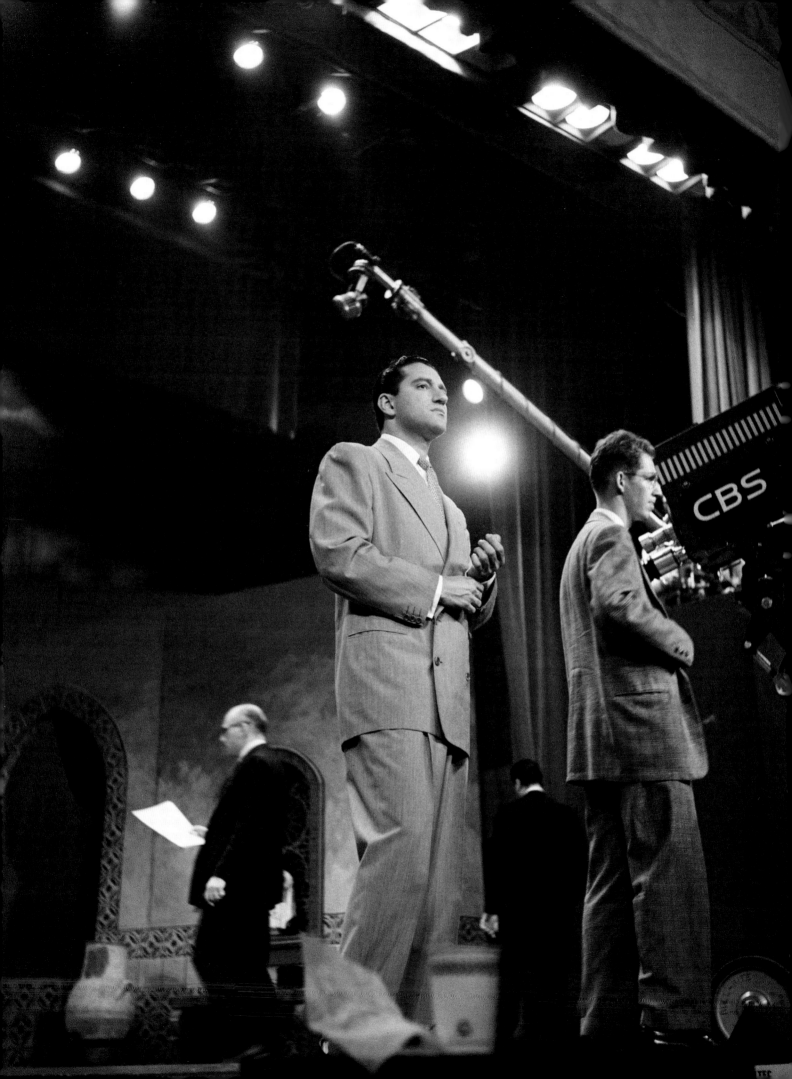

## MARLO LEWIS

MAY 1951 / PHOTOGRAPHER: DOUGLAS JONES (d. 1987)

CBS executive producer Marlo Lewis
(1916–1993) was a pioneering figure in the
new medium of television. In 1948, Lewis
co-created the long-running *Ed Sullivan
Show*, which he co-produced for twelve
years. Here he is seen on the show's set.
Wisely understanding the growing influence
of the television industry, initially centered
in New York, *Look* covered many television
personalities, including Sullivan and late-
night talk show host Jack Paar. Ironically,
the popularity of television would ultimately
contribute to the demise of pictorial
magazines such as *Look*.

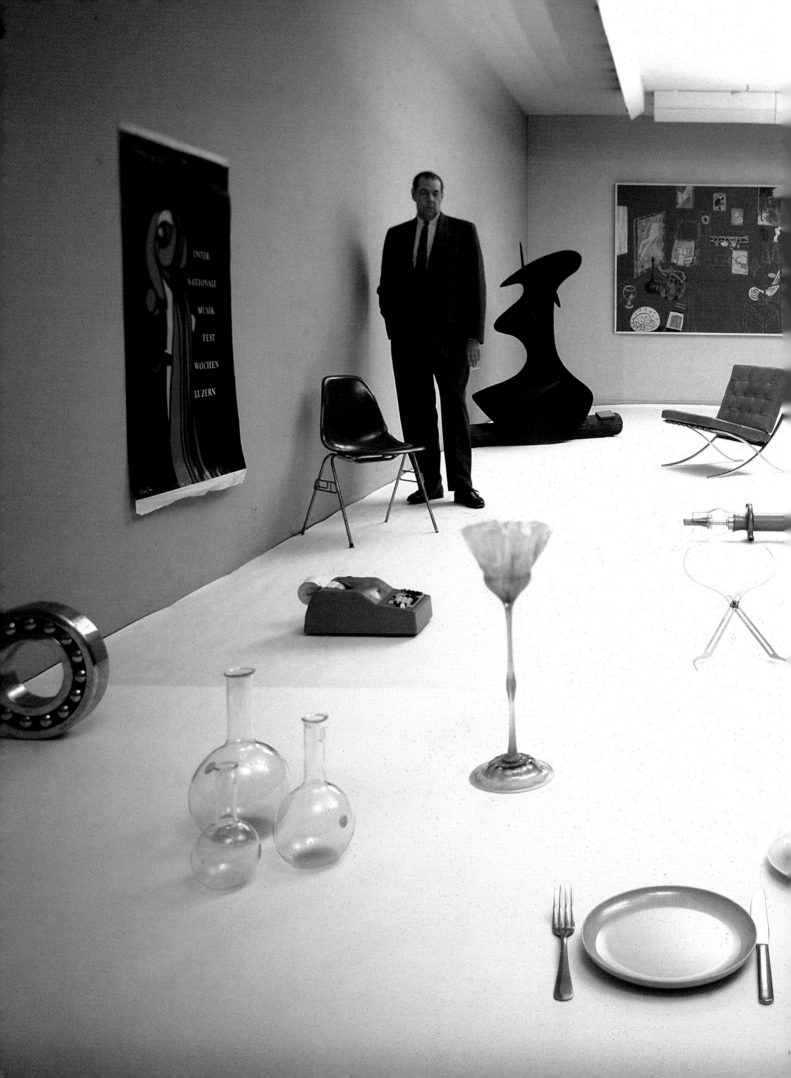

INTER
NATIONALE
MUSIK
FEST
WOCHEN
LUZERN

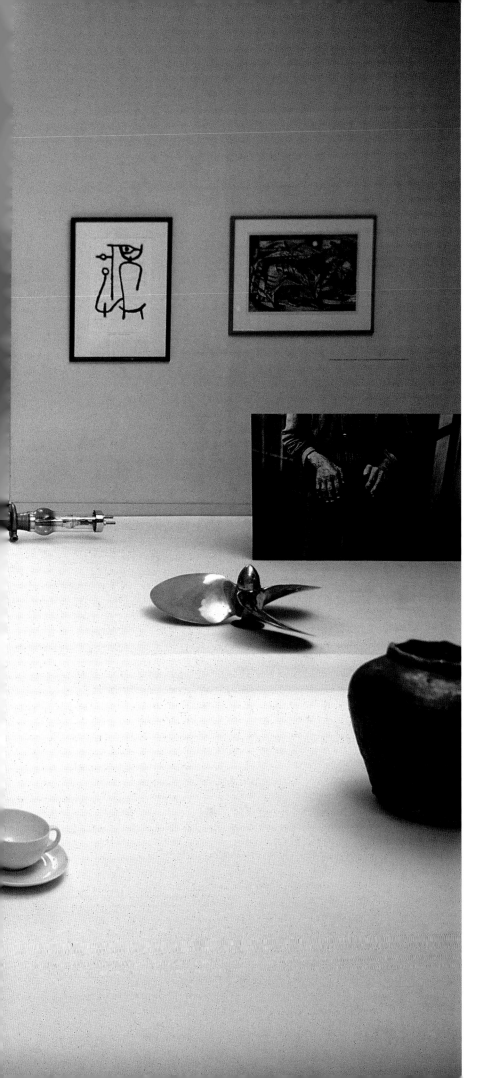

## RENÉ D'HARNONCOURT
**NOVEMBER 1957**
**PHOTOGRAPHER: PHILLIP HARRINGTON**

Born in Vienna, René d'Harnoncourt rose to the top of the New York art world in 1949 when he became director of the Museum of Modern Art, an institution conceived to promote modernist aesthetics in art, architecture, and design. Reflecting the museum's contention that high-quality design could be found anywhere, d'Harnoncourt was photographed standing amid twenty-one pieces from the museum's collection of 11,000 objects, from a Japanese vase, to an Italian calculator, to a boat propeller, plastic chair, and glass chemical flasks, all designed in America. This image appeared in an article titled "New York: The Taste Shaper," focusing on the Museum of Modern Art, in *Look*'s February 18, 1958, issue devoted to New York.

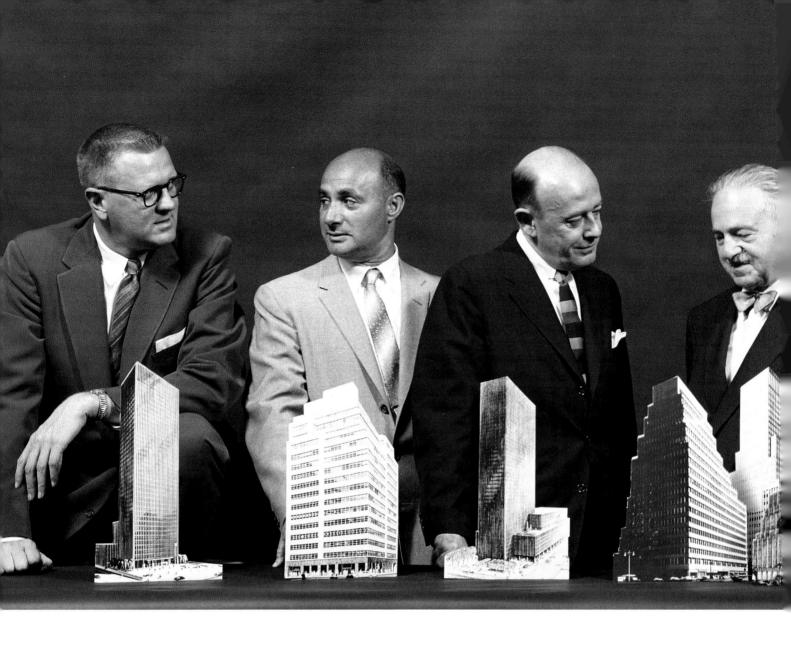

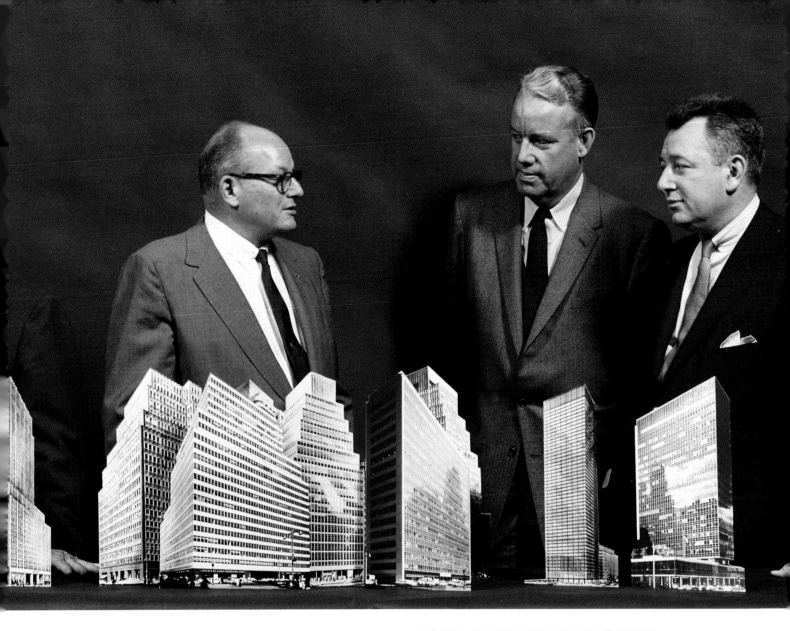

## PARK AVENUE DEVELOPERS
## AND ARCHITECTS

**1957 / PHOTOGRAPHER: ARTHUR ROTHSTEIN**

The new steel-and-glass towers of Manhattan's Park
Avenue, seen here as miniature cutouts, represented
corporate America's adaptation of International Style
architecture, which the Museum of Modern Art had
heavily promoted since its landmark exhibition of 1932.
Standing behind the cutouts are the architects and devel-
opers responsible for the design and construction of these
buildings. They include architects Ely Jacques Kahn
(1884–1972, center), Richard Roth Sr. (1904–1987, right
of Kahn), and Gordon Bunshaft (1909–1990, far right) of
the highly influential architectural firm Skidmore,
Owings & Merrill. He is seen with an image of his design
for Lever House, which launched the transformation of
Park Avenue from a street of traditional brick apartment
houses to a man-made canyon composed of technologi-
cally and stylistically state-of-the-art office high-rises.

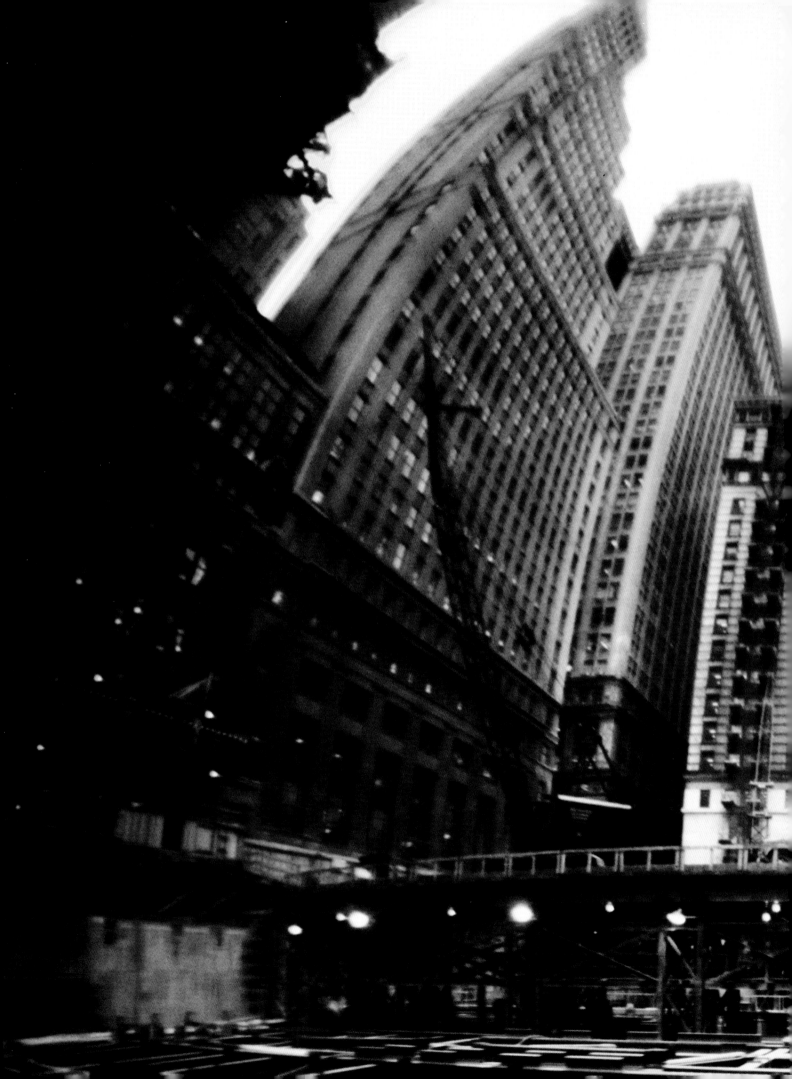

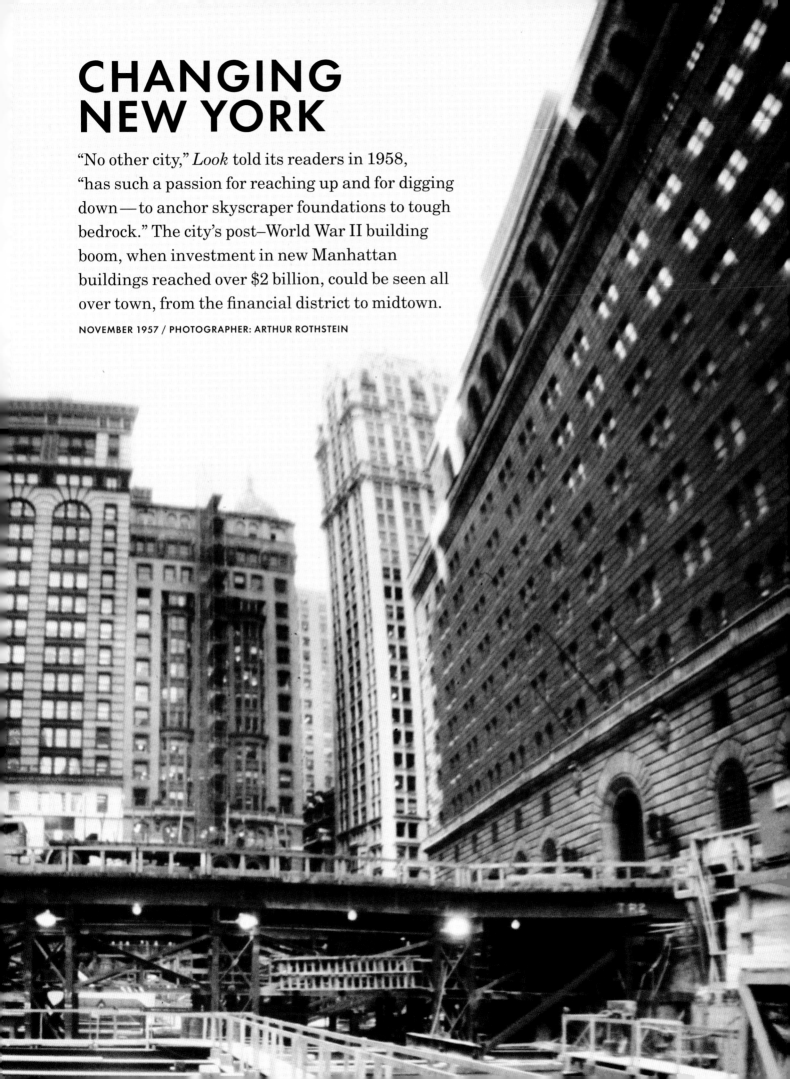

# CHANGING NEW YORK

"No other city," *Look* told its readers in 1958, "has such a passion for reaching up and for digging down—to anchor skyscraper foundations to tough bedrock." The city's post–World War II building boom, when investment in new Manhattan buildings reached over $2 billion, could be seen all over town, from the financial district to midtown.

NOVEMBER 1957 / PHOTOGRAPHER: ARTHUR ROTHSTEIN

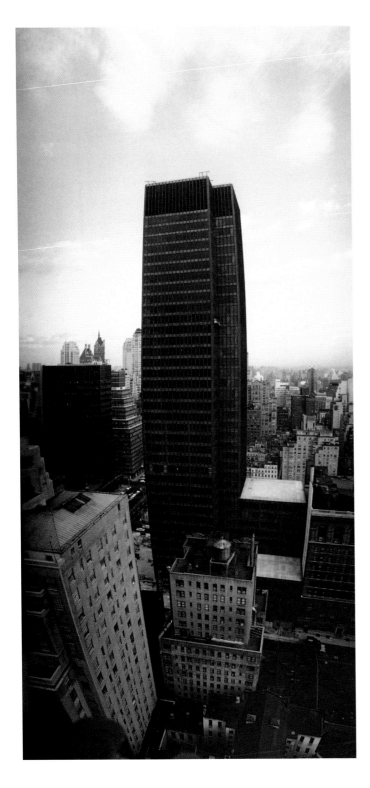

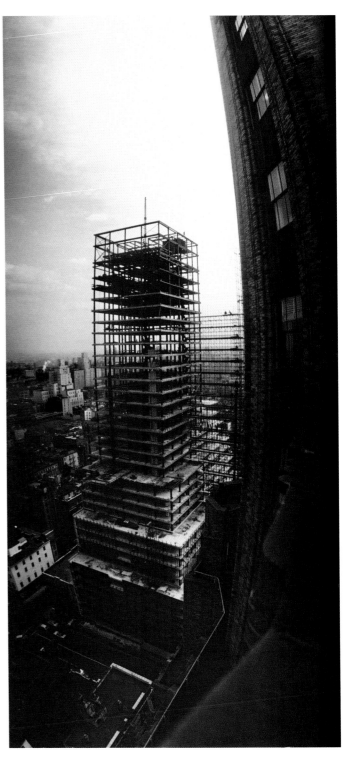

New construction in
midtown Manhattan,
including (above) the
Seagram Building,
designed by Ludwig
Mies van der Rohe
and Philip Johnson.

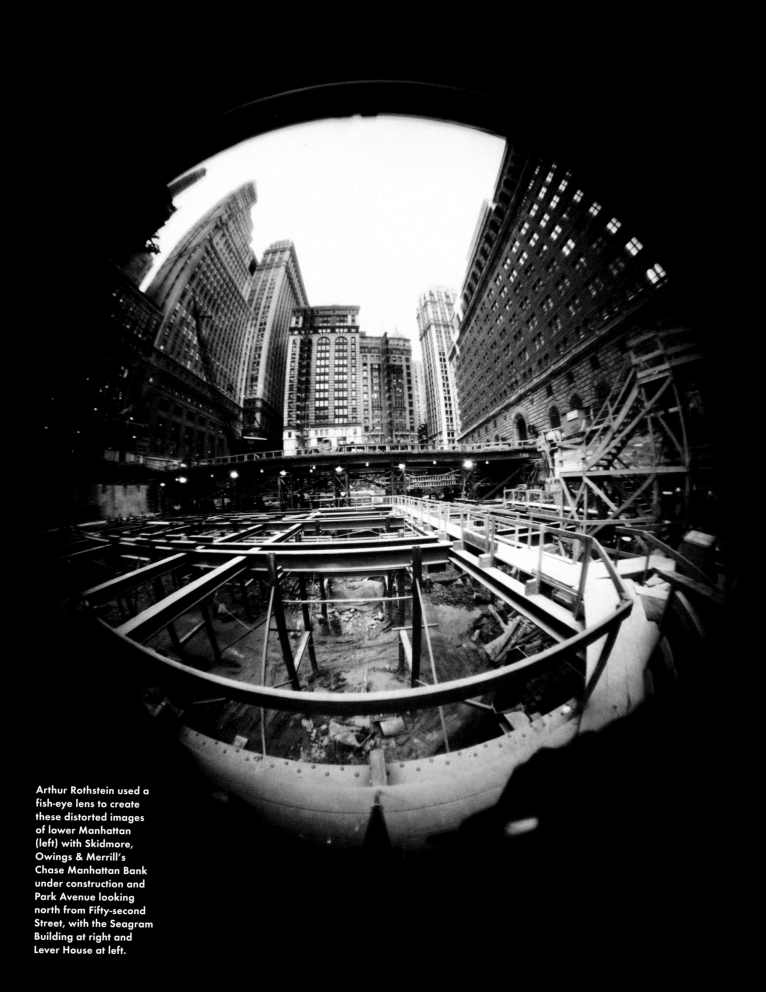

Arthur Rothstein used a fish-eye lens to create these distorted images of lower Manhattan (left) with Skidmore, Owings & Merrill's Chase Manhattan Bank under construction and Park Avenue looking north from Fifty-second Street, with the Seagram Building at right and Lever House at left.

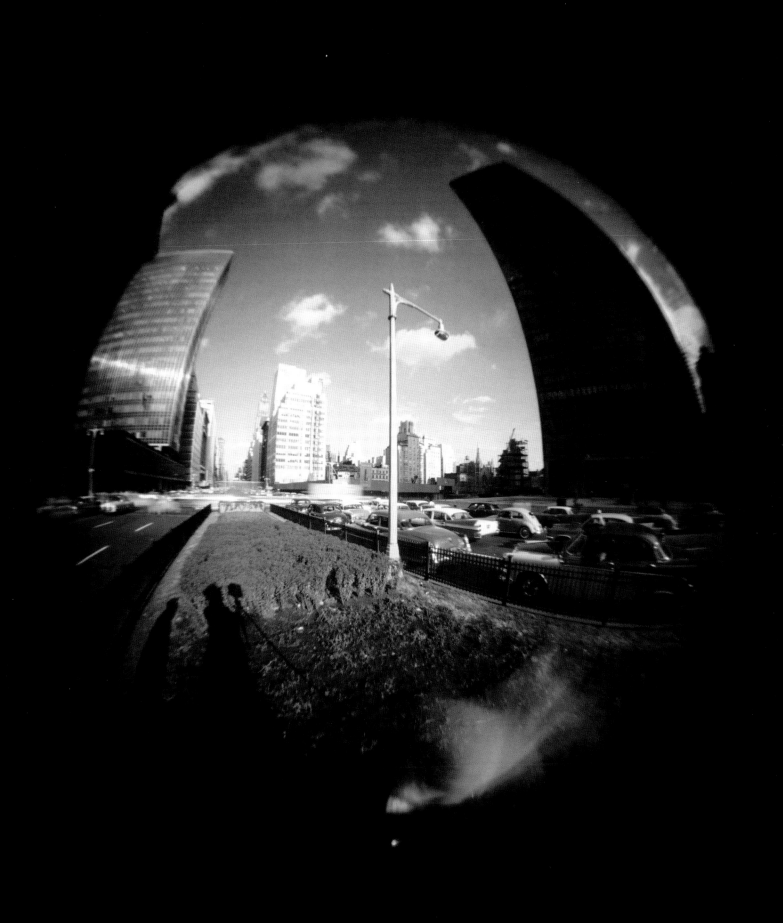

# FASHIONISTAS

What defines New York style? Common wisdom has
long contended that while Parisian women of means,
relying on couture, dress to please men, New York
women, with access to a hometown garment industry
producing clothes at every price point, dress to please
themselves. New York's clothing manufacturers,
focused on Seventh Avenue and the Garment District,
collectively constituted the city's biggest industry
and by the late 1950s surpassed $3 billion in annual
revenue. The industry was supported not only by
designers and merchants, but also by an army of
fashion writers, publicists, models, and stylists who
guided women through a maze of choices.

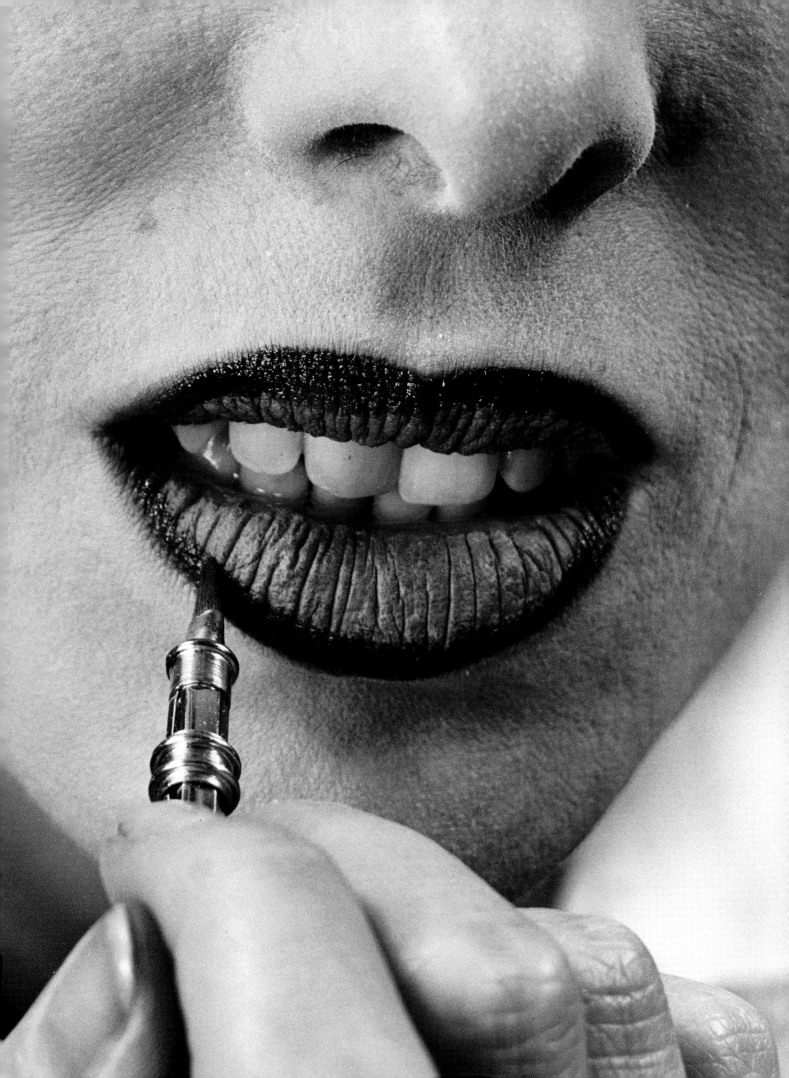

# A TALE OF TWO MODELS

1947 / PHOTOGRAPHERS: ARTHUR ROTHSTEIN
(PAGES 82–84) AND BOB SANDBERG (PAGE 85)

*Look*'s story "A Tale of Two Models"
published in its January 6, 1948, issue
chronicled the activities of Meg Mundy
(b. 1915) and Lisa Fonssagrives (1911–
1992). Mundy, whose father managed the
Metropolitan Opera orchestra, had a highly
successful career as a model and an actress,
starring on Broadway in Jean-Paul Sartre's
1946 play *The Respectable Prostitute*.
Fonssagrives, who once dismissed herself
as merely a "good clothes hanger," is
widely acknowledged as the world's first
"supermodel." She was featured on more
than two hundred *Vogue* covers—a record
that remains unsurpassed.

Lisa Fonssagrives is seated
between *Harper's Bazaar*
editor Diana Vreeland
(1906–1989, left) and
photographer Louise
Dahl-Wolfe (1895–1989).

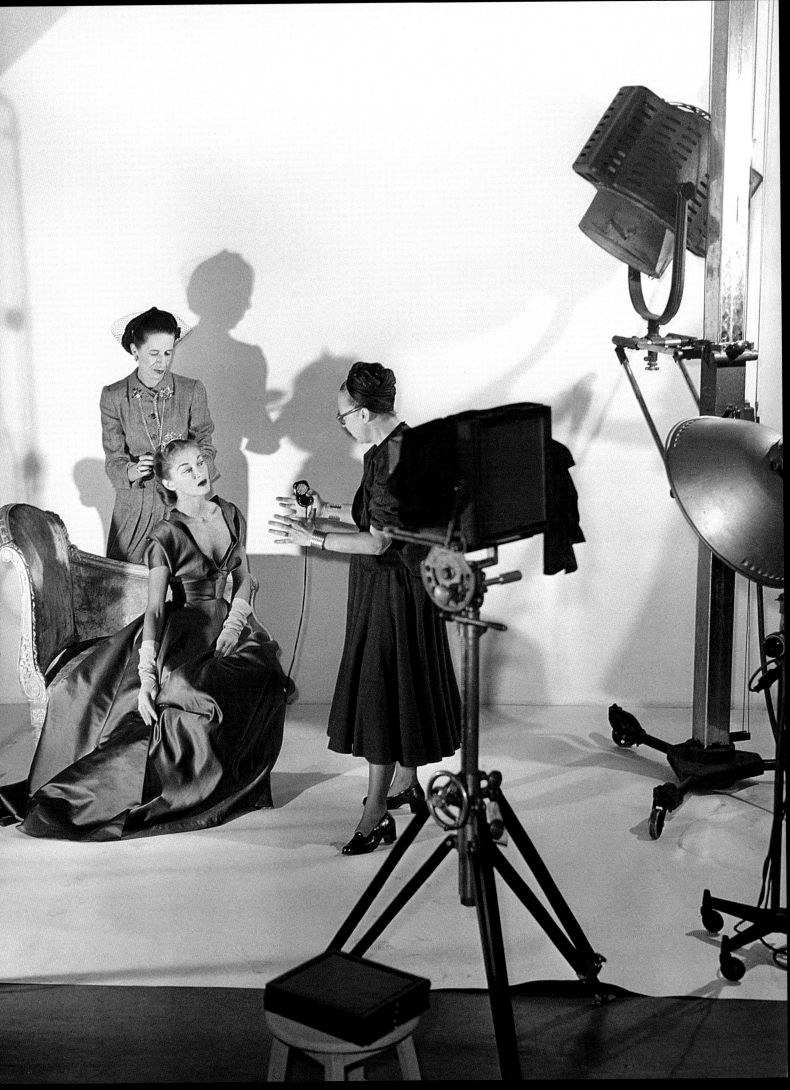

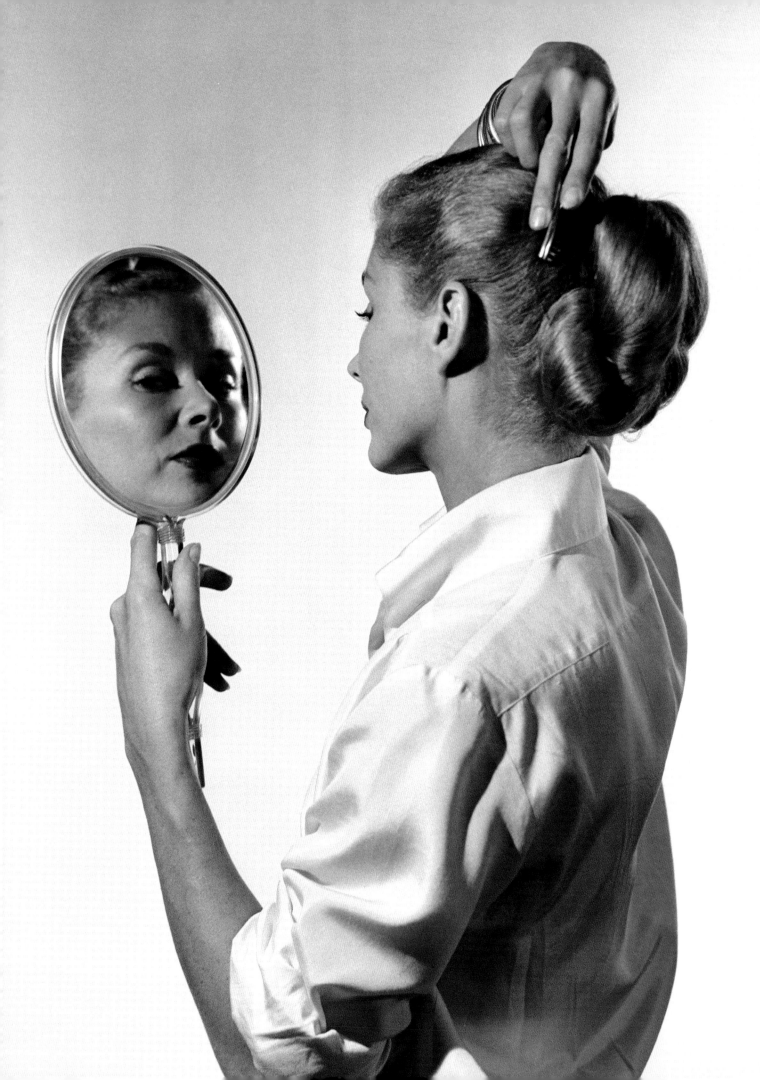

Meg Mundy

Lisa Fonssagrives

## ANTOINE

**1947 / PHOTOGRAPHER UNKNOWN**

Antoine, born Antoni Cierplikowski in
Poland in 1884, inspired women to adopt
daring new hairstyles through his work
for celebrity clients ranging from Sarah
Bernhardt to Brigitte Bardot. Gaining his
reputation in Paris, where he collaborated
with Coco Chanel on her signature look for
the modern woman, complete with a boyish
bob, Antoine brought his artistry to the
United States after World War II, opening
an eponymous salon in New York.

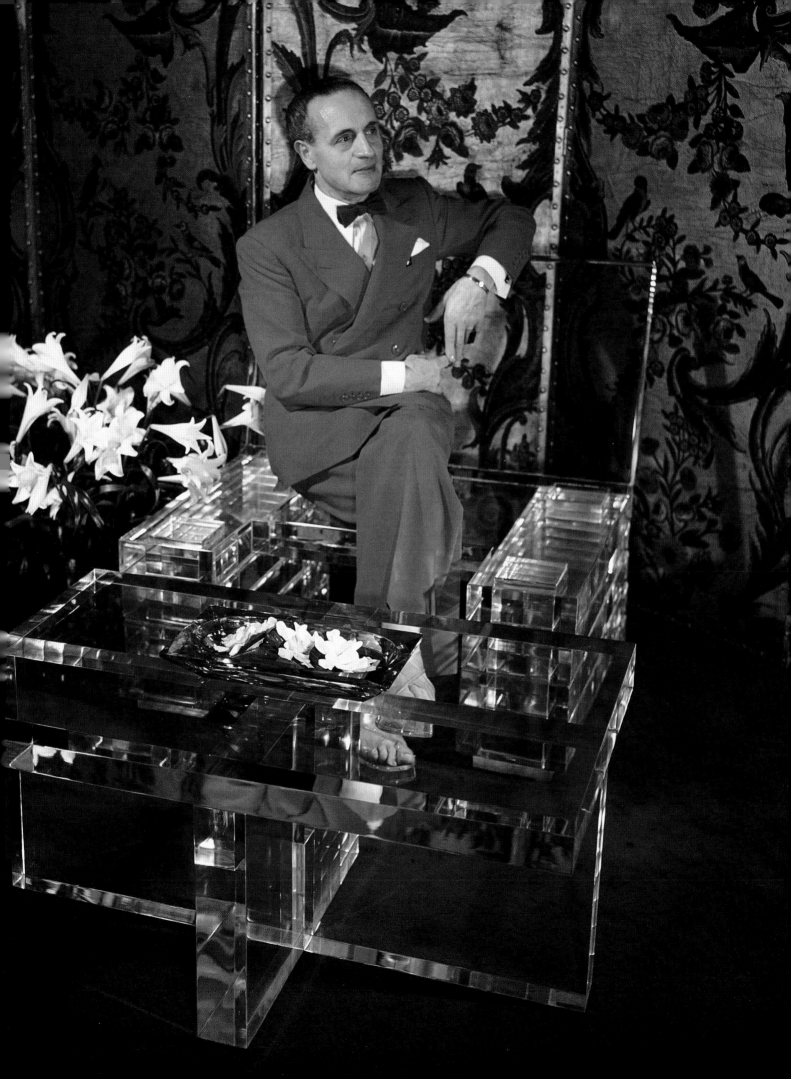

## CHARLES JAMES

**1952 / PHOTOGRAPHER: MICHAEL A. VACCARO**

Born in England to a well-to-do family, Charles James
(1906–1978) moved to New York in 1928 and began
a career as a fashion designer who would expand the
city's reputation as a center of couture, not merely
clothing manufacturing and retailing. Best known for
his complexly cut sculptural ball gowns, James also
designed coats, capes, and day dresses, as modeled on
pages 90 through 95. James's influence ranged from
designing the popular children's toy "Barbie, Teenage
Fashion Model," which would help shape the tastes
of generations of American women, to serving as the
reputed inspiration for Parisian designer Christian
Dior's seminal "New Look" of 1947. That year the
Brooklyn Museum became the first cultural institution
to exhibit James's work.

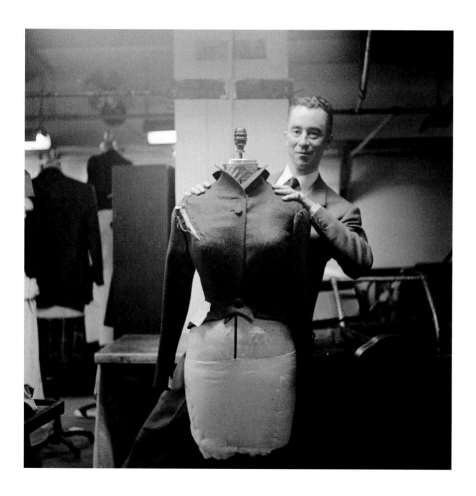

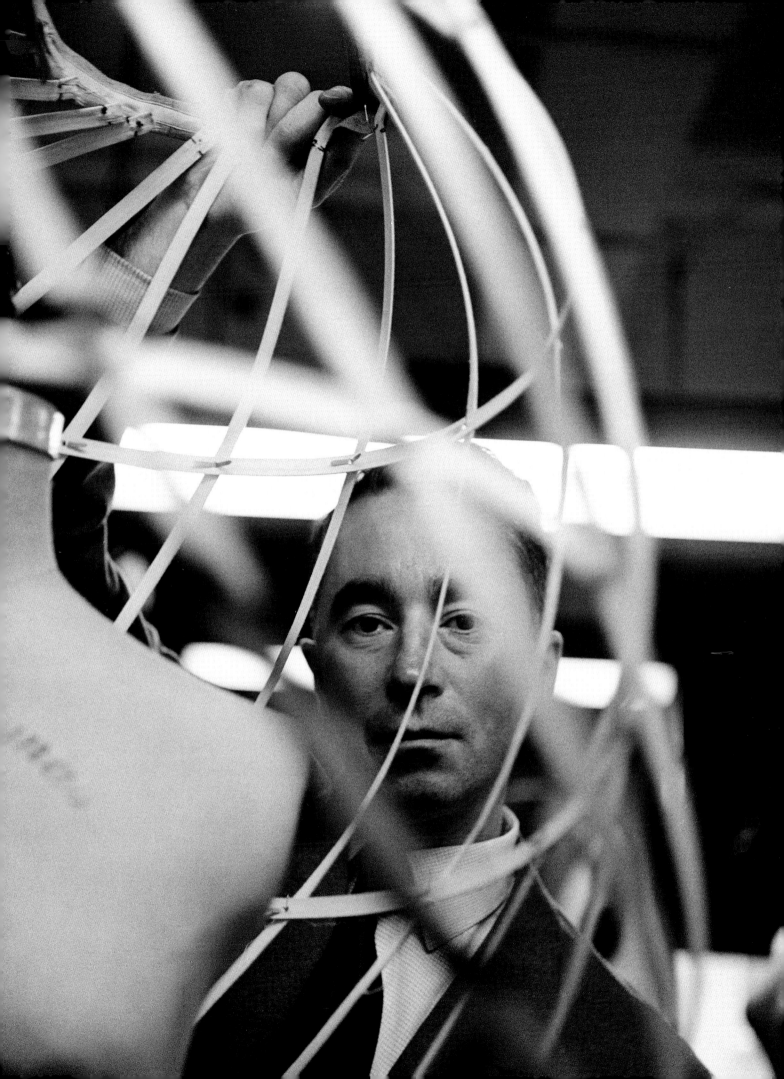

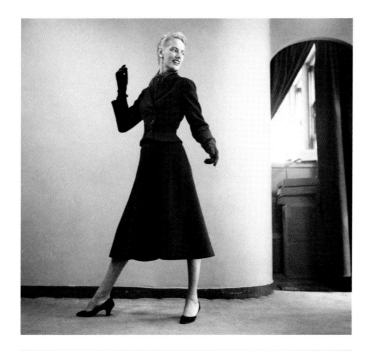
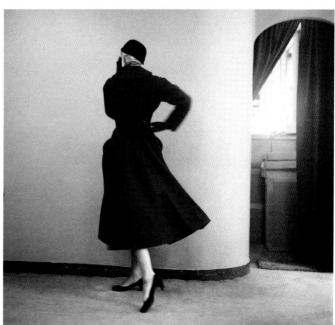
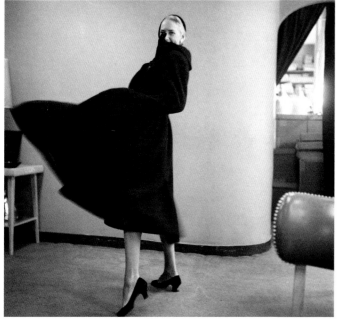
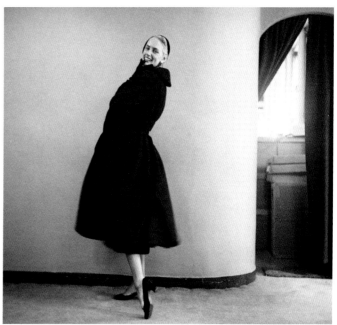

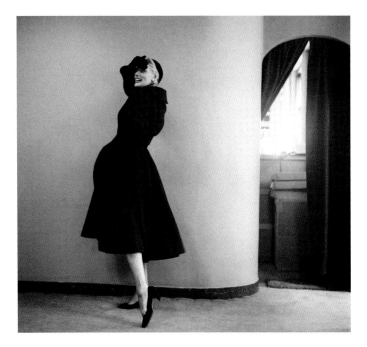

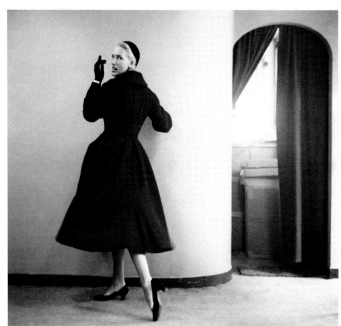

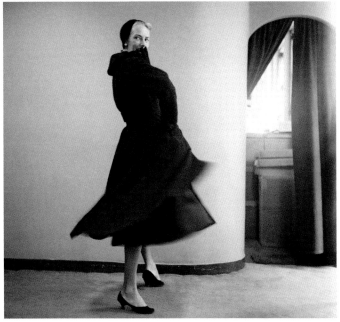

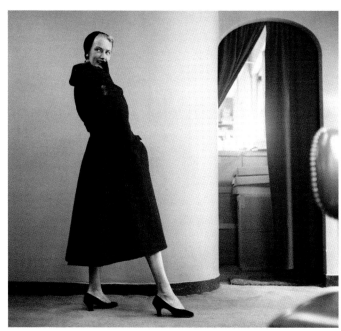

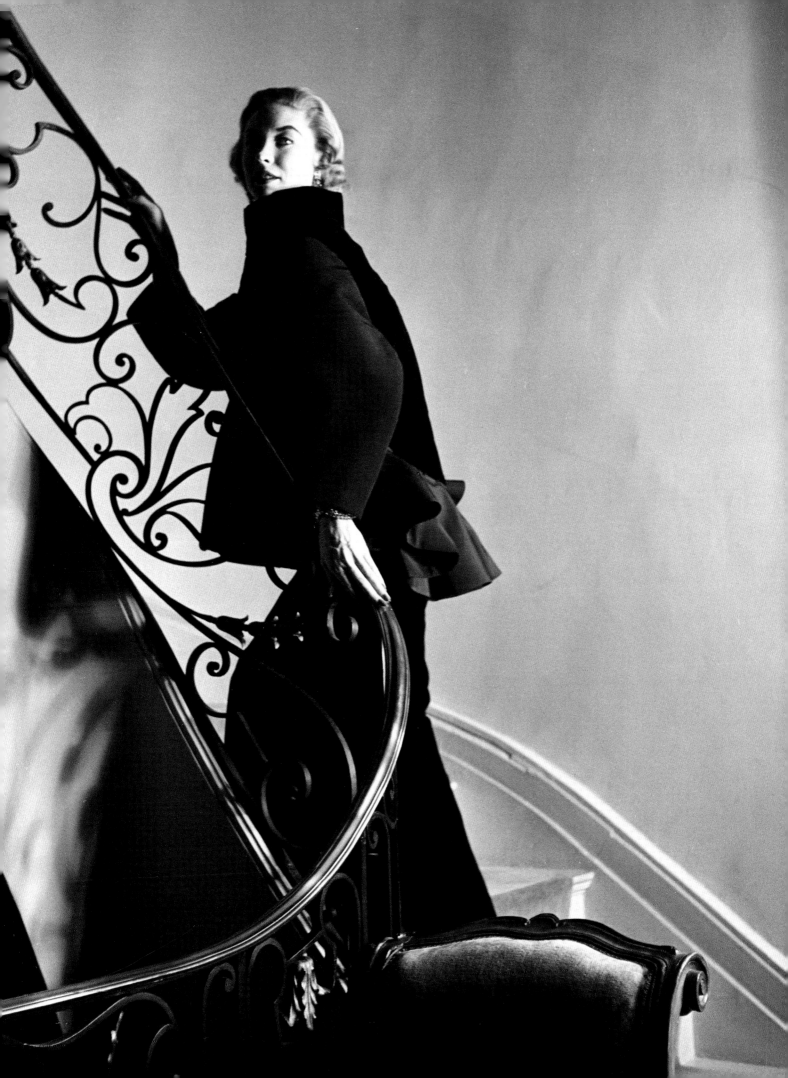

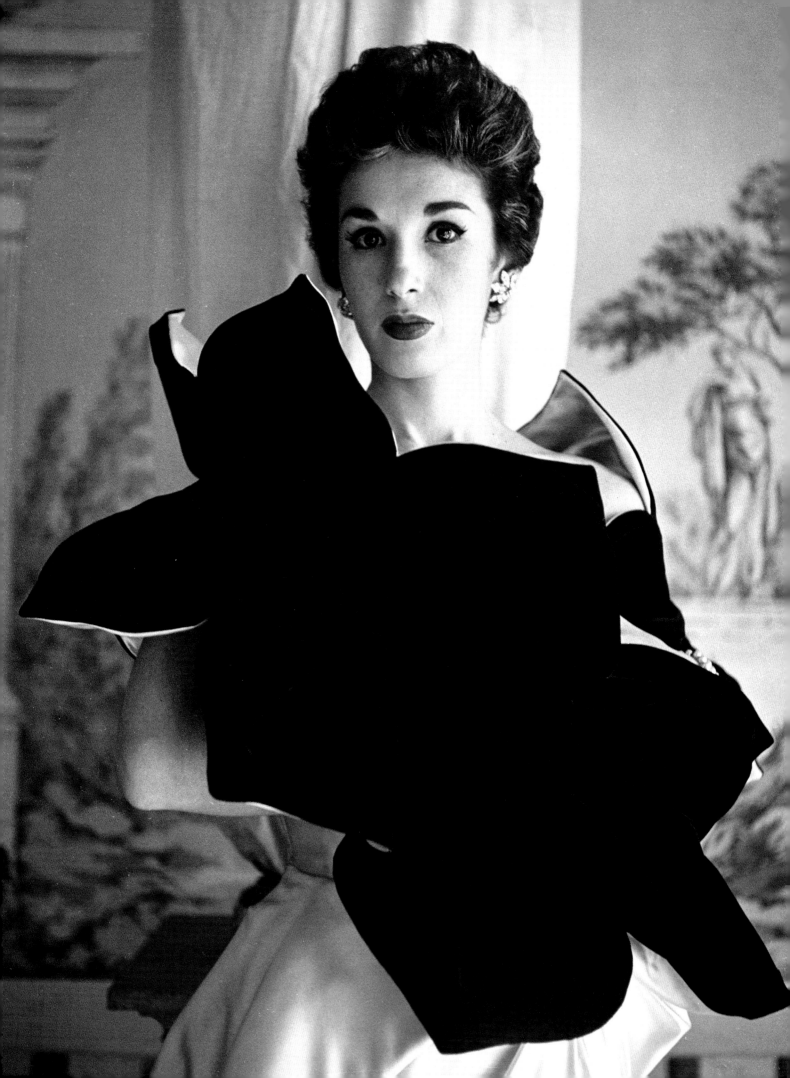

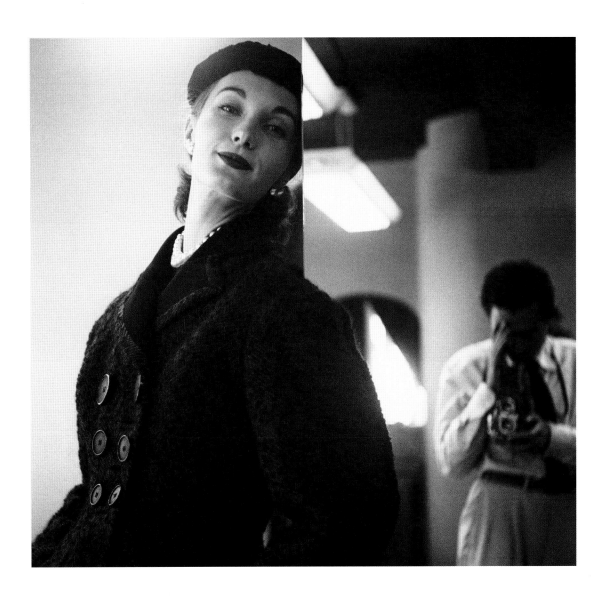

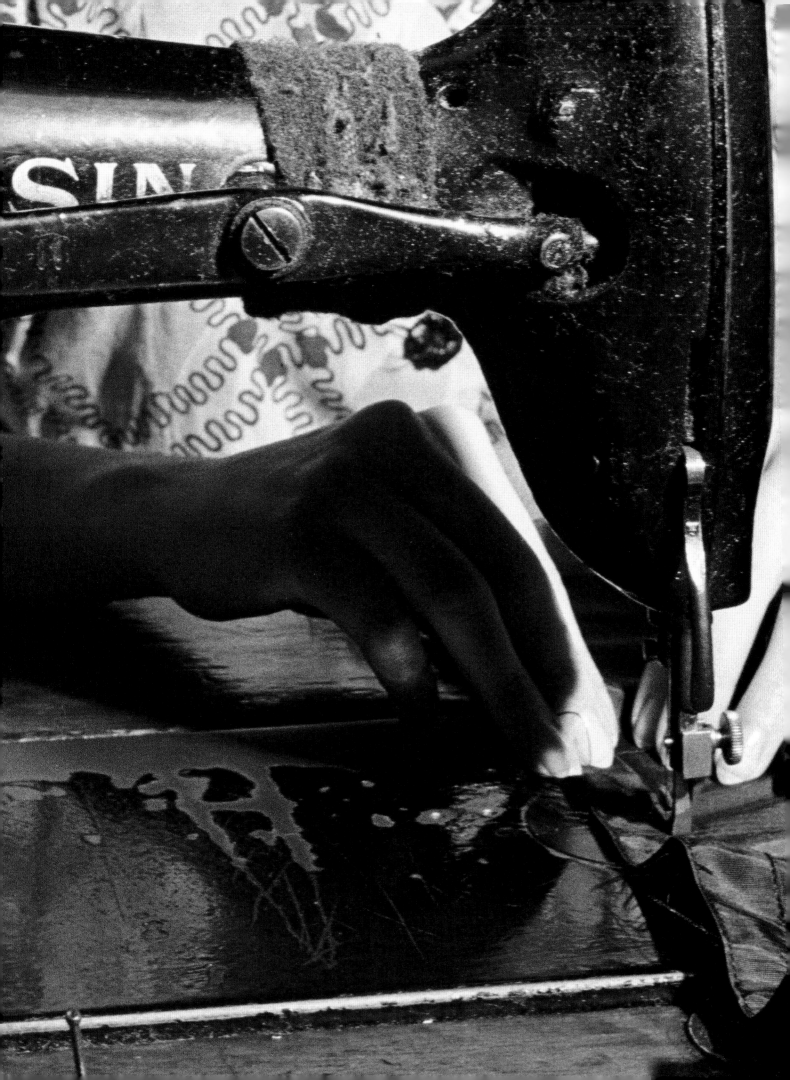

# GARMENT INDUSTRY

While postwar designers such as Charles James elevated
New York City's fashion profile to the level of couture
(though still not rivaling Paris), the city had long supported
a large and thriving garment industry, centered on the
Garment District in midtown Manhattan, but spreading
throughout the city as well. In this photo shoot devoted to
the International Ladies Garment Workers Union, *Look*
combined high-angle images of rows upon rows of desks and
worktables seemingly receding into infinity with intimate
portraits of individual workers.

**JANUARY–FEBRUARY 1949 / PHOTOGRAPHER: JOHN VACHON**

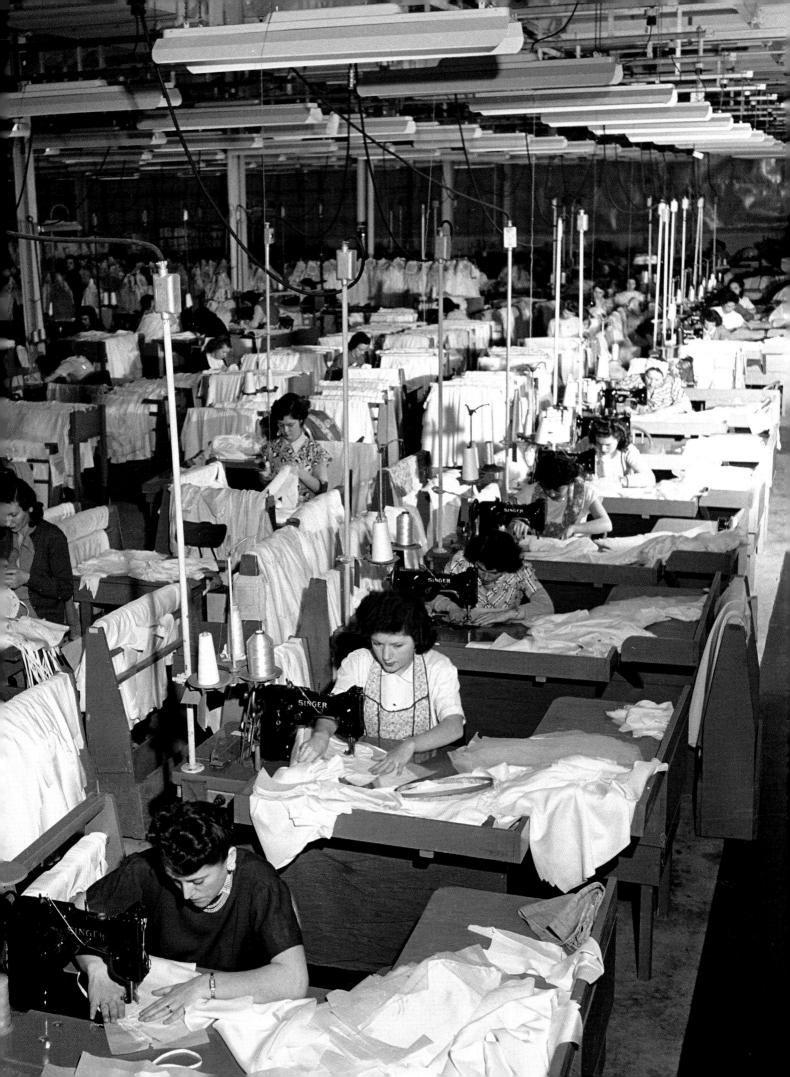

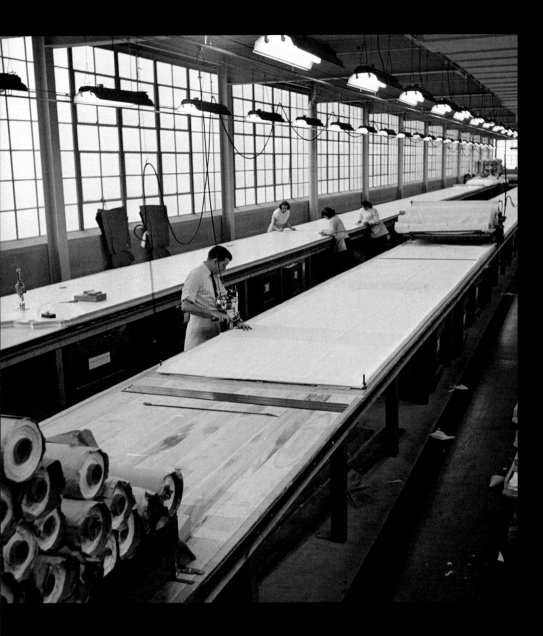

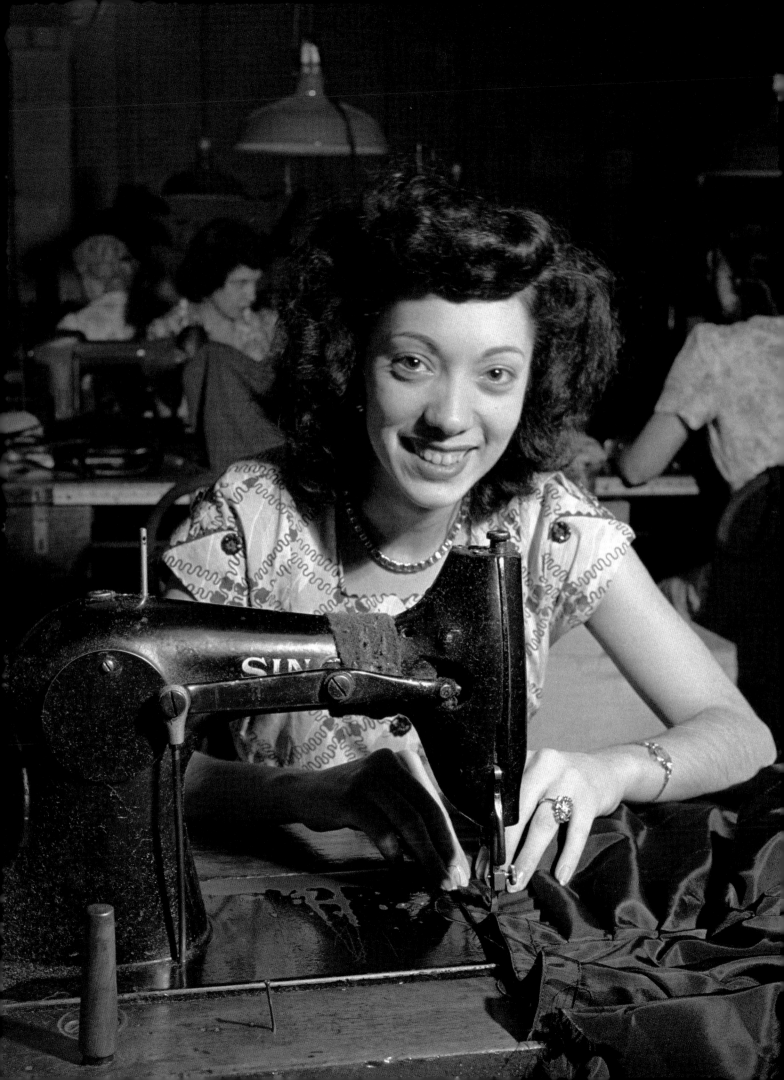

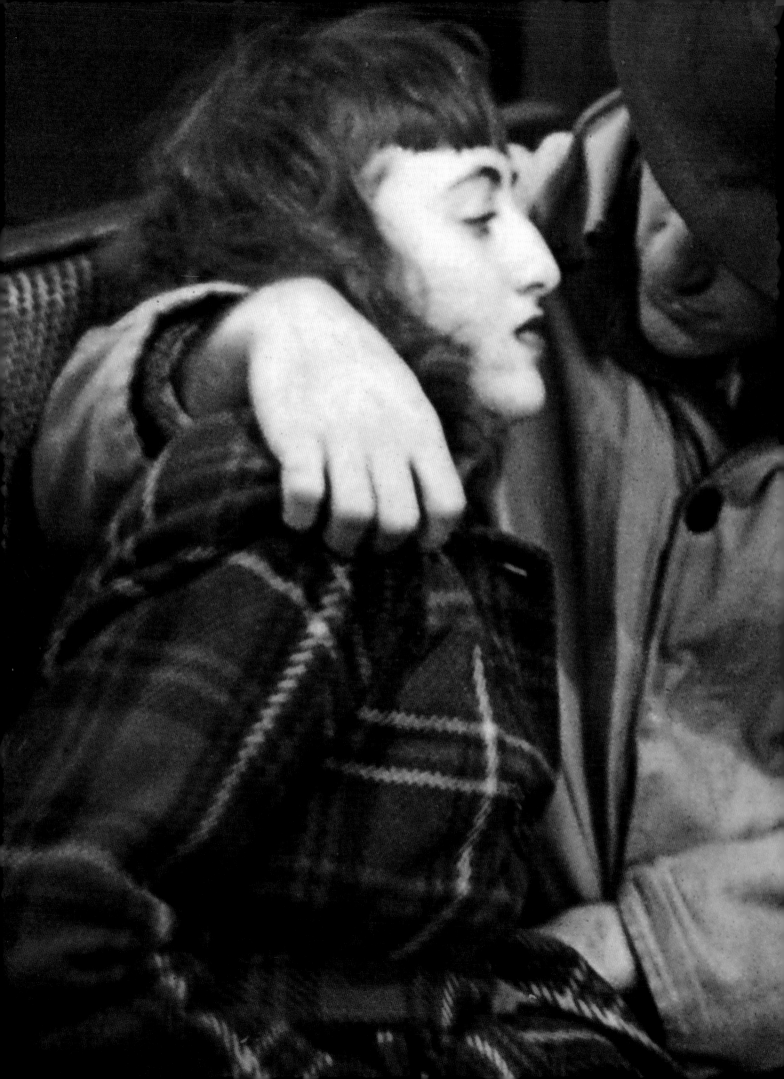

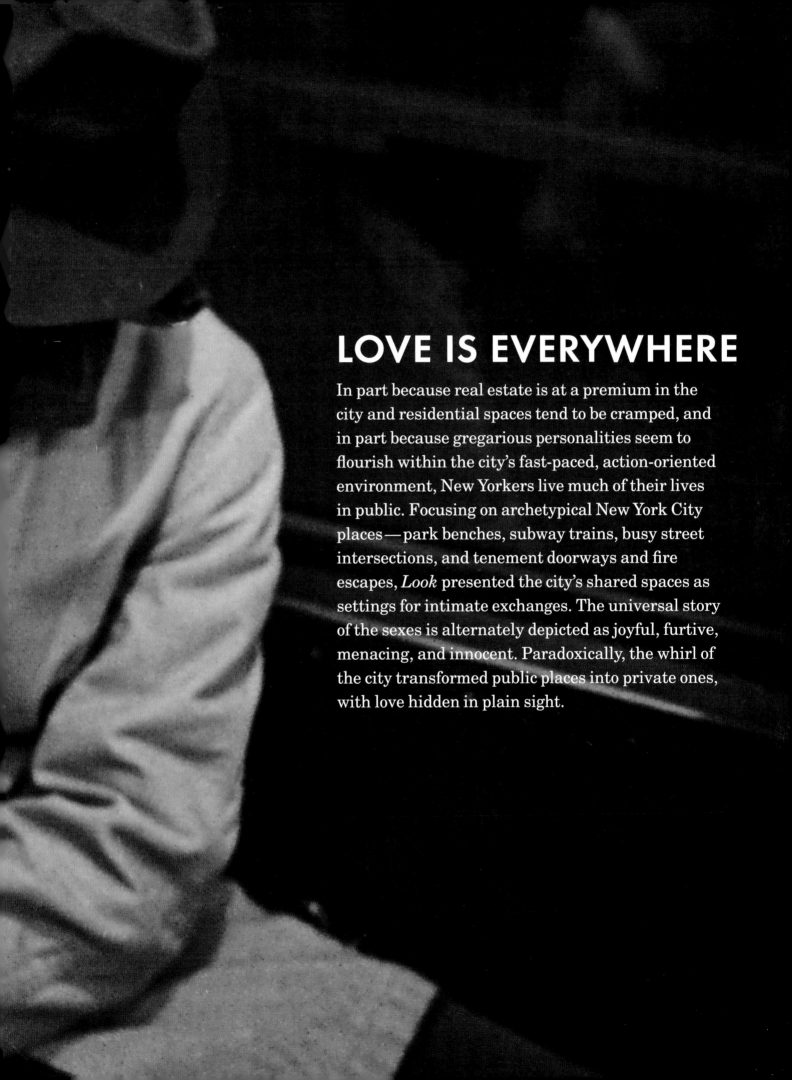

# LOVE IS EVERYWHERE

In part because real estate is at a premium in the city and residential spaces tend to be cramped, and in part because gregarious personalities seem to flourish within the city's fast-paced, action-oriented environment, New Yorkers live much of their lives in public. Focusing on archetypical New York City places—park benches, subway trains, busy street intersections, and tenement doorways and fire escapes, *Look* presented the city's shared spaces as settings for intimate exchanges. The universal story of the sexes is alternately depicted as joyful, furtive, menacing, and innocent. Paradoxically, the whirl of the city transformed public places into private ones, with love hidden in plain sight.

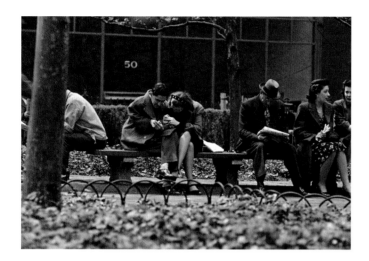

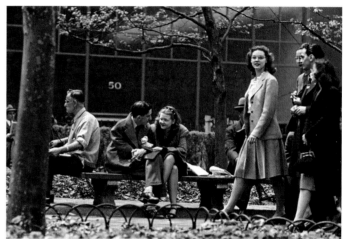

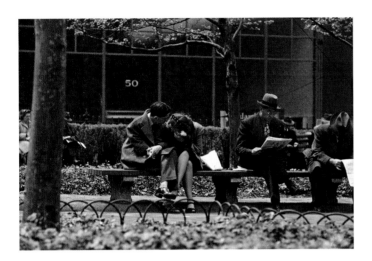 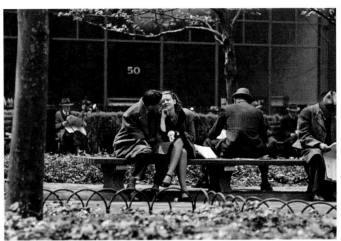

PHOTOGRAPHS ON PAGES 104–111:
1947 / PHOTOGRAPHER: STANLEY KUBRICK

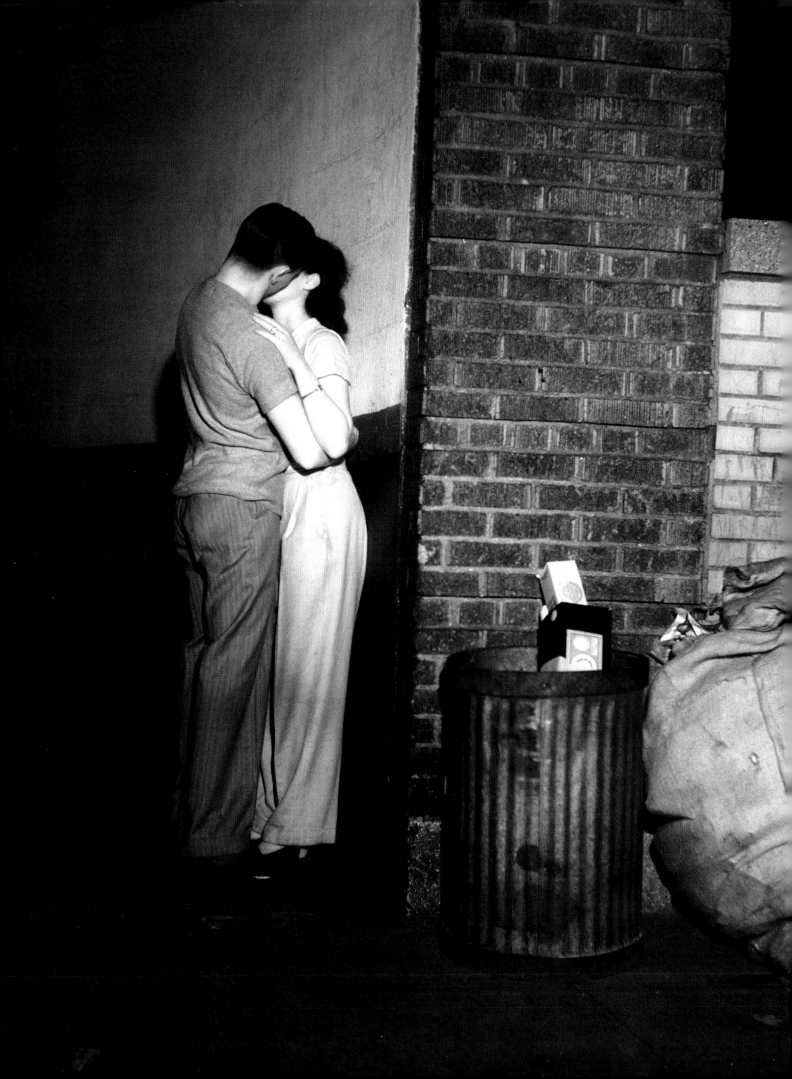

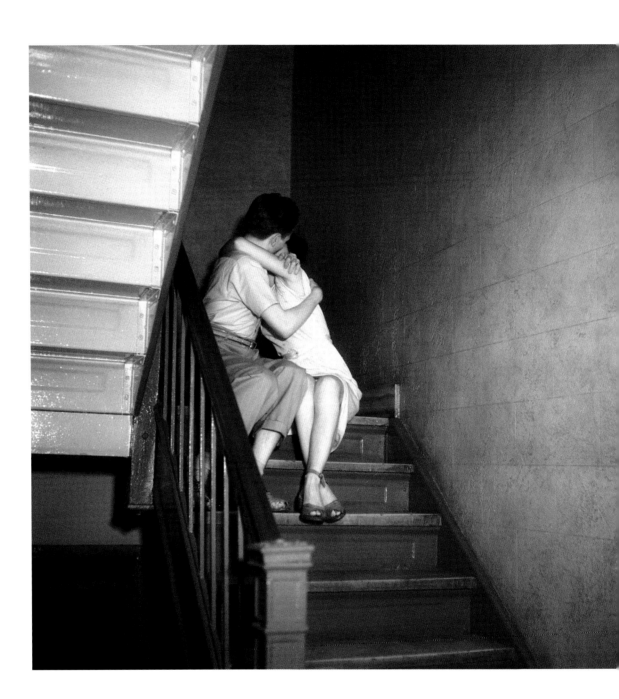

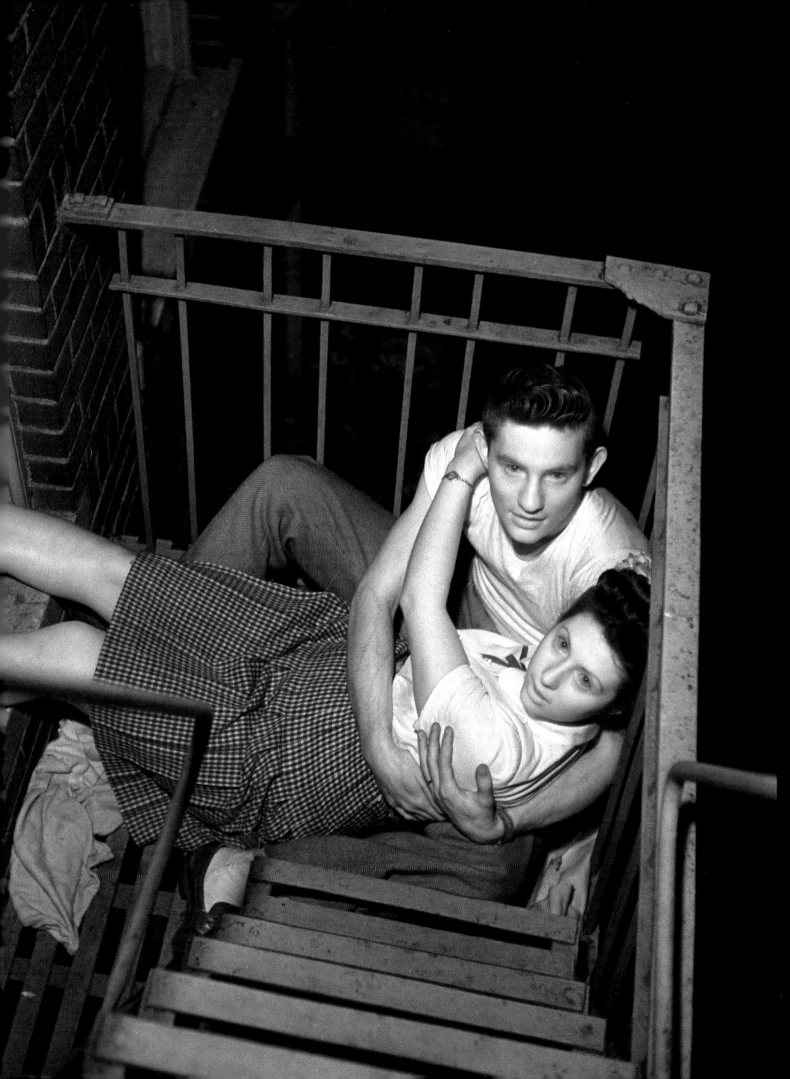

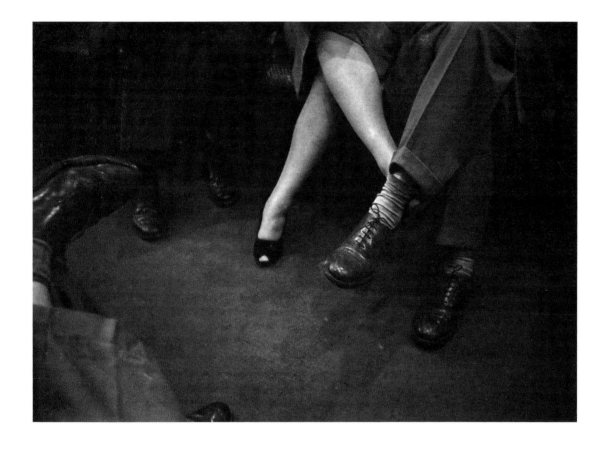

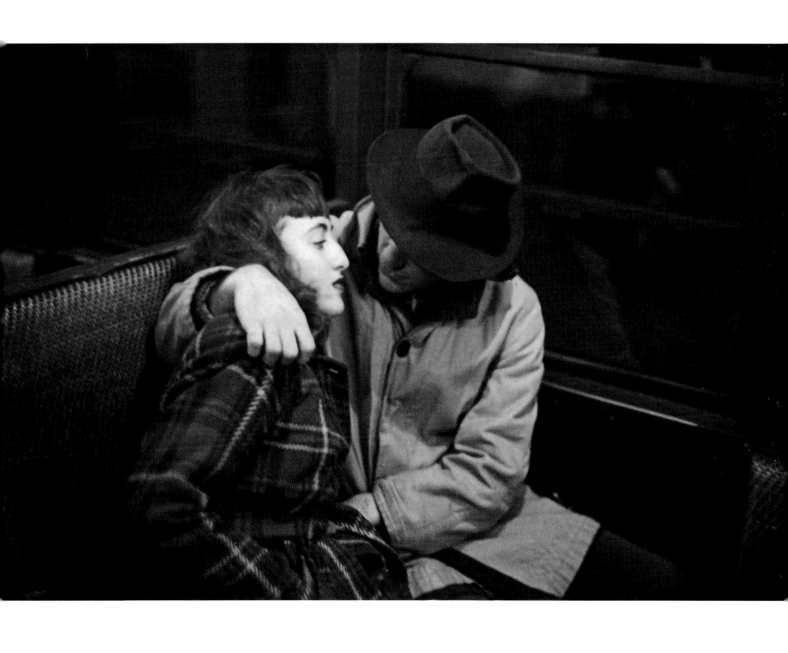

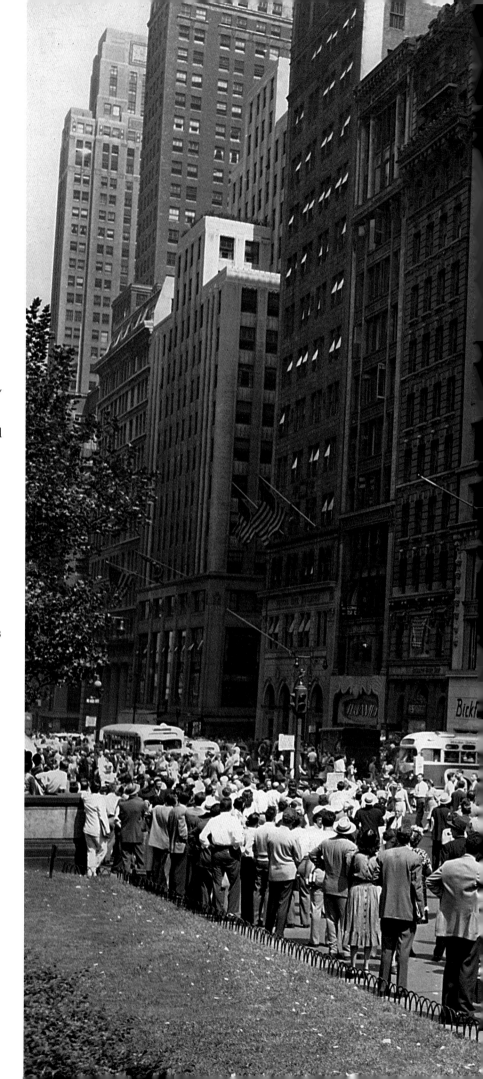

SEPTEMBER 1947
PHOTOGRAPHERS: TOMMY WEBER (PAGES 112–113, 117),
STANLEY KUBRICK (PAGES 114–115), AND FRANK
BAUMAN (PAGE 116)

The corner of Fifth Avenue and Forty-second
Street, diagonally across from the New
York Public Library, provides a particularly
"only in New York" take on girl-watching as
a young woman's likeness is painted on a
billboard advertising the Merry-Go-Round,
a product of the Peter Pan bra company.
The model's image is accompanied by text
proclaiming that "the secret's in the circle!"
as her moment of fame draws alternately
befuddled, amused, and approving reactions
from men and women in the streets below.
Three photographers were assigned to this
shoot: Frank Bauman was on the scaffold;
Stanley Kubrick took close-ups of people on
the street; and Tommy Weber, also on the
street, captured the event from a distance.

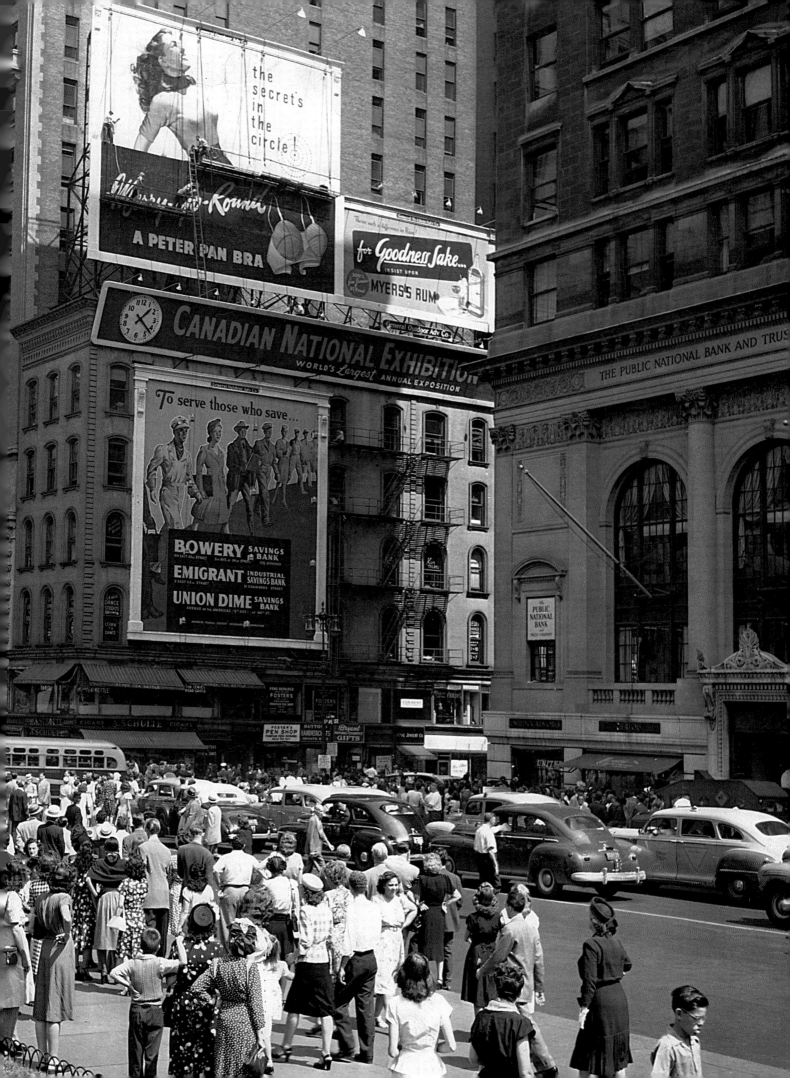

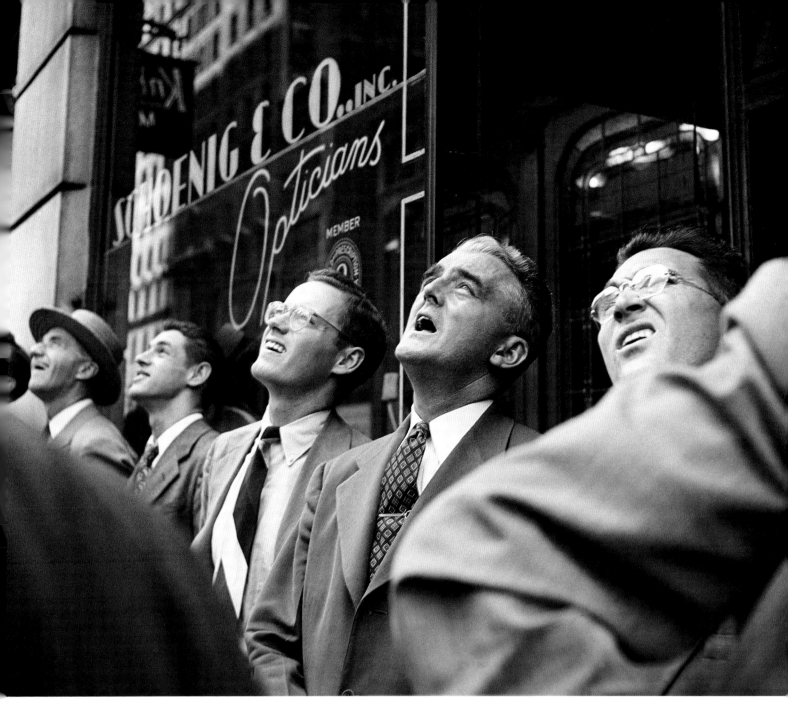

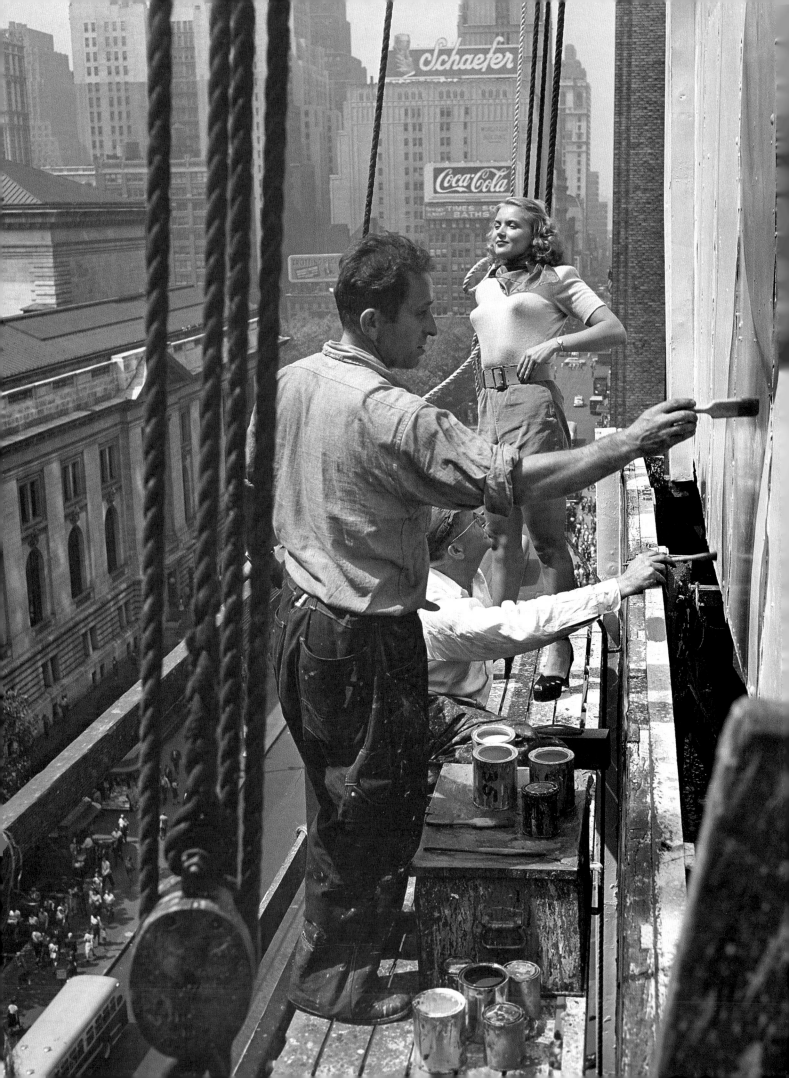

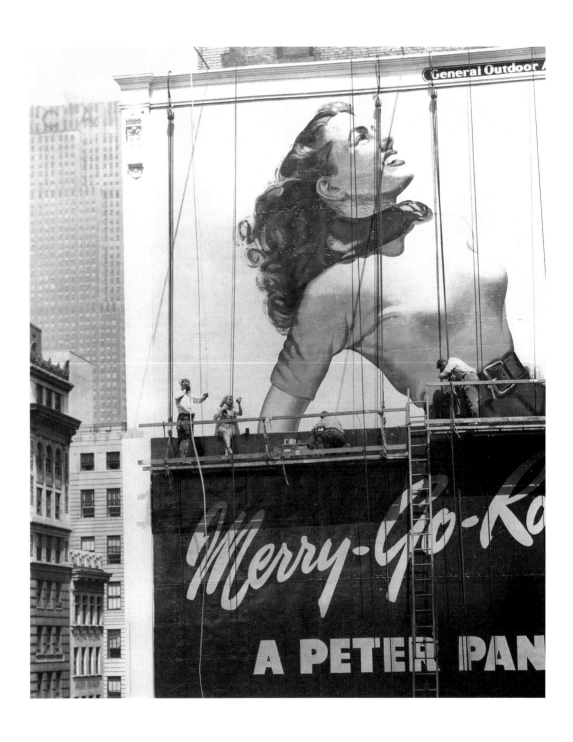

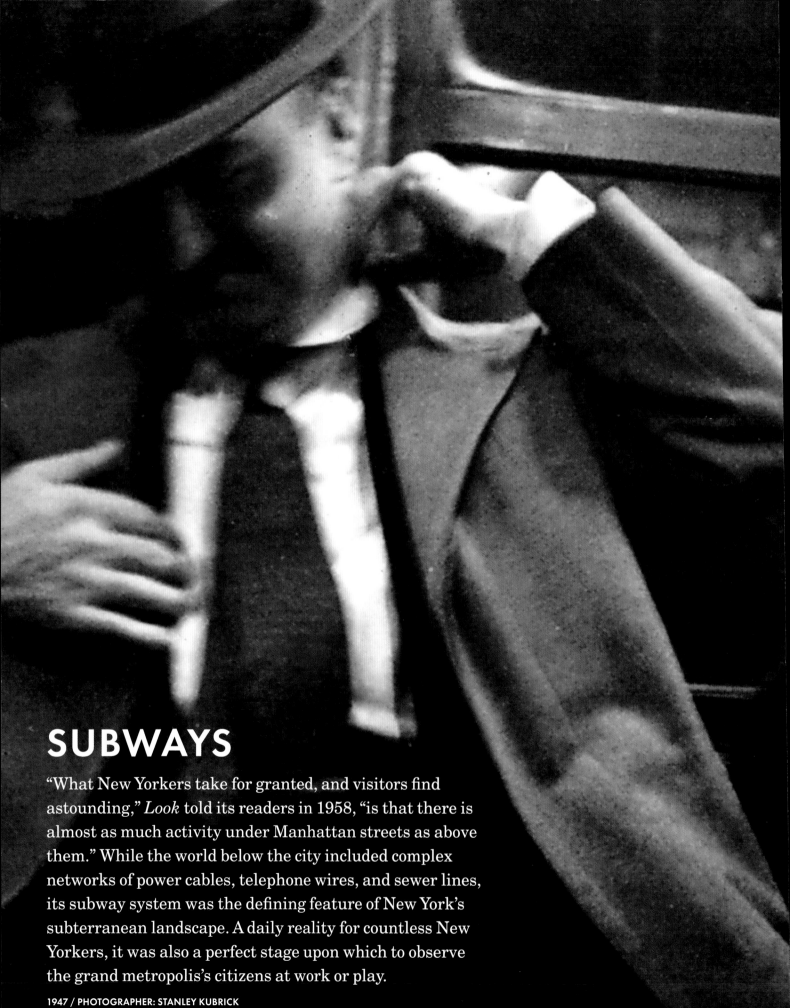

# SUBWAYS

"What New Yorkers take for granted, and visitors find astounding," *Look* told its readers in 1958, "is that there is almost as much activity under Manhattan streets as above them." While the world below the city included complex networks of power cables, telephone wires, and sewer lines, its subway system was the defining feature of New York's subterranean landscape. A daily reality for countless New Yorkers, it was also a perfect stage upon which to observe the grand metropolis's citizens at work or play.

1947 / PHOTOGRAPHER: STANLEY KUBRICK

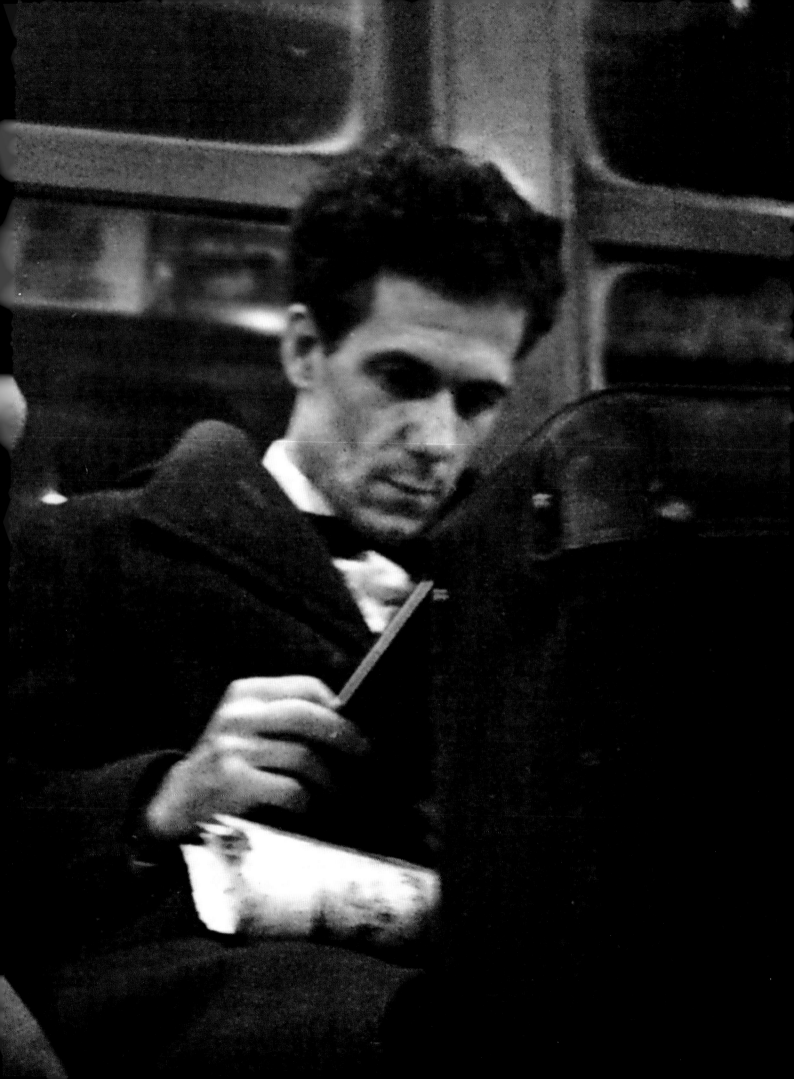

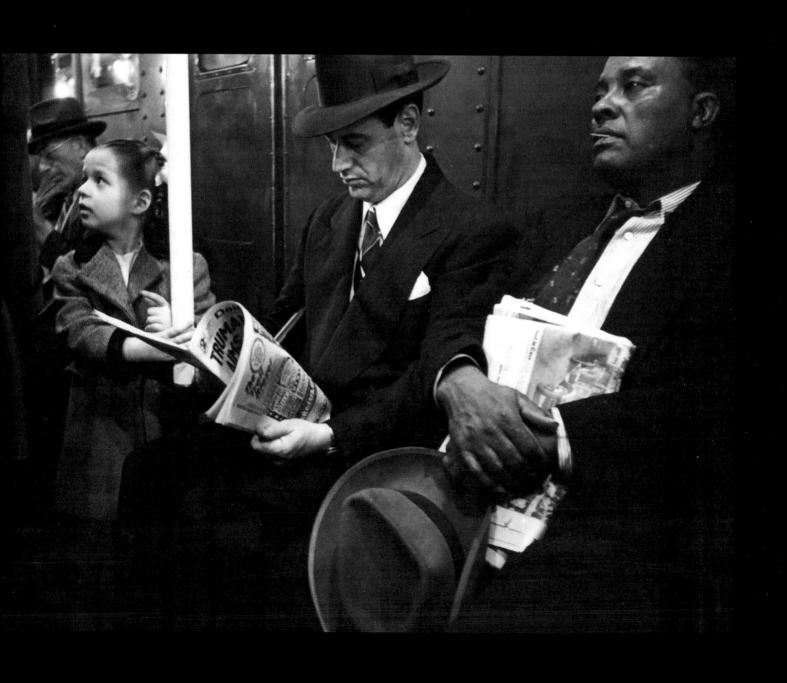

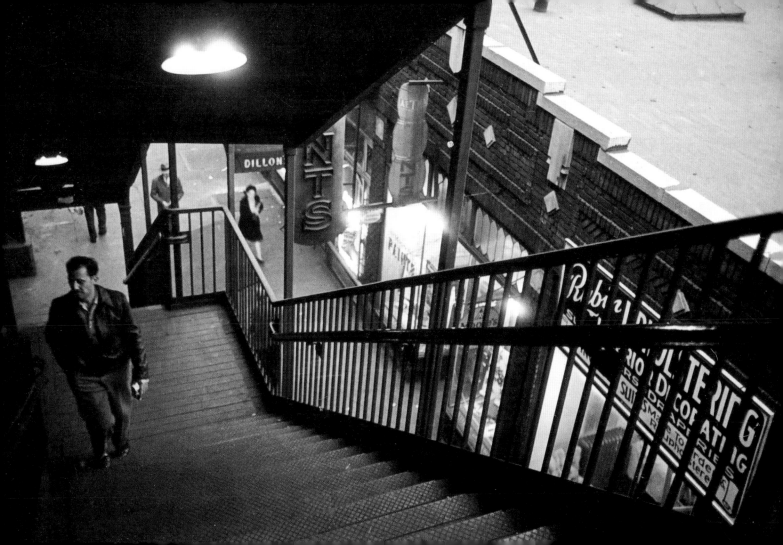

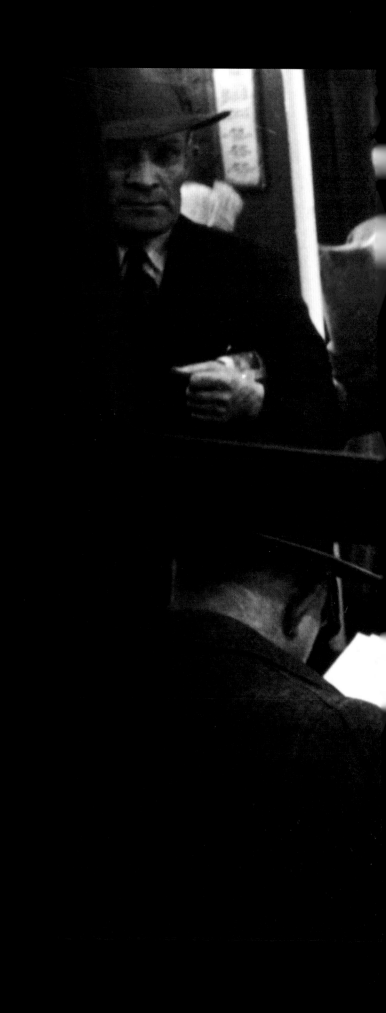

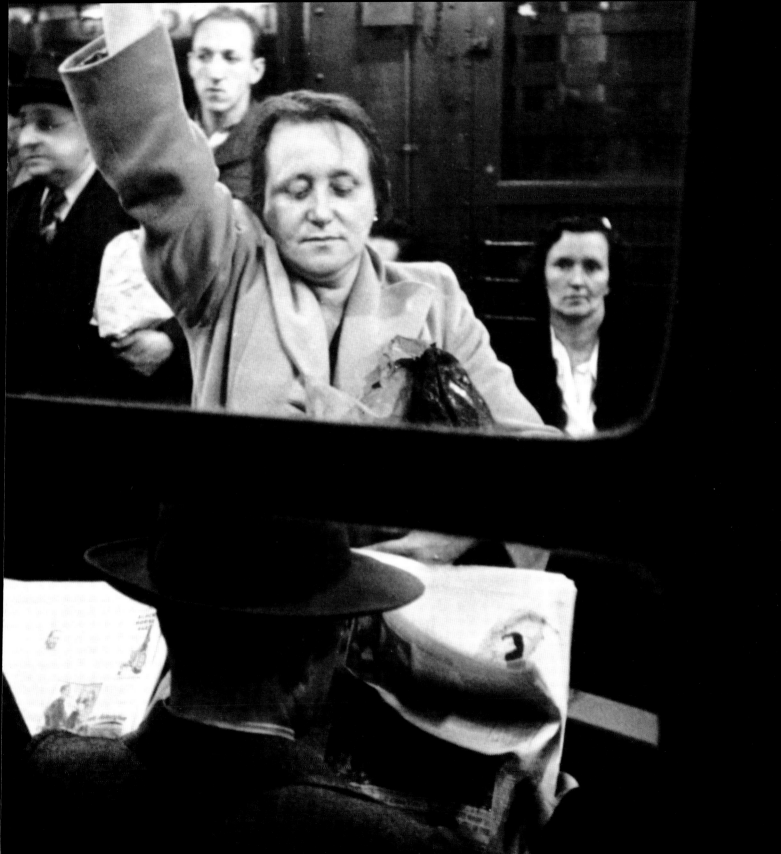

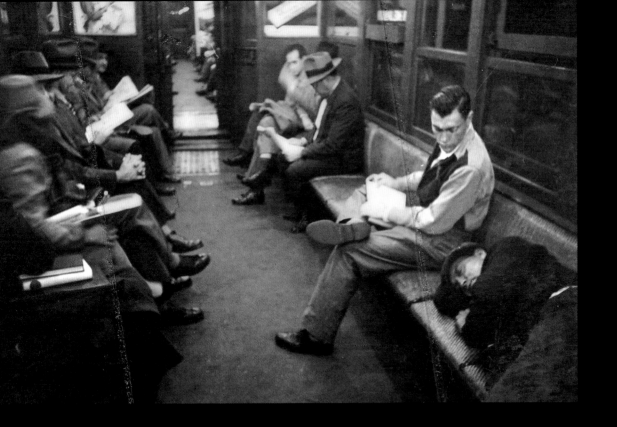

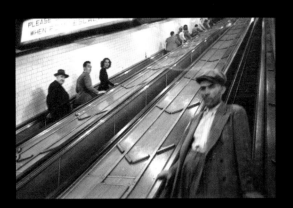

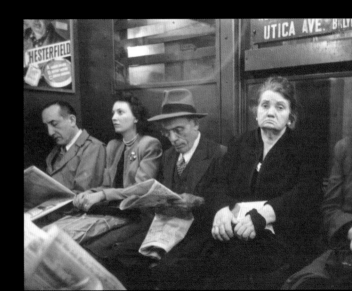

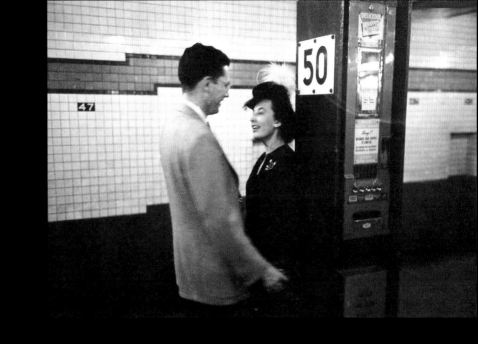

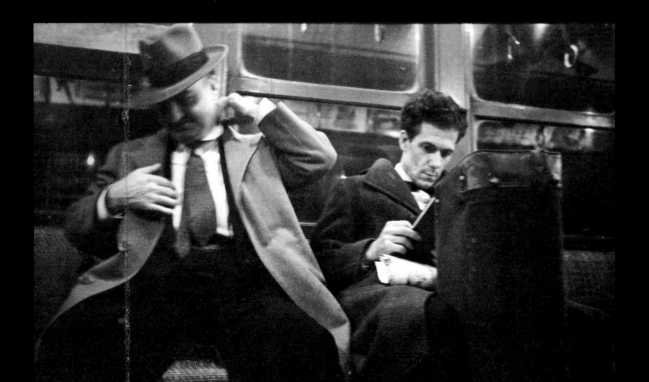

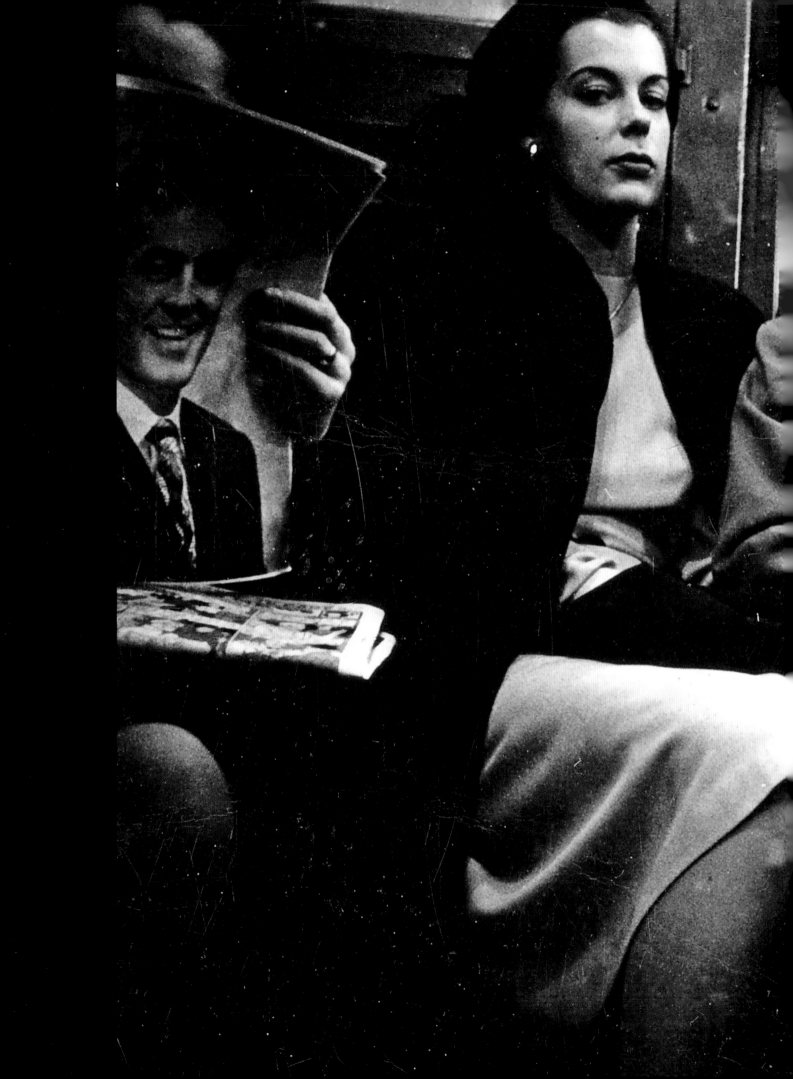

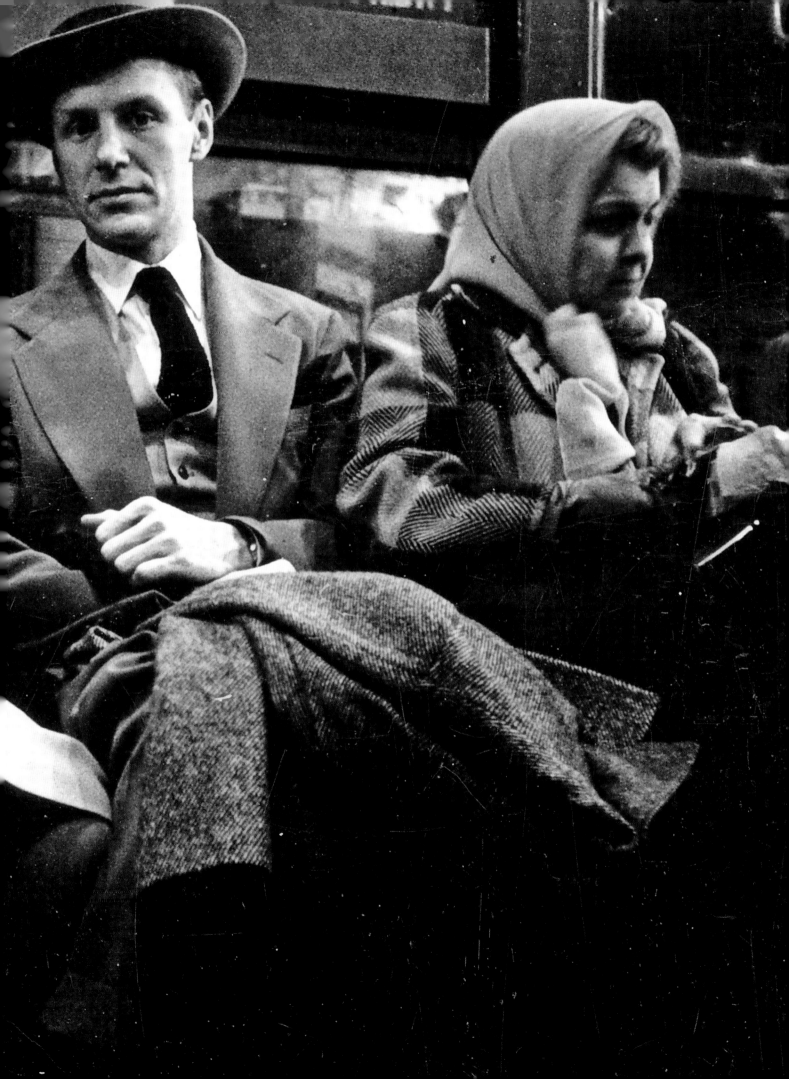

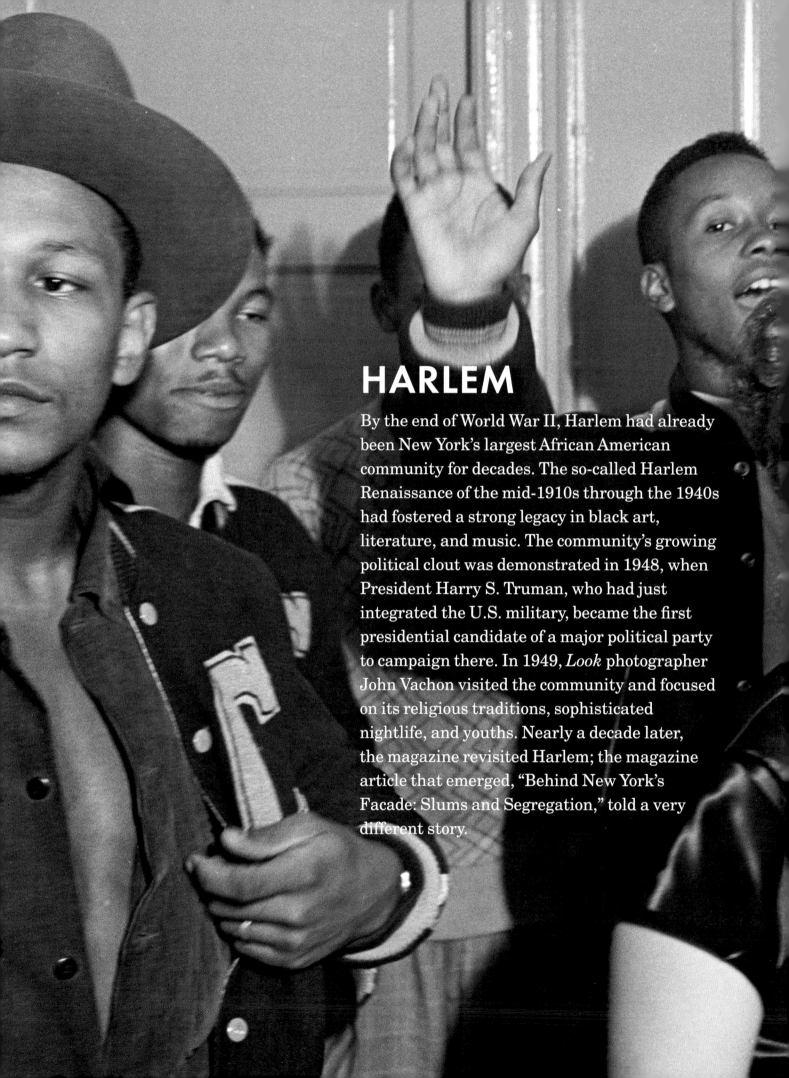

# HARLEM

By the end of World War II, Harlem had already been New York's largest African American community for decades. The so-called Harlem Renaissance of the mid-1910s through the 1940s had fostered a strong legacy in black art, literature, and music. The community's growing political clout was demonstrated in 1948, when President Harry S. Truman, who had just integrated the U.S. military, became the first presidential candidate of a major political party to campaign there. In 1949, *Look* photographer John Vachon visited the community and focused on its religious traditions, sophisticated nightlife, and youths. Nearly a decade later, the magazine revisited Harlem; the magazine article that emerged, "Behind New York's Facade: Slums and Segregation," told a very different story.

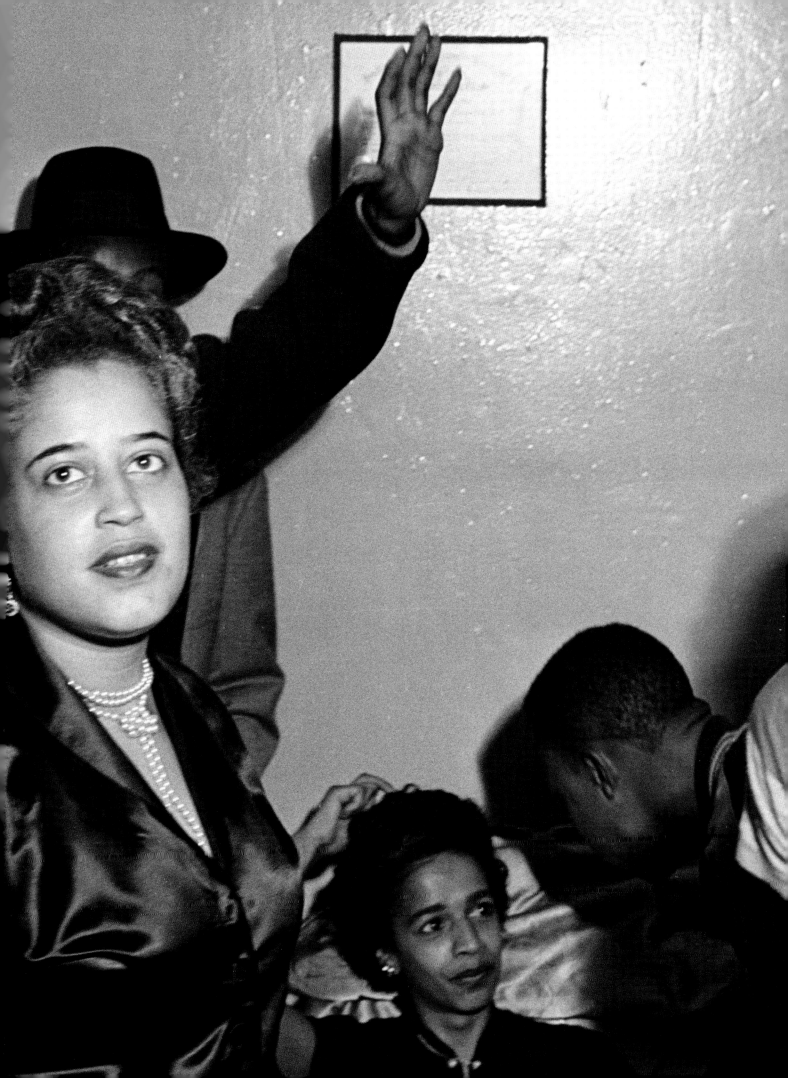

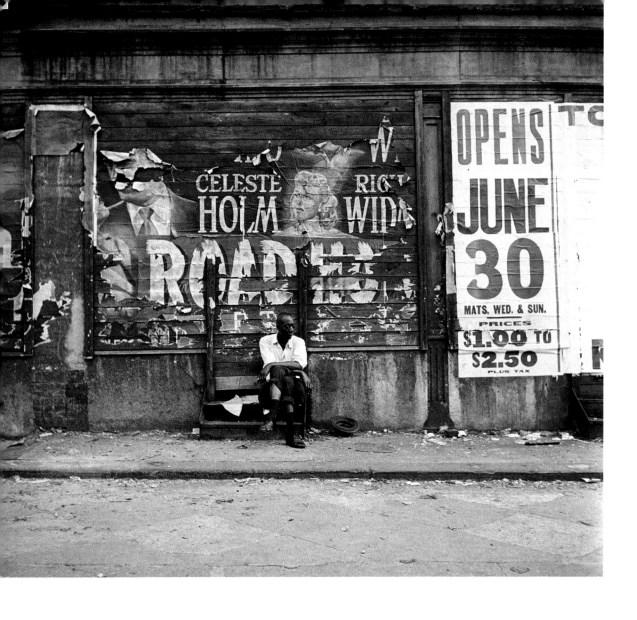

PHOTOGRAPHS ON PAGES 130–135:
JULY–AUGUST 1949
PHOTOGRAPHER: JOHN VACHON

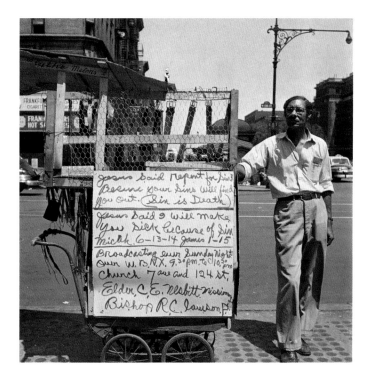

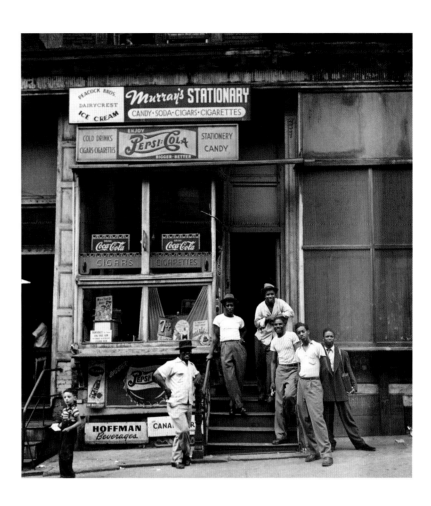

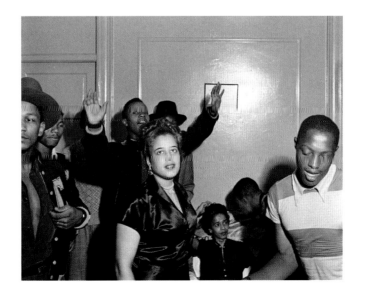

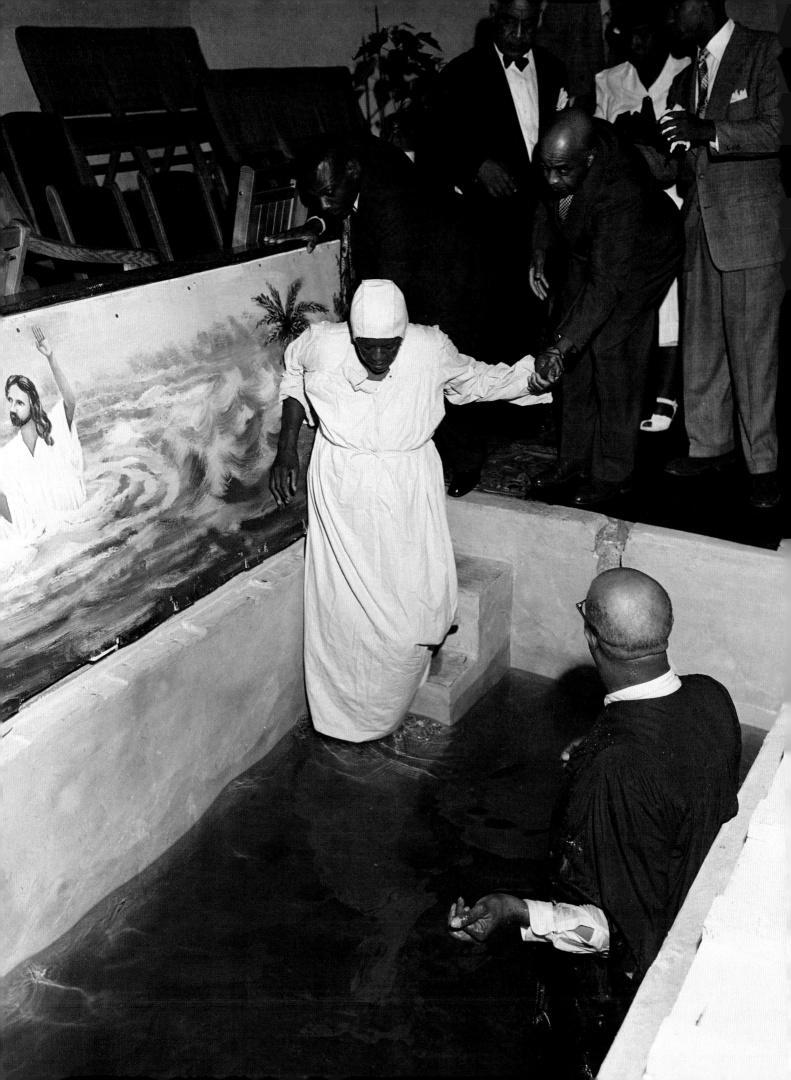

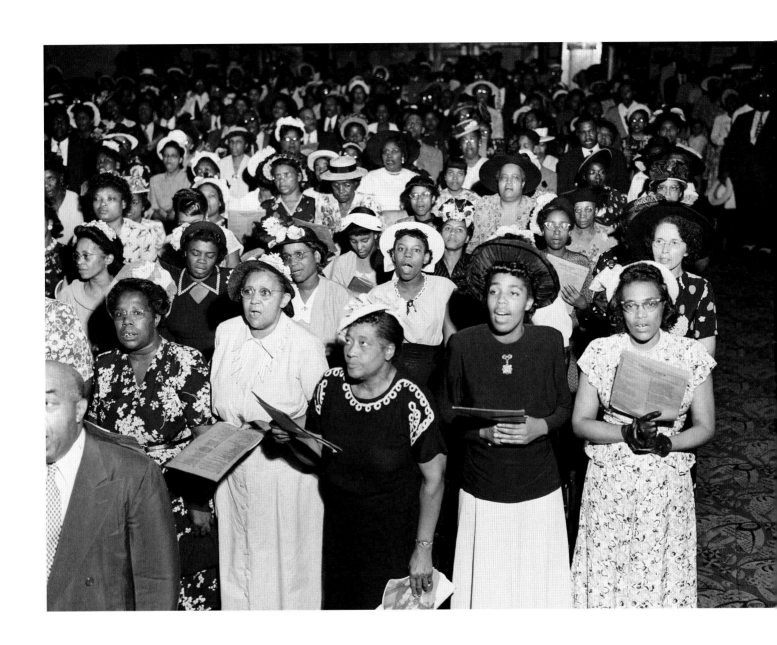

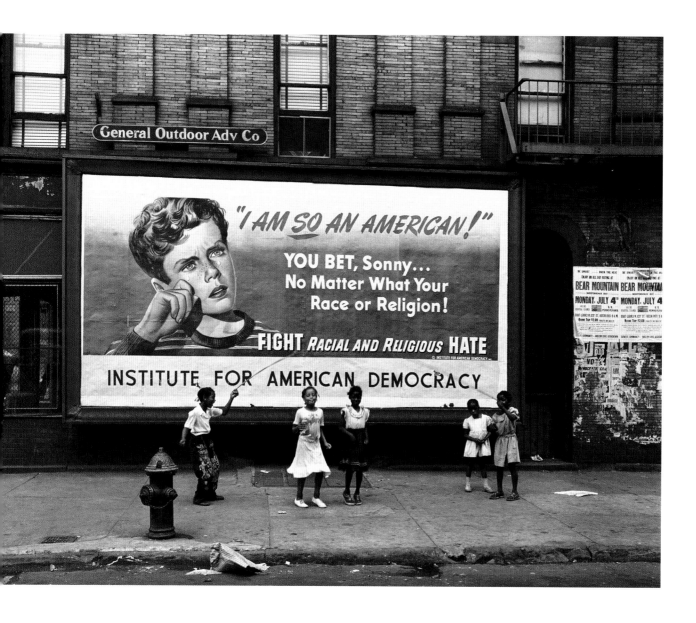

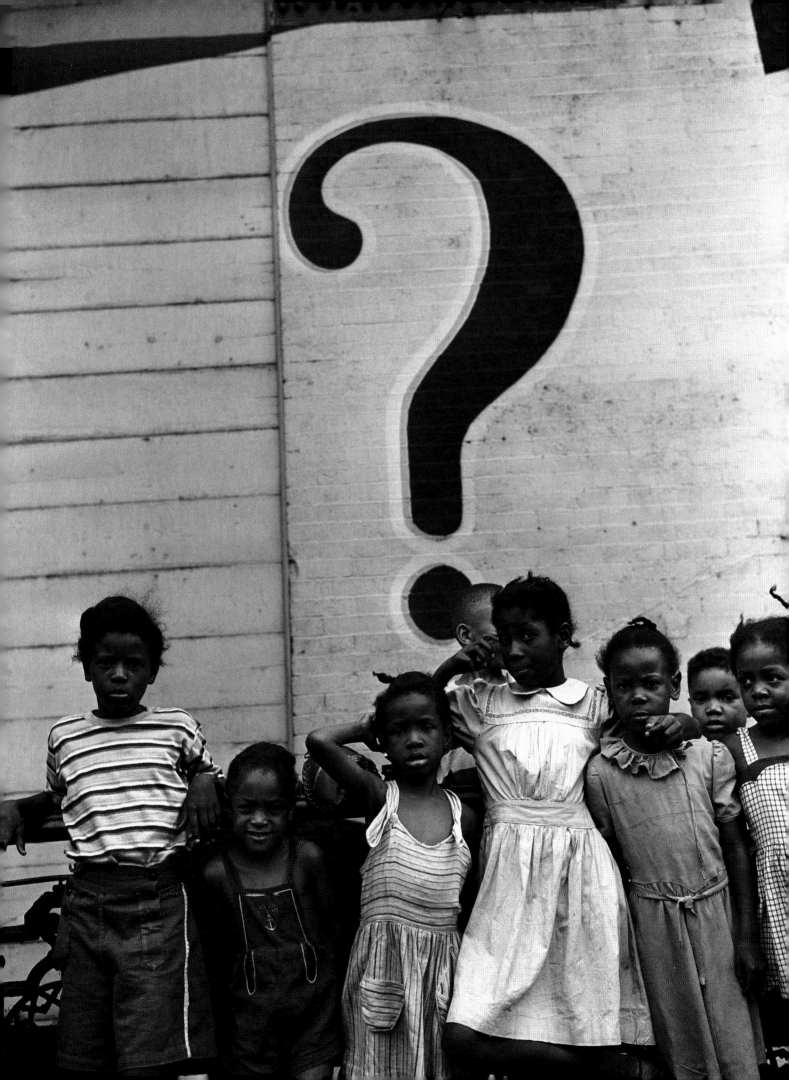

**PHOTOGRAPHS ON PAGES 136–139:**
**JANUARY 1958**
**PHOTOGRAPHERS: PAUL FUSCO AND ROBERT LERNER**

These images were taken to accompany the
story "Behind New York's Facade: Slums
and Segregation," published on February
18, 1958. The photographs depicting
children climbing—and seemingly confined
by—a chain-link fence visually supported
the article's title and presented a far
darker view of Harlem than Vachon had
a decade earlier.

*Note: Credit for the specific images of this assignment is
not identified in the* Look *collection, although a published
photograph of children climbing a chain-link fence was
credited to Paul Fusco.*

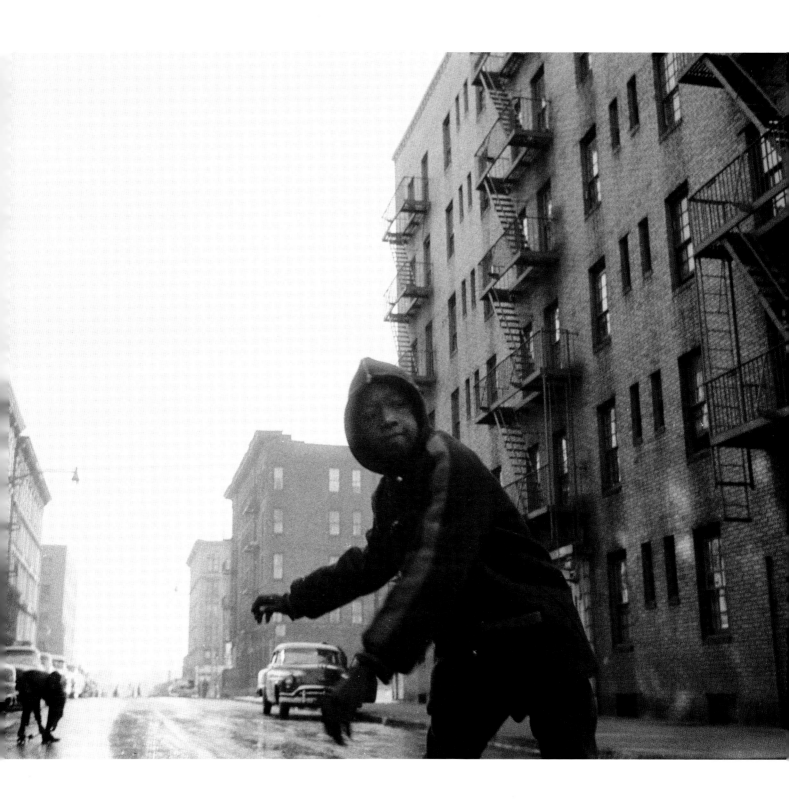

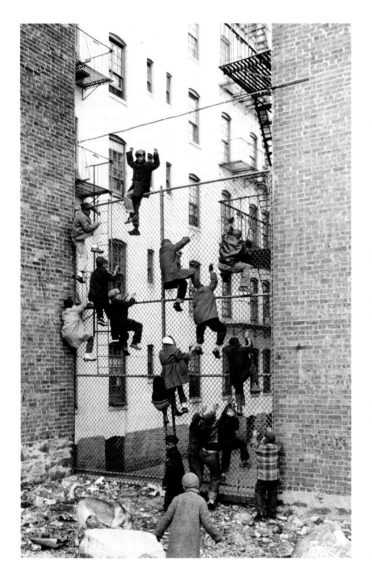
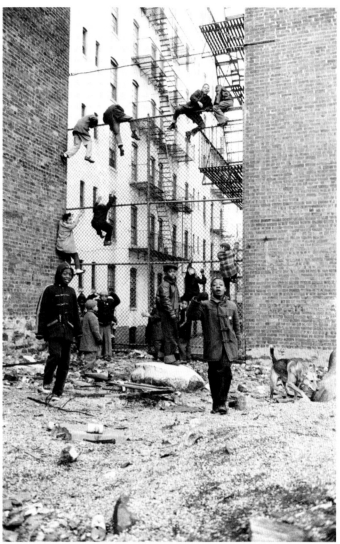

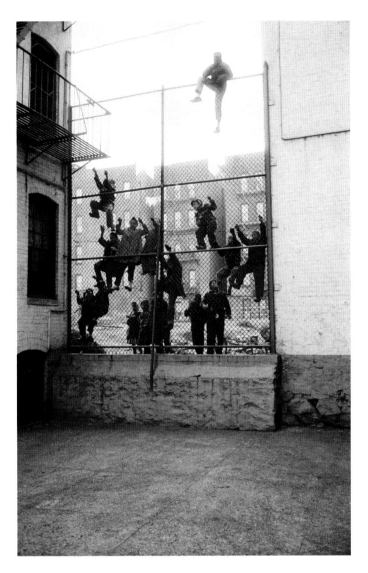 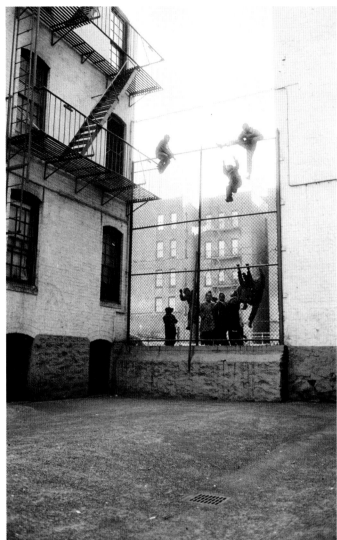

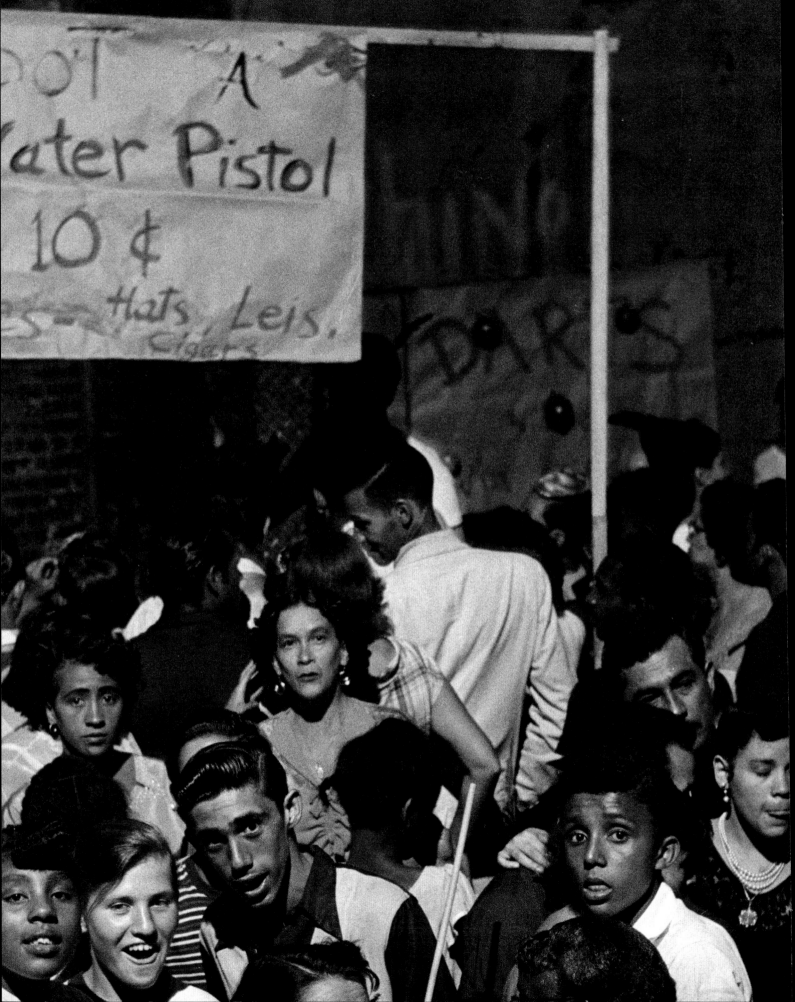

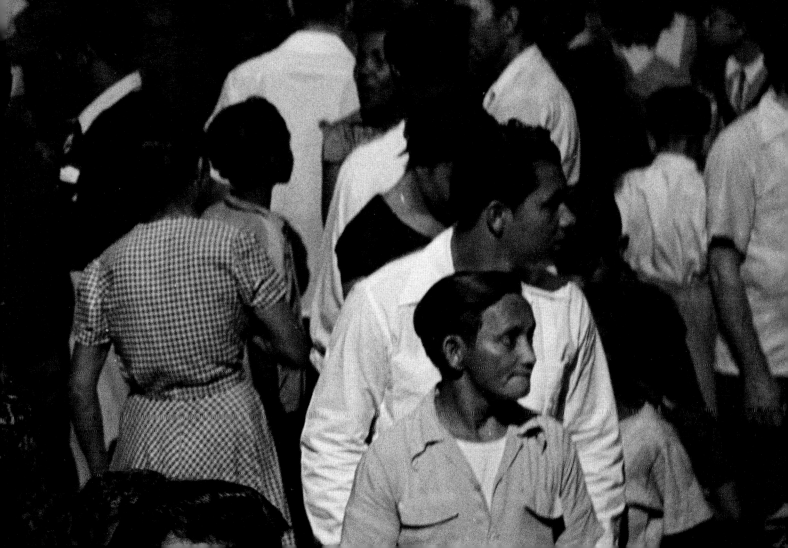

# EAST HARLEM

In the postwar period, New York, long a refuge for immigrants, attracted large numbers of new arrivals, particularly from Puerto Rico, radically changing the city's demographics. The area east of Fifth Avenue and north of Ninety-sixth Street became known as Spanish Harlem or El Barrio and incorporated the neighborhood previously known as Italian Harlem. Nuyoricans, as the new residents were sometimes identified, imbued the city with a distinctly Latin flavor. The area was immortalized in the popular song of 1961, "Spanish Harlem," by Jerry Leiber and Phil Spector, which described a rose bursting through the concrete and thriving by the light of the moon.

APRIL–AUGUST 1953 / PHOTOGRAPHER: PHILLIP HARRINGTON

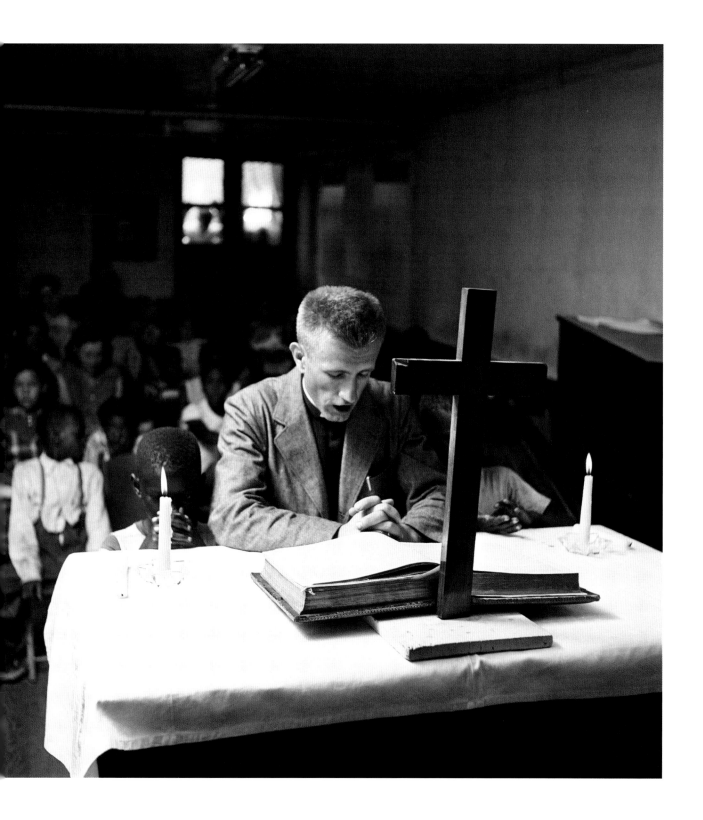

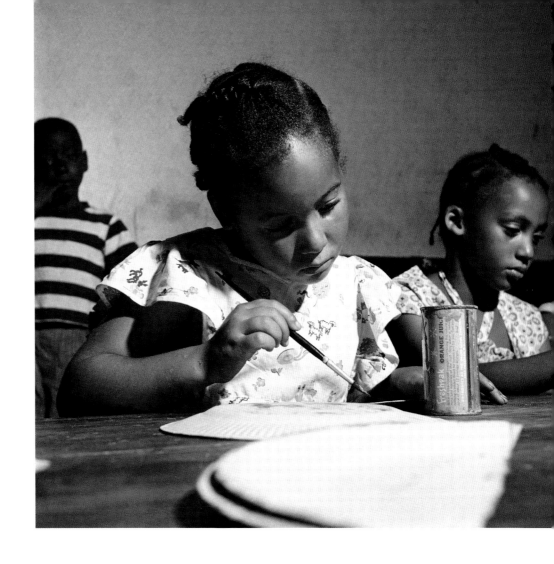

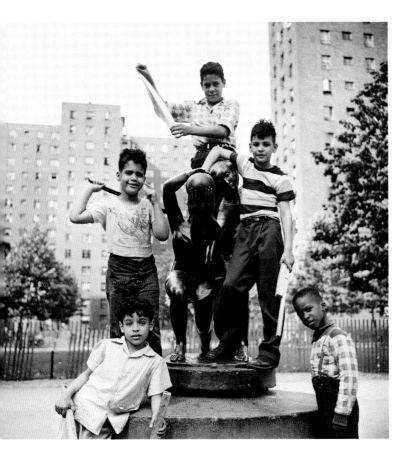

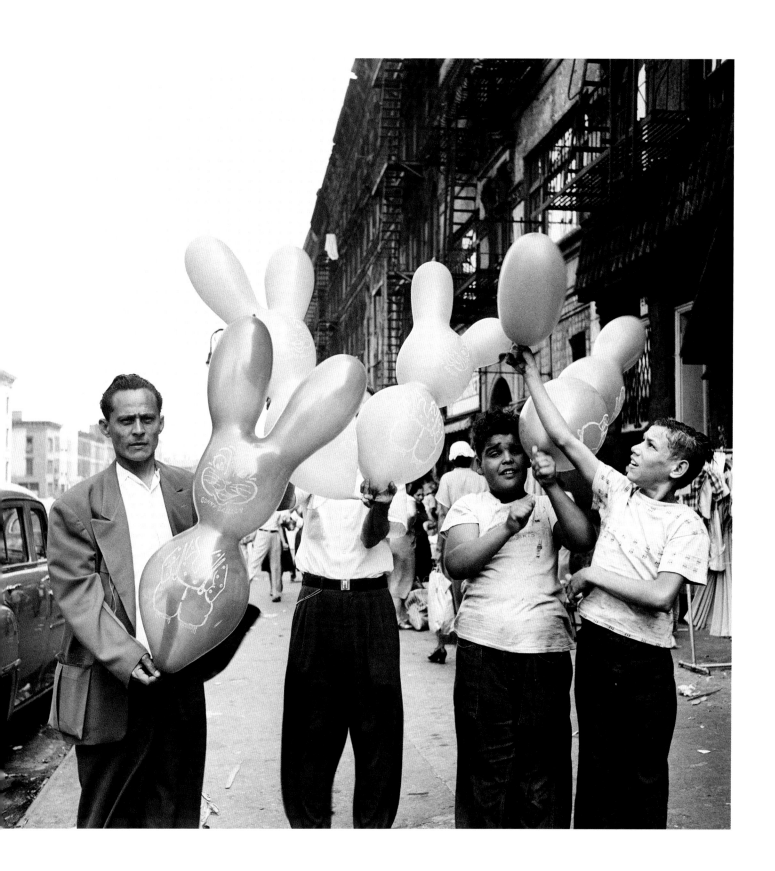

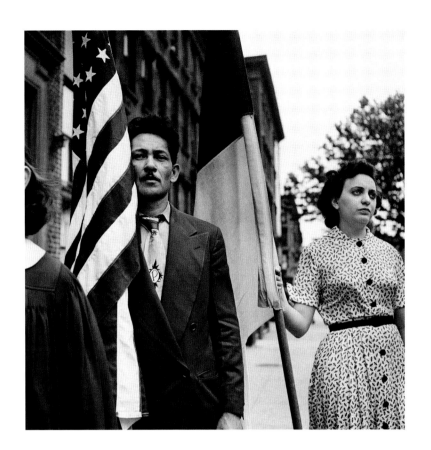

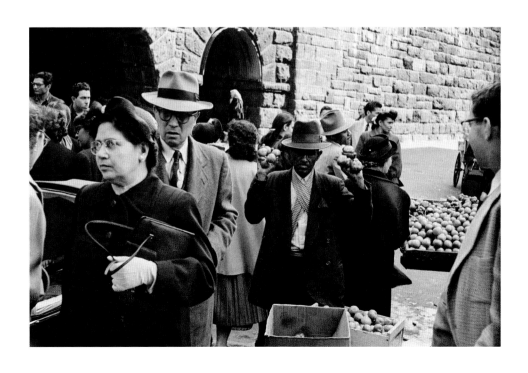

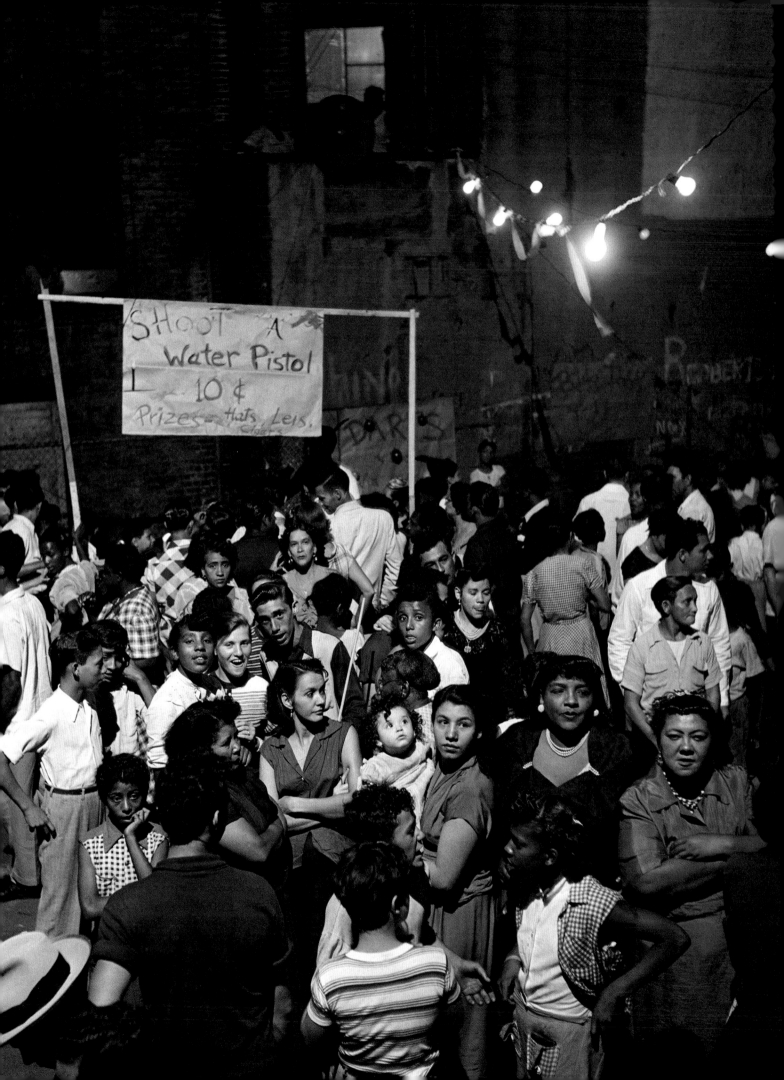

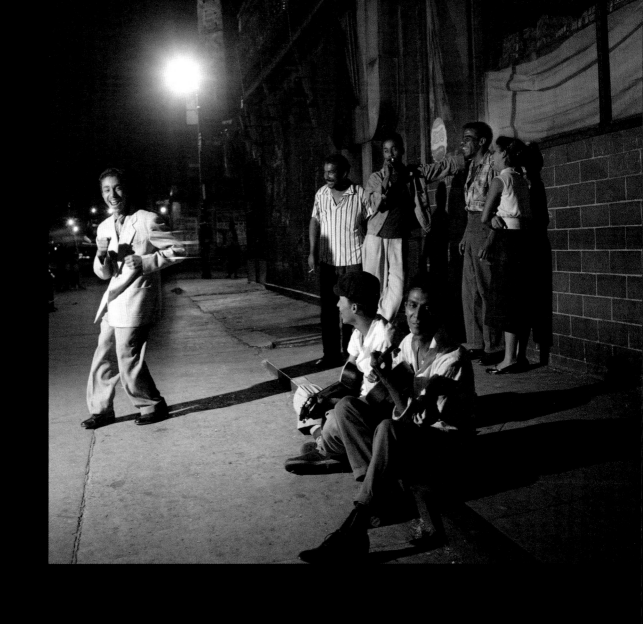

# ATHLETES

The 1940s and 1950s were a golden age for New York sports. Three hometown teams—the Yankees, the Giants, and the Brooklyn Dodgers—dominated professional baseball. Football, hockey, and basketball were gaining popularity—and a night at the fights remained a coveted ticket. Athletes were regarded as far more than naturally gifted professionals and celebrated as larger-than-life heroes. They also became associated with the city and served as de facto ambassadors nationally, and sometimes internationally. *Look*'s coverage of sports was not limited, however, to heroes and winners. Through the trenchant lens of Stanley Kubrick, both well- and lesser-known prizefighters were portrayed as inhabiting a world in which a patina of glamour and potential success masked unforgiving physical brutality and emotional degradation.

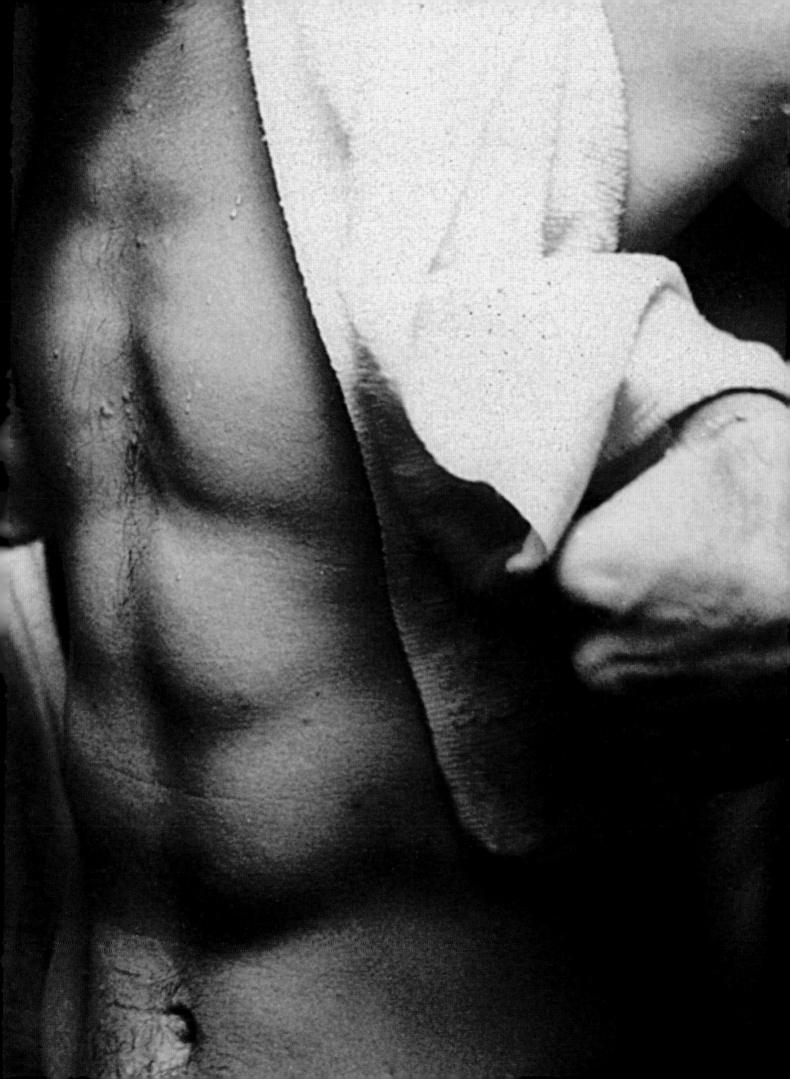

# WALTER CARTIER

**JULY–SEPTEMBER 1948**
**PHOTOGRAPHER: STANLEY KUBRICK**

This photo assignment, published as the story "Prizefighter" in *Look*'s January 18, 1949, issue showcased twenty-four-year-old Walter Cartier (1922–1995), a resident of Greenwich Village. It juxtaposed images from his personal life—intimate scenes with his girlfriend, twin brother Vincent, and nephew with graphic, brutal ones of his struggles to become the middleweight champion. Kubrick followed Cartier to his apartment, local church, a Staten Island beach, the gym, and, after the fight, a Greenwich Village street. Especially noteworthy was Kubrick's use of light, shadow, and pitch-black backgrounds to heroicize Cartier's body. Kubrick's first film, *The Day of the Fight*, made in 1951 when he was twenty-three, featured Cartier and his brother.

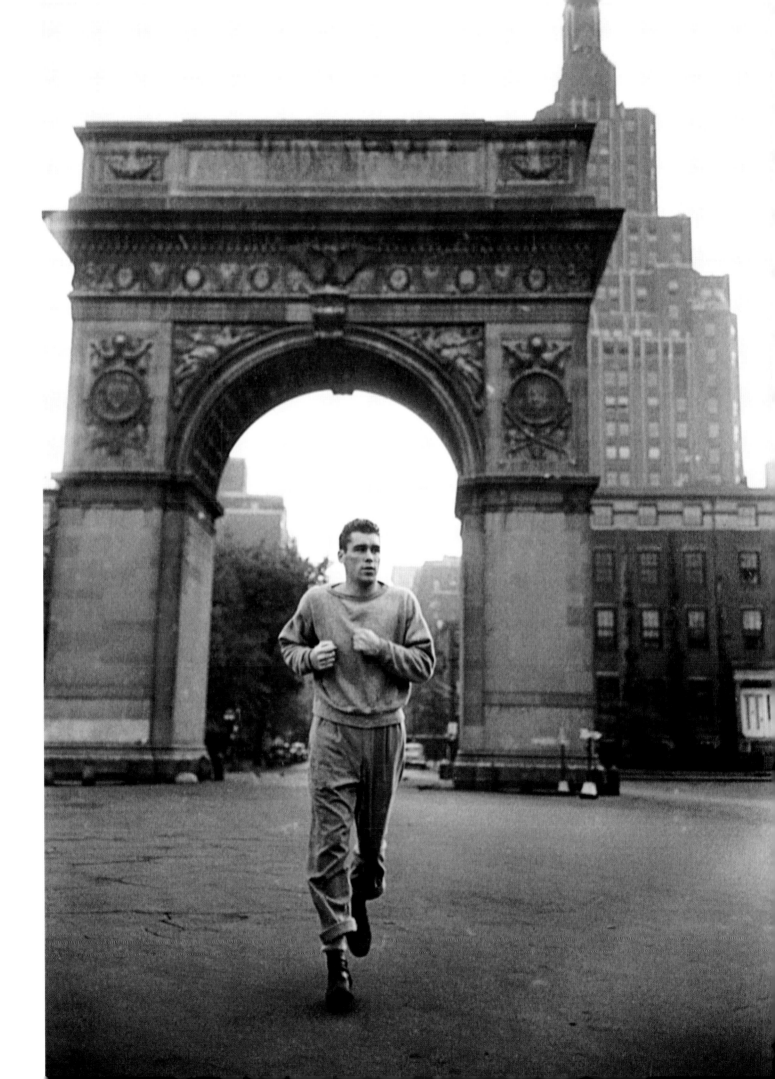

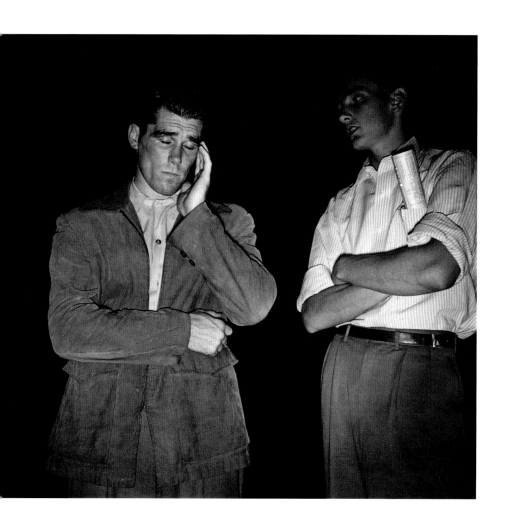

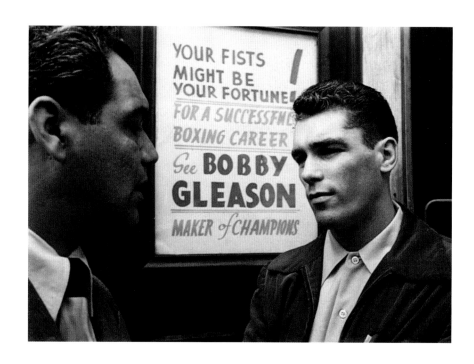

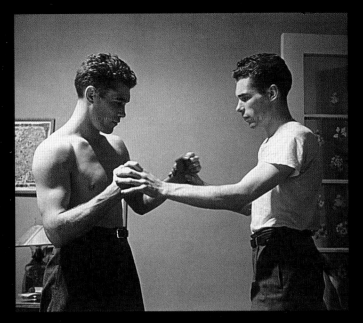
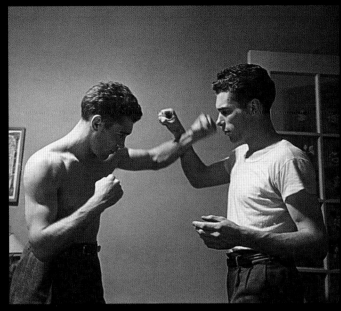
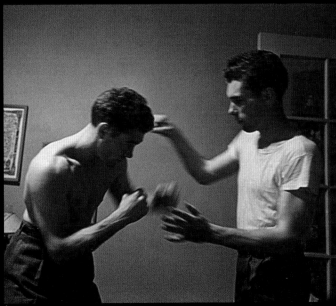
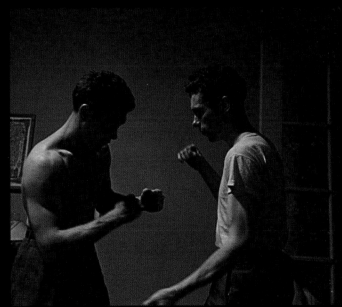

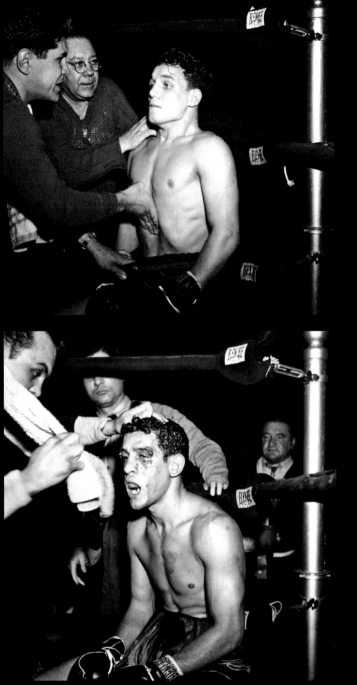

# BROADWAY ARENA

**OCTOBER–NOVEMBER 1947**
**PHOTOGRAPHER: STANLEY KUBRICK**

Kubrick highlights boxing's savage nature in these photographs. Taken at the popular Broadway Arena, they depict various fighters, including one of the era's leading contenders Willie Beltram, who is shown in the lower image on this page and on the next one.

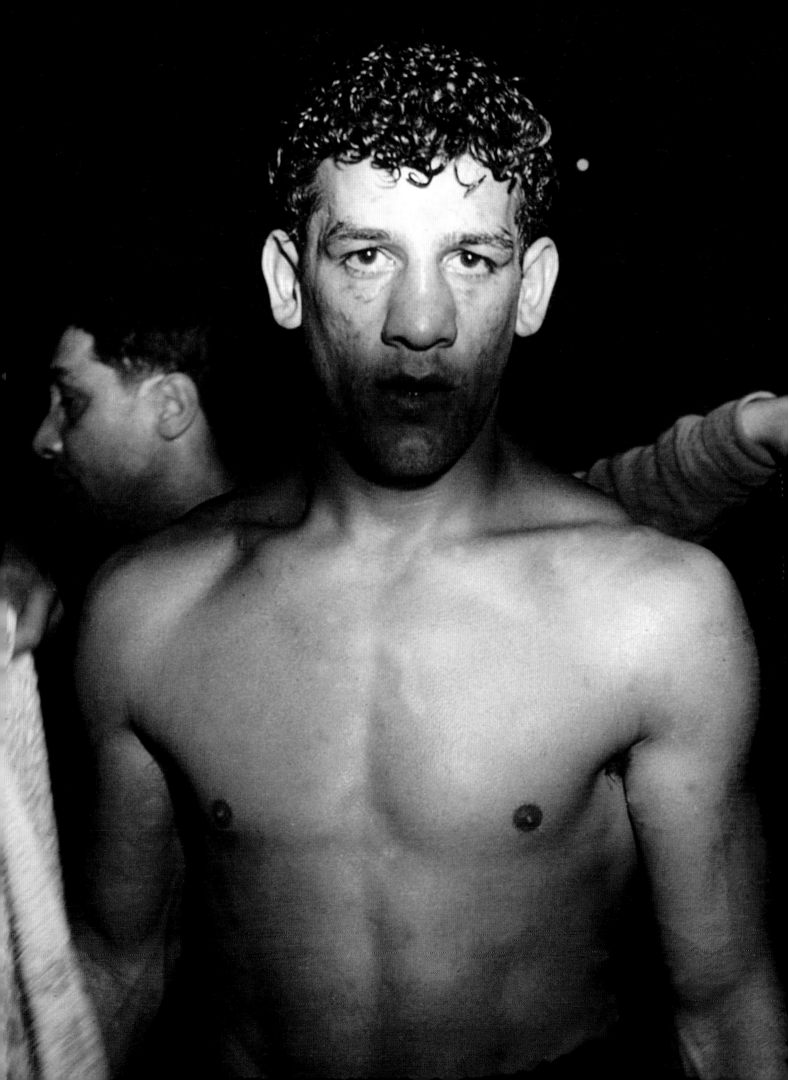

# ROCKY GRAZIANO

**DECEMBER 1949 / PHOTOGRAPHER: STANLEY KUBRICK**

Although Rocky Graziano (1922–1990) was a professional boxer for only ten years, he was one of the most popular athletes of his generation. In the late 1940s, Graziano fought against Tony Zale in some of the sport's most brutal battles for the title of World Middleweight Champion. Known for his self-deprecating wit, Graziano described his early brushes with the law while growing up in poverty on Manhattan's Lower East Side: "We stole everything that began with an 'a'—a piece of fruit, a bicycle, a watch, anything that was not nailed down." *Look* published an article, "Rocky Graziano: He's a Good Boy Now," with Kubrick's photographs, in its February 14, 1950, issue. In 1956, Graziano's life story served as the basis of the movie *Somebody Up There Likes Me*, starring Paul Newman.

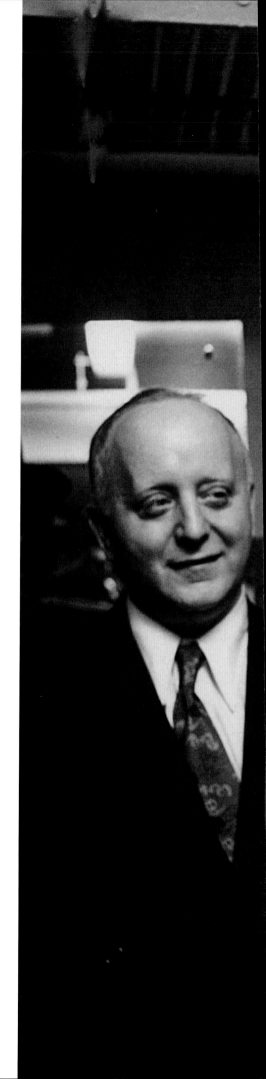

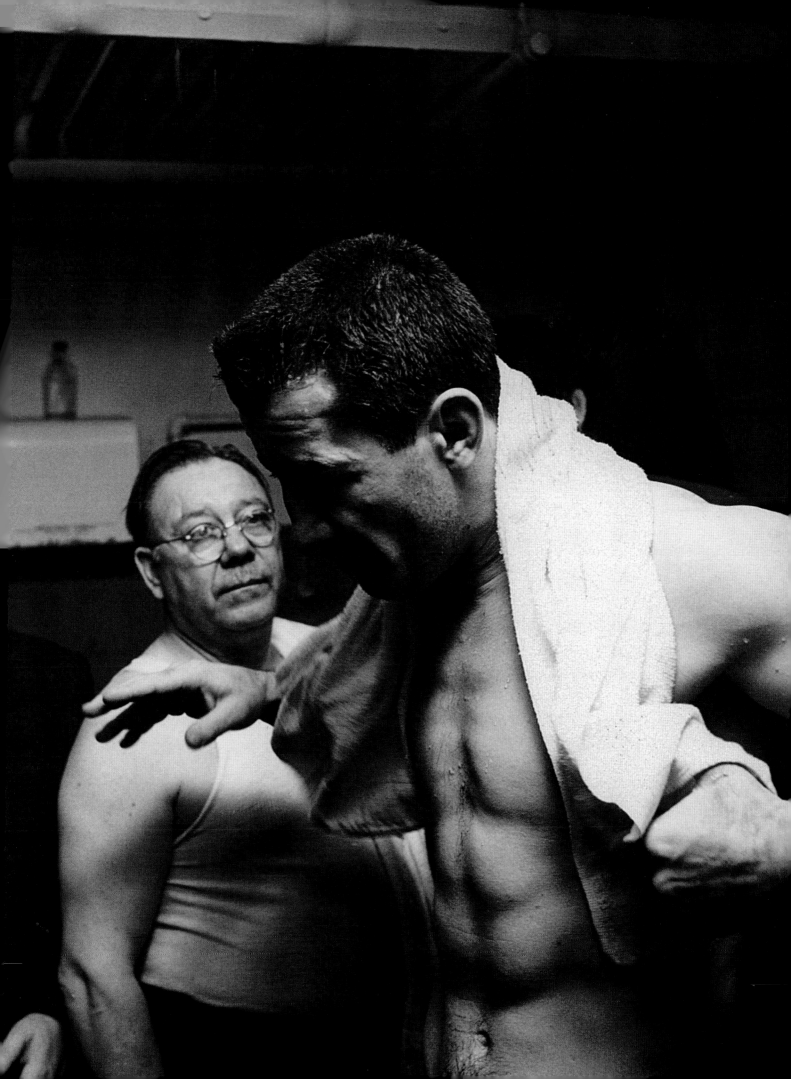

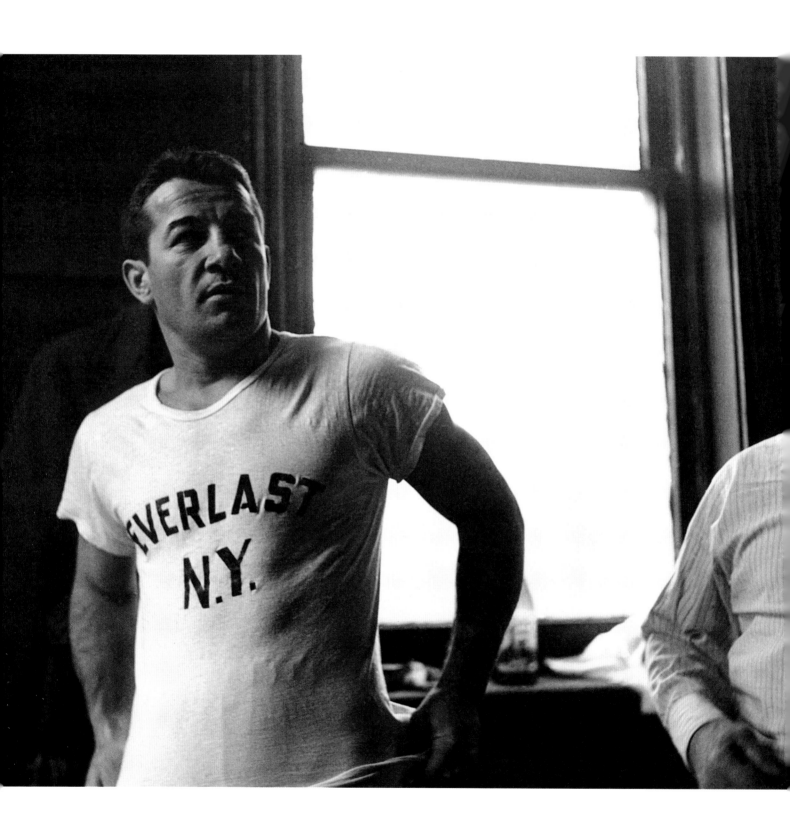

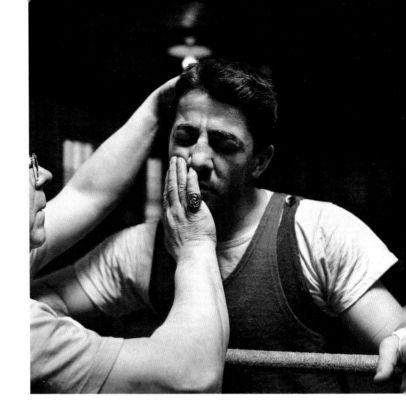

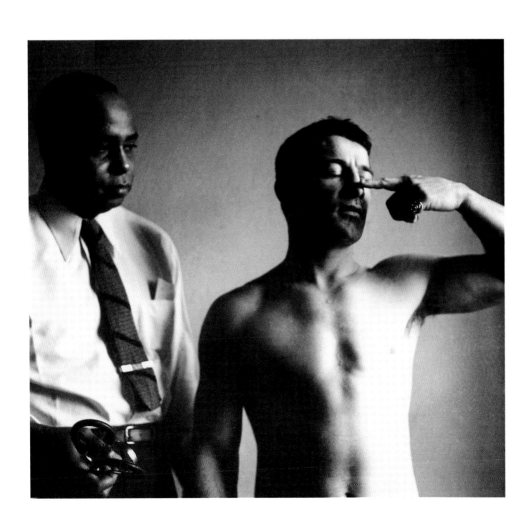

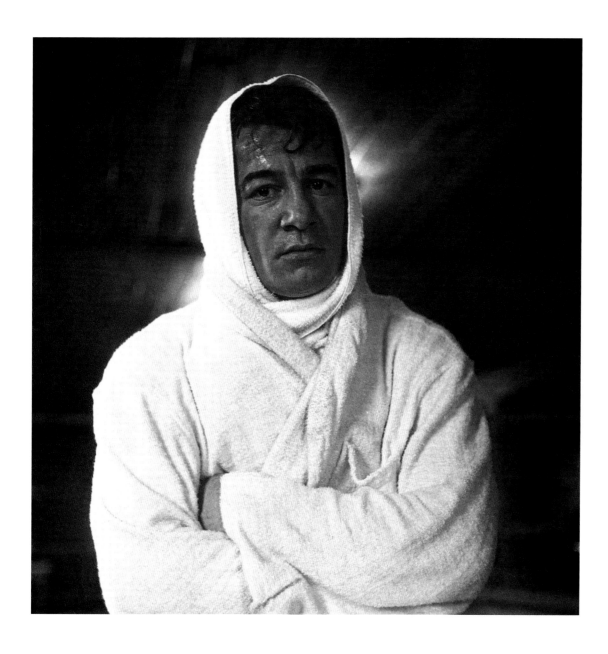

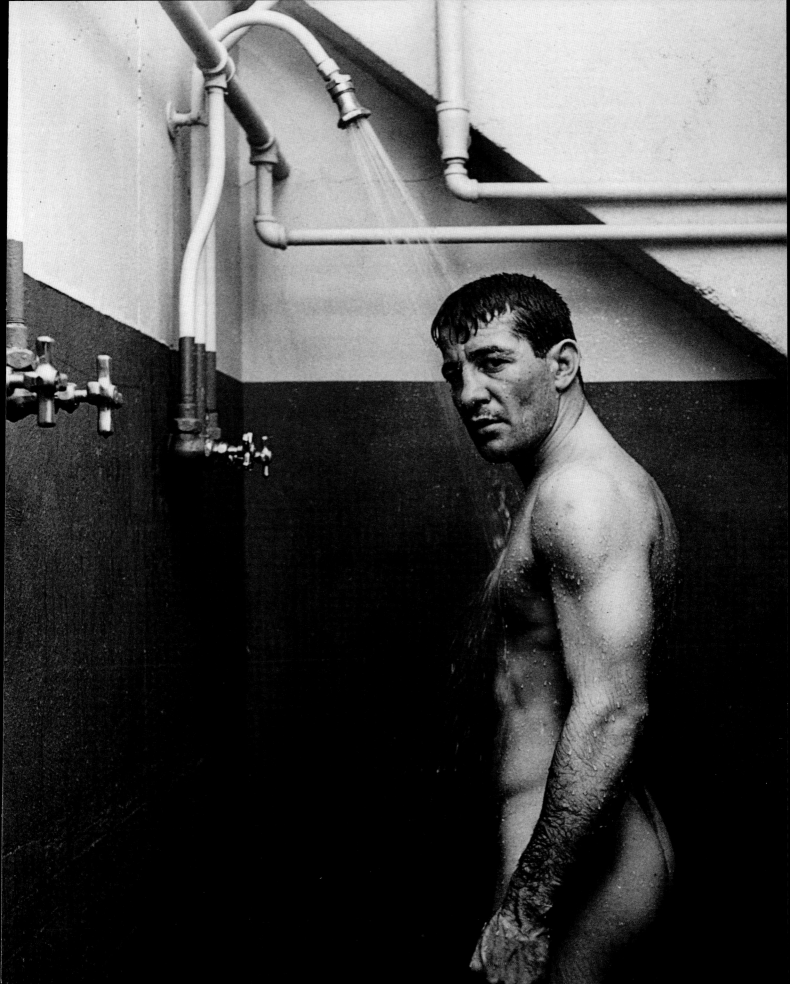

# JACKIE ROBINSON

**JULY 1949 / PHOTOGRAPHER: FRANK BAUMAN**

In 1947, at the age of twenty-eight, Jackie
Robinson (1919–1972) broke the color line
in Major League Baseball as a member
of the Brooklyn Dodgers. This event,
which would forever change the nature of
professional sports in America, fittingly took
place in New York, a city long defined by its
multiculturalism, if not always by a history
of racial equality. Robinson excelled as a
second baseman and in 1962 was inducted
into the National Baseball Hall of Fame.
Two years later Robinson, active in business
and politics following his baseball career,
helped to establish the African American–
owned Freedom National Bank, located on
125th Street in Harlem.

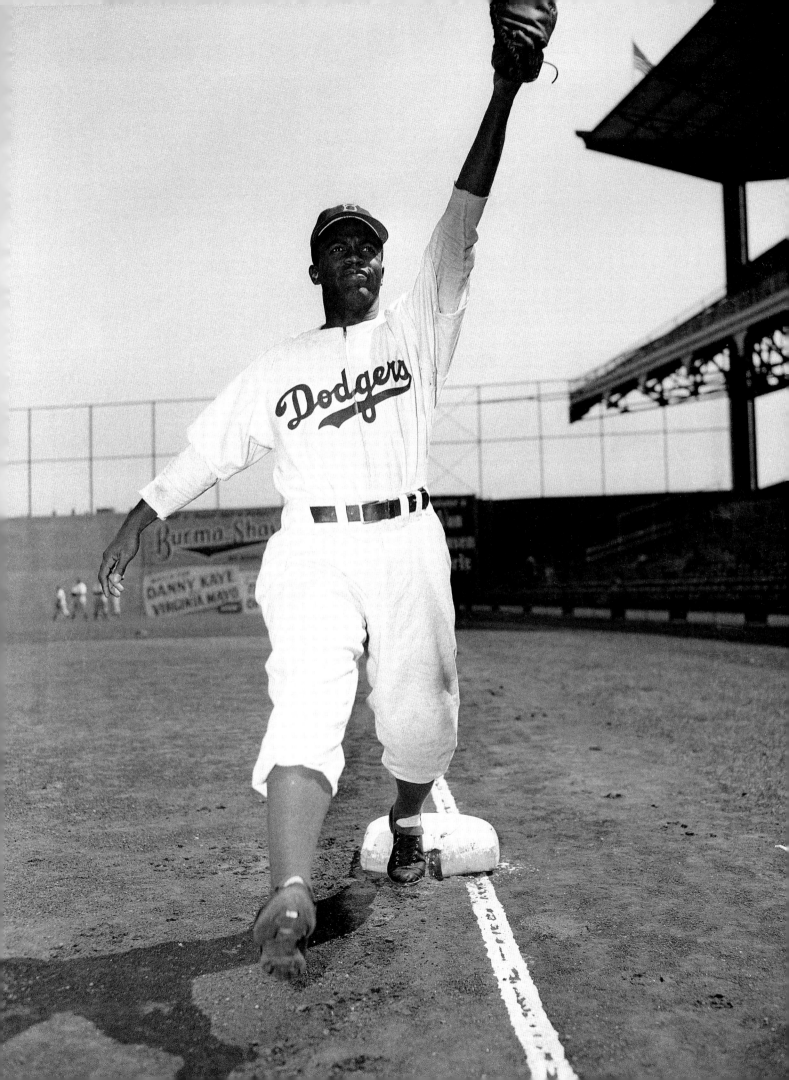

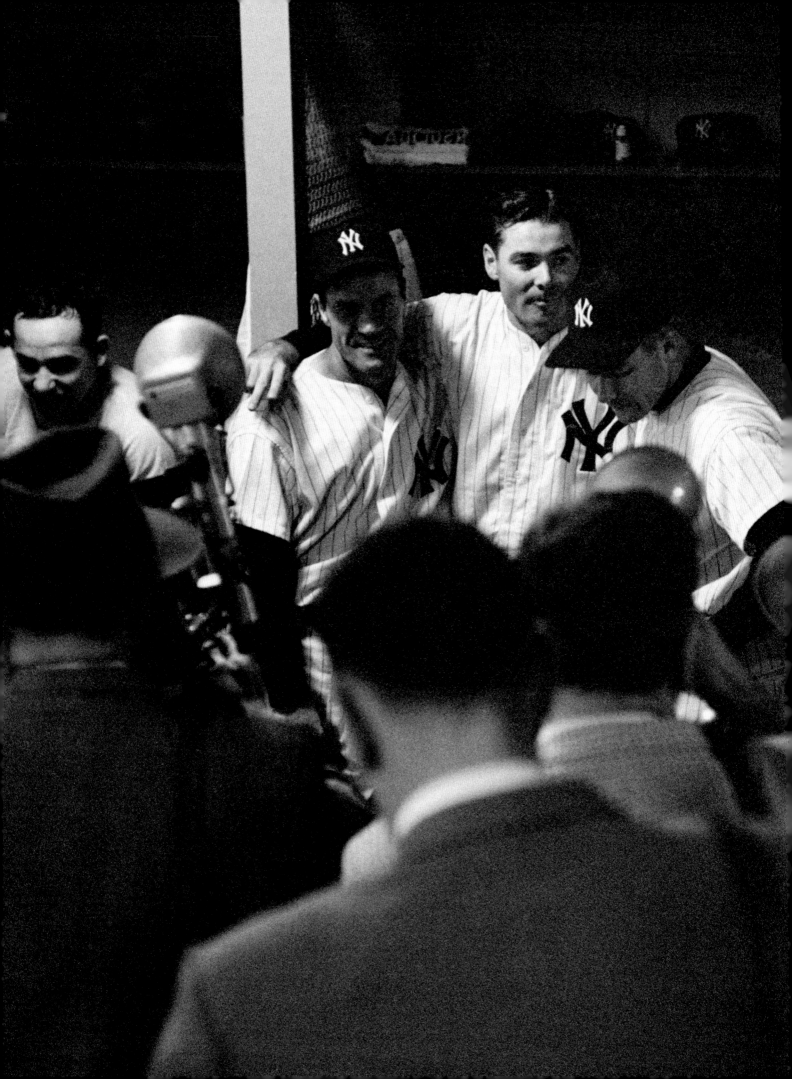

PHOTOGRAPHS ON PAGES 164–169:
# 1956 WORLD SERIES
OCTOBER 1956 / PHOTOGRAPHER: MARVIN E. NEWMAN

The 1956 World Series was a classic "subway series," pitting the New York Yankees against the Brooklyn Dodgers. In these photographs, Marvin E. Newman, a freelance photographer hired by *Look* because of his expertise in documenting fast-paced sports events, recorded the fifth game of the Series, played on October 8. This legendary event was the first and only "perfect game" in a World Series. Yankee pitcher Don Larsen (b. 1929) retired twenty-seven consecutive batters, allowing no runs, hits, or even walks. Yogi Berra, the Yankees' catcher during the game is shown on the following page from a later *Look* photo assignment.

Yankees' locker room

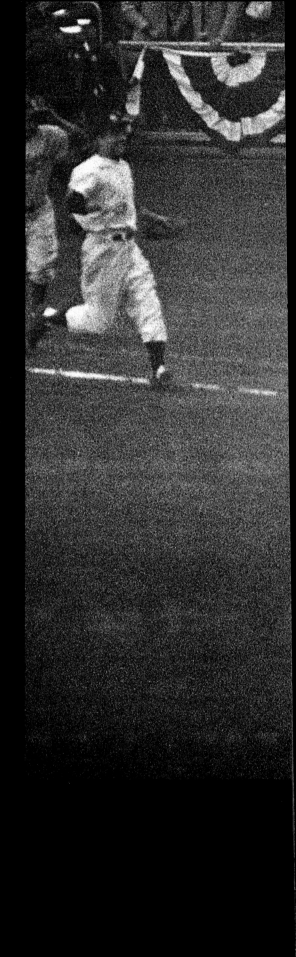

# YOGI BERRA

**MARCH 1957 / PHOTOGRAPHER: MARVIN E. NEWMAN**

A legendary catcher, Yogi Berra (b. 1925) played for the New York Yankees for nineteen seasons, from 1945 to 1963. He served as the team's manager in 1964 and again in 1984 and 1985. He also managed the Mets from 1972 to 1975. Berra was well known for his poetically fractured English, and issued such memorable lines as "It's déjà vu all over again" and "Ninety percent of the game is half mental."

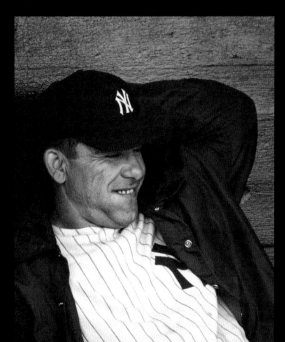

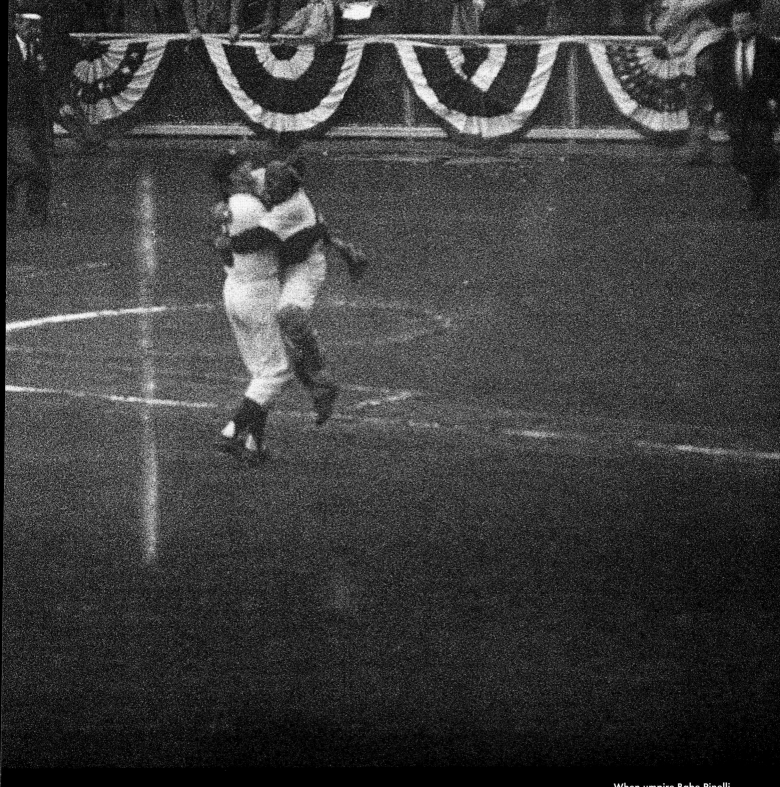

When umpire Babe Pinelli signaled strike three on the game's last batter, Newman captured catcher Yogi Berra running to the mound and leaping into Larsen's arms.

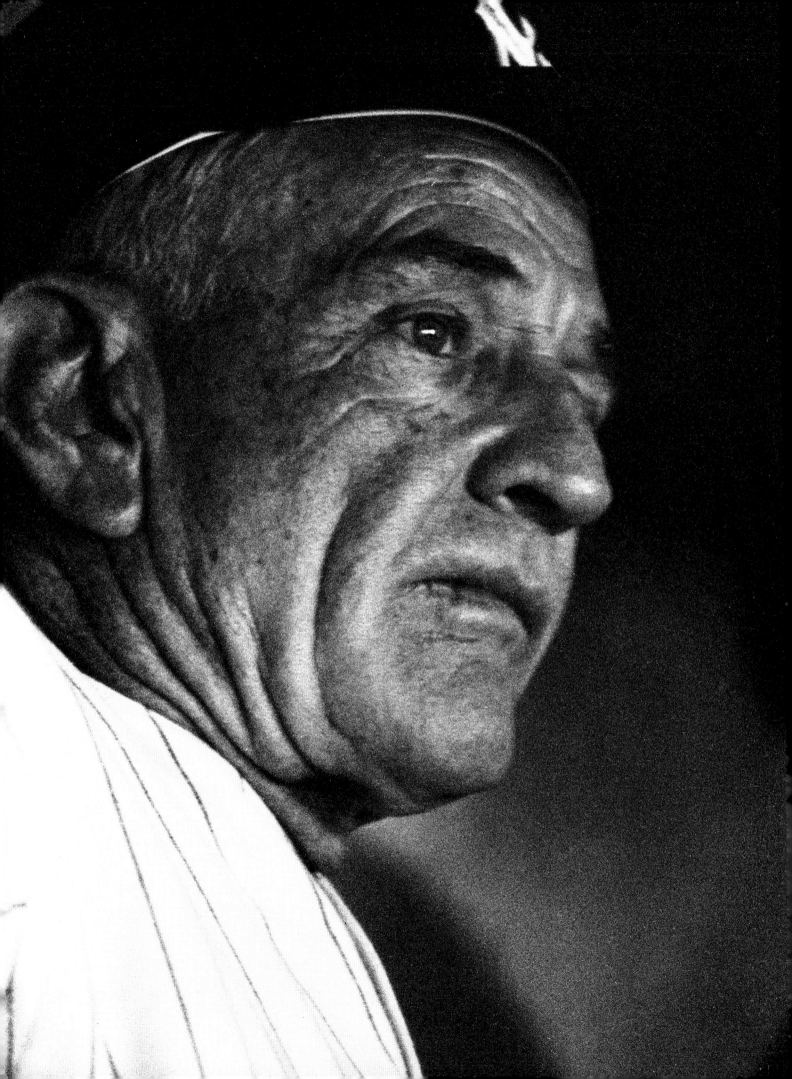

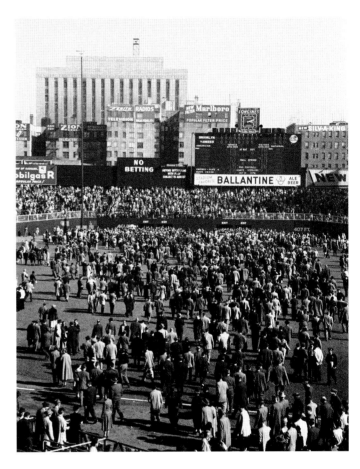

Yankee Stadium

## CASEY STENGEL

**OCTOBER 1956 / PHOTOGRAPHER: MARVIN E. NEWMAN**

Casey Stengel (1891–1975), manager of
the New York Yankees from 1949 to 1960,
was famous not only for his sports acumen,
but also, like Yogi Berra, for his comically
long-winded proclamations and quotable
quips known as "Stengelese." "The secret
of managing," Stengel noted, "is to keep the
guys who hate you away from the guys who
are undecided."

# BROOKLYN

For *Look* magazine, New York was identified more often than not with Manhattan, but its editors and photographers did sometimes widen their focus. Two articles on Brooklyn, published five years apart, offered radically different views of the city's most populous borough. "The Brooklyn Nobody Knows," published on January 18, 1949, defied the expectation that the borough housed nothing but homes and churches. The article focused instead on Brooklyn's major cultural institutions, celebrated artists and writers, and "architectural vistas as lovely as any in Paris." The November 2, 1954, story, "Could this Happen to Your Boy?" stood in marked contrast. Its impetus was the arrest, in the summer of that year, of four local youths dubbed Brooklyn's "thrill killers," accused of unprovoked physical attacks and murders. The young men had not argued with their victims or attempted to rob them. Rather than concentrating on the youths, *Look* photographed and interviewed their neighbors, most of whom were stunned and bewildered by the crimes.

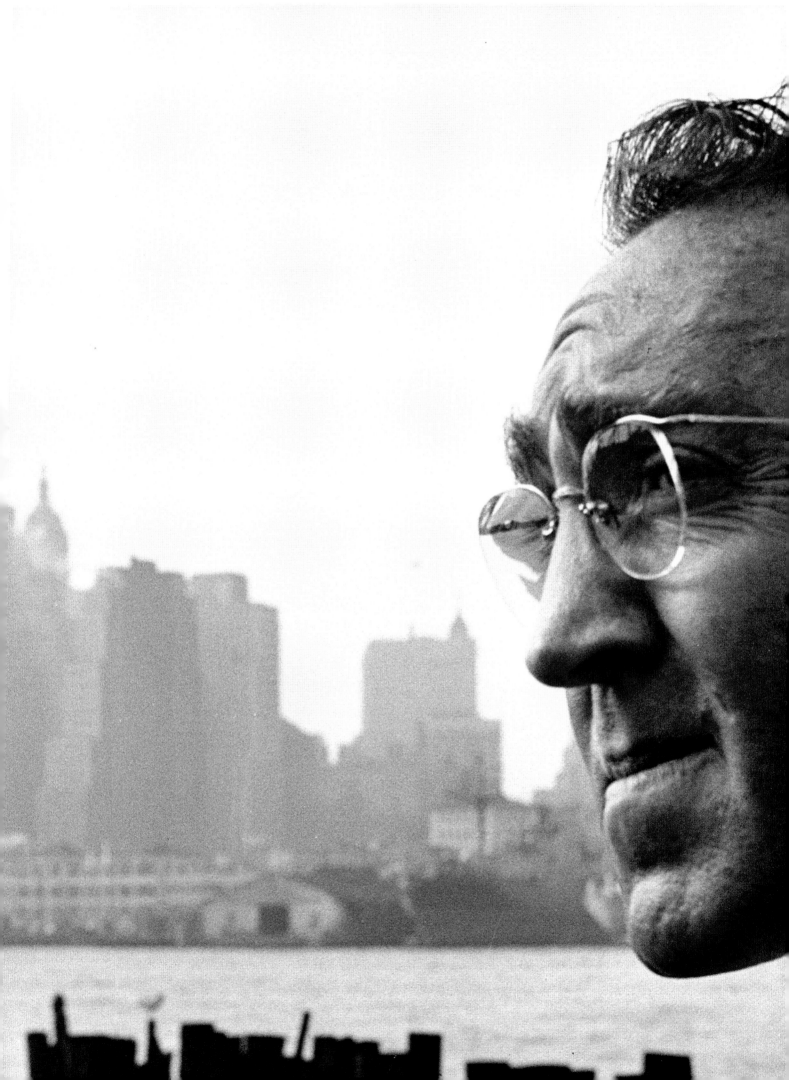

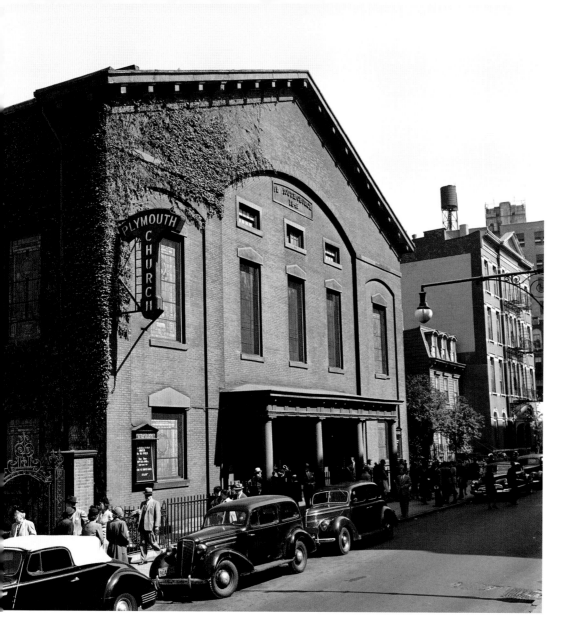

Plymouth Church, Brooklyn Heights

# THE BROOKLYN
# NOBODY KNOWS

SEPTEMBER 1948 / PHOTOGRAPHER: JOHN VACHON

Park Slope

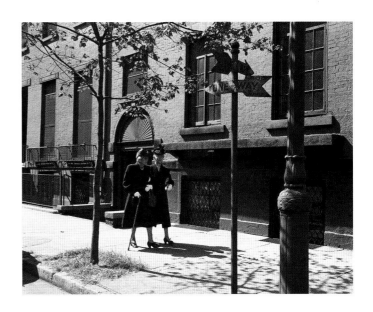

Brooklyn Botanic Garden

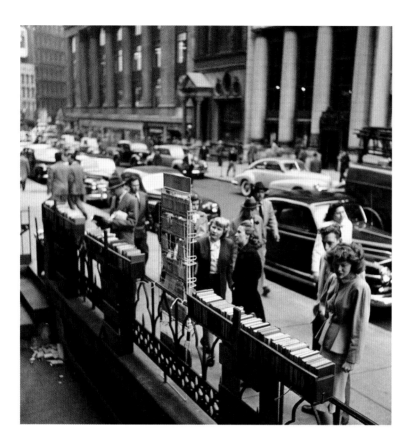

Court Street

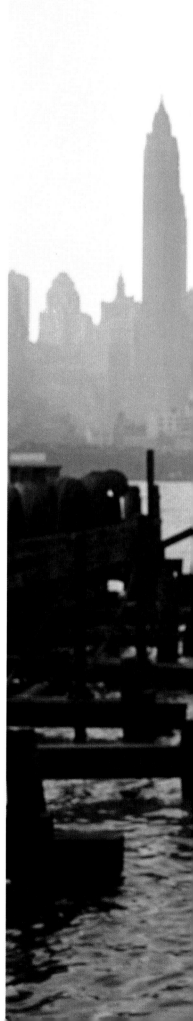

Author and humorist
S. J. Perelman wrote many
articles for *The New Yorker*
magazine as well as
screenplays for the Marx
Brothers and the book
for the Broadway musical
*One Touch of Venus*.

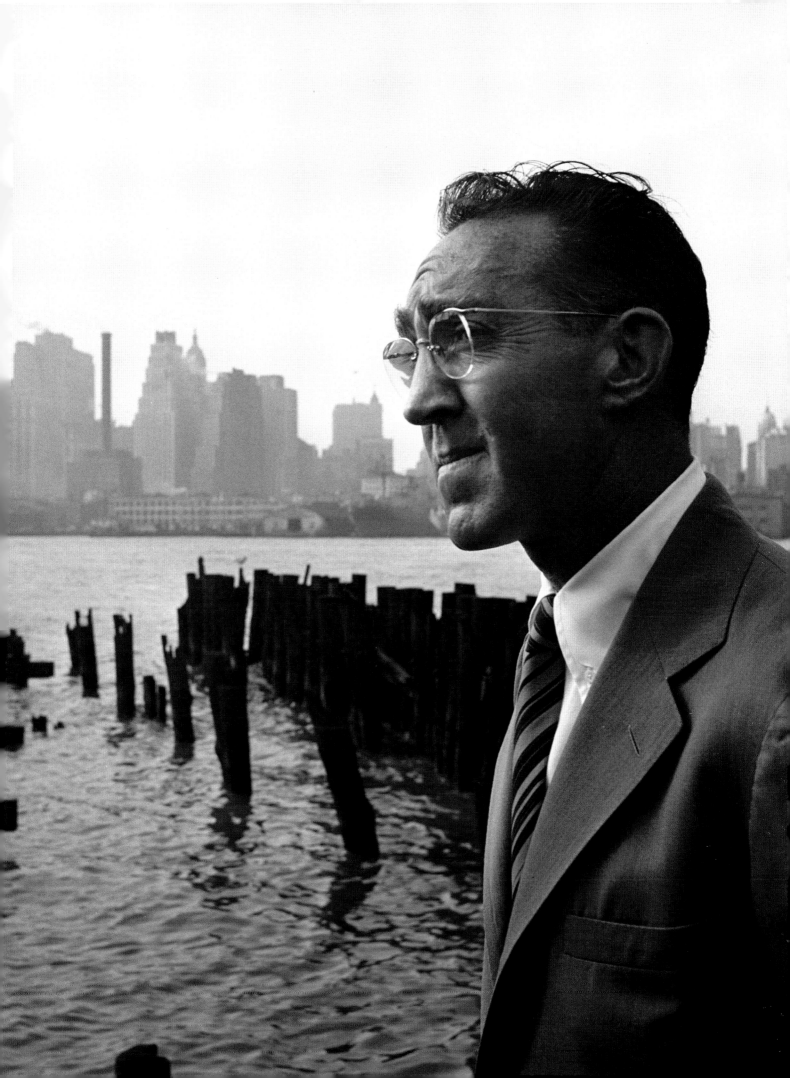

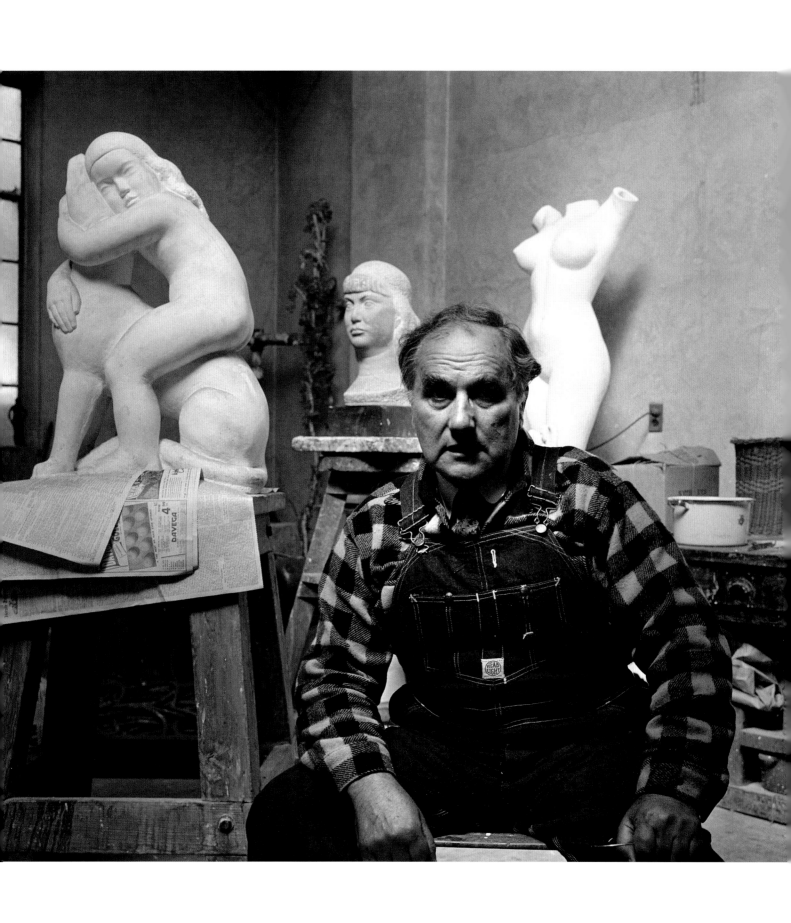

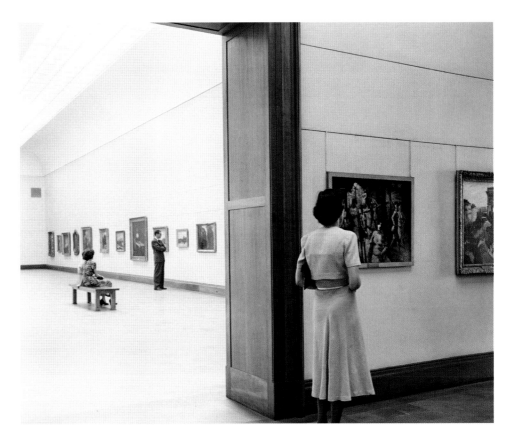

Brooklyn Museum

In *Look*'s article on Brooklyn, sculptor, painter, and printmaker William Zorach says that the borough is "peaceful to live and work in," in contrast to the red-hot center of the art world, Manhattan.

# COULD THIS HAPPEN TO YOUR BOY?

**AUGUST 1954 / PHOTOGRAPHER: JAMES HANSEN**

While the article "Could This Happen to Your Boy?" featured mug shots of the four so-called Brooklyn thrill killers, the piece's primary visuals were images of their neighbors. "Where else can they go?" read a caption to a photograph of young lovers in the park where one of the crimes was committed. Other captions chronicled various reactions to the criminals. One was remembered as "a bully," another as "a good boy . . . I was in school with him eight years. You never know." *Look* observed, "The neighbors are baffled for they have known the boys from babyhood. Good boys, they say, and always polite, but now such a sadness for these poor parents."

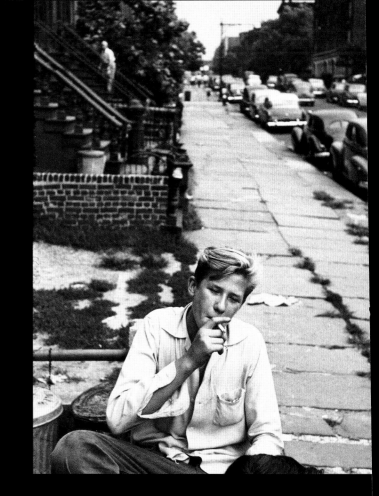

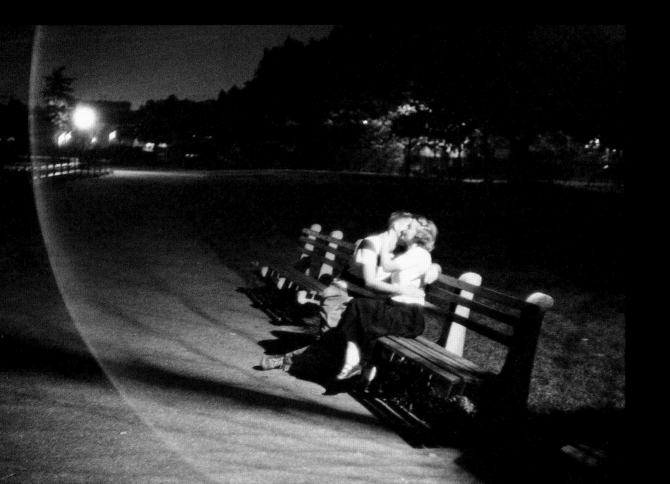

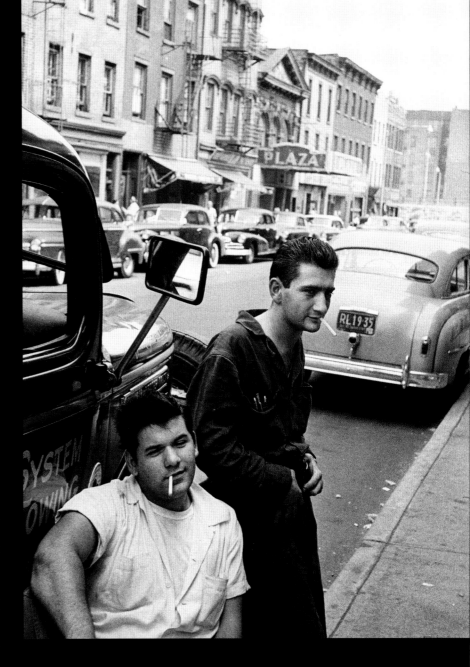

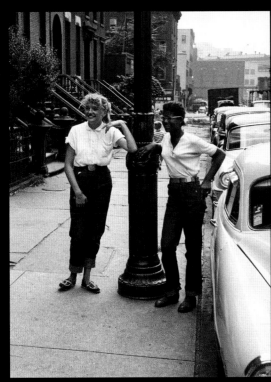

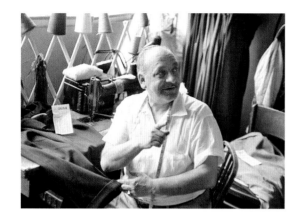

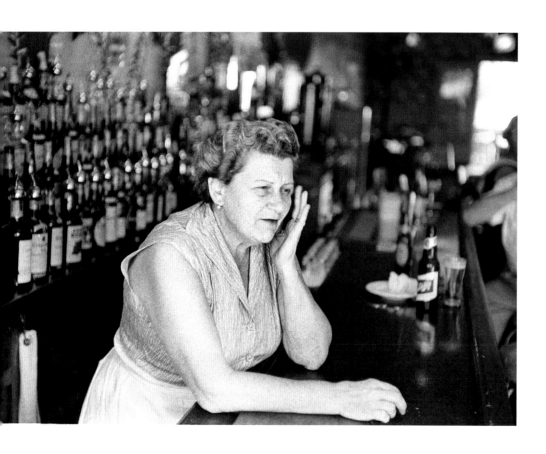

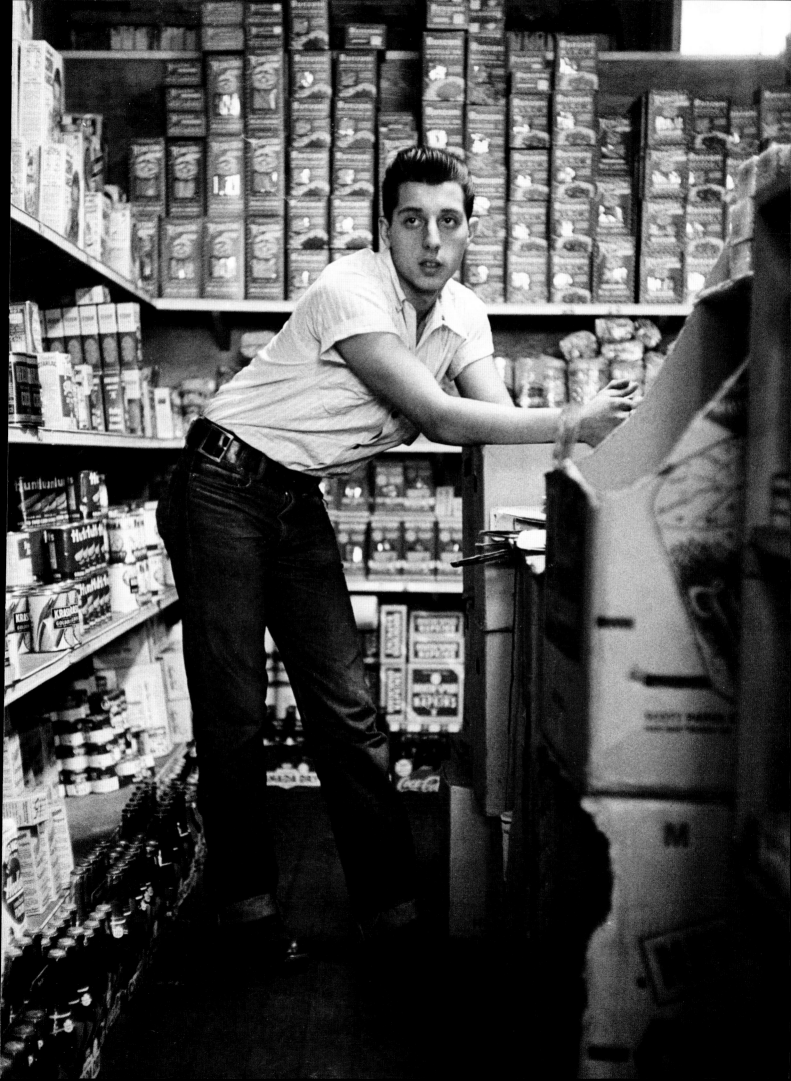

# WATERFRONT

Frequently overlooked as an archipelago, New York City was long tied to its harbor and rivers for economic vibrancy. In 1948, decades before the city's shipping industry declined, *Look*'s photographers used the city's distinctive skyline and its magnificent bridges as backdrops to the longshoremen and tugboats that kept the flow of sea traffic moving.

JULY 1948 / PHOTOGRAPHER: JAMES CHAPELLE

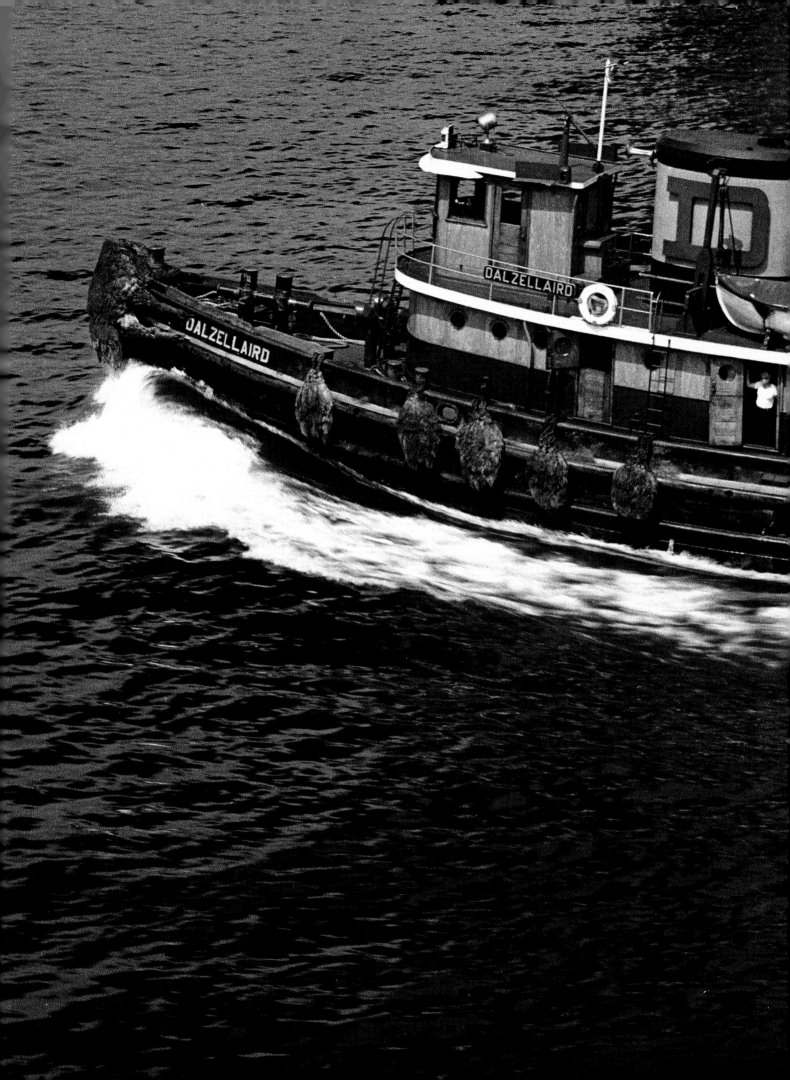

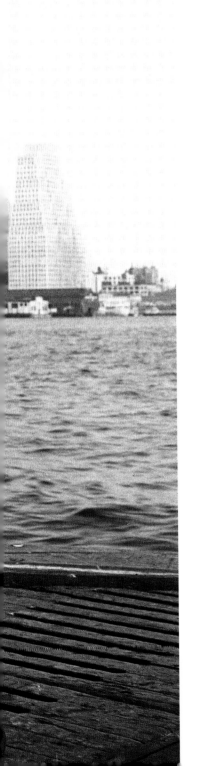

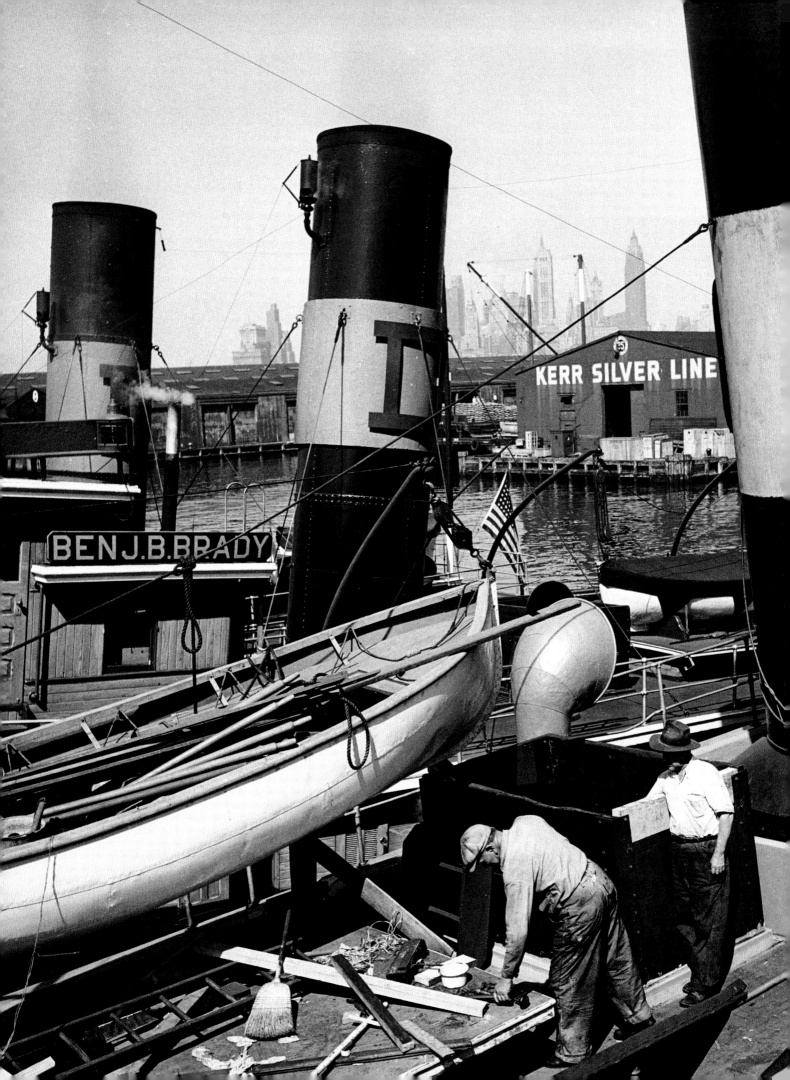

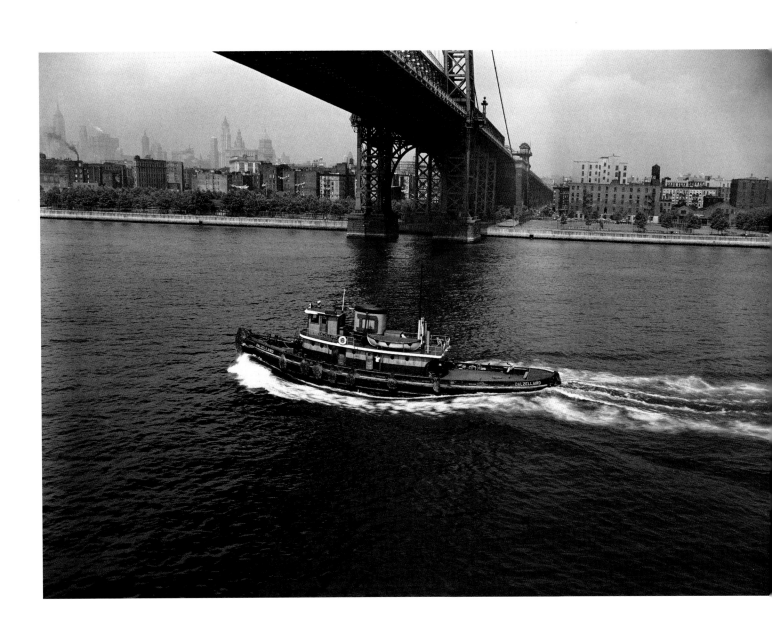

# NIGHTSPOTS

Not surprisingly in the "city that never sleeps,"
nightspots have played a key role. Throughout
the postwar period, *Look* chronicled the city's
leading good-time venues, and in so doing,
charted a trajectory from the formal glamour
of the 1940s to the incipient do-your-own-thing
attitude of the 1960s.

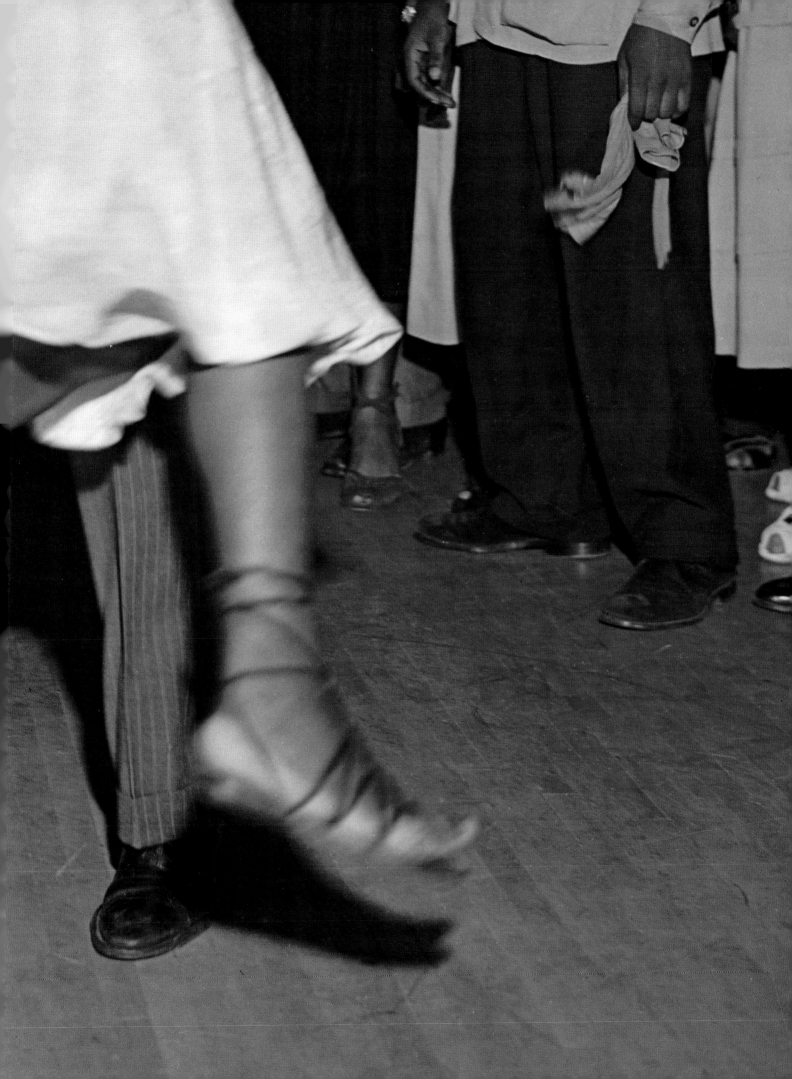

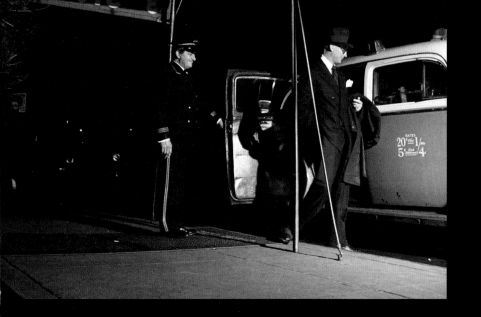

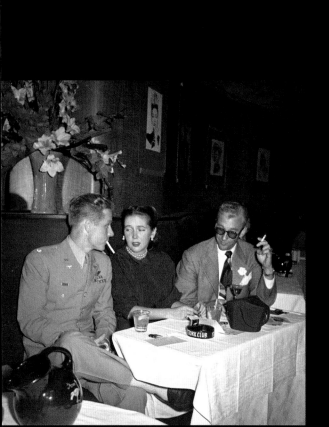

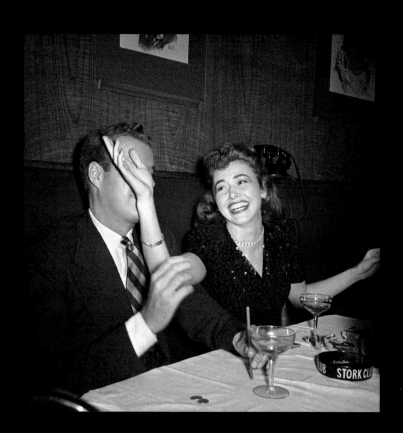

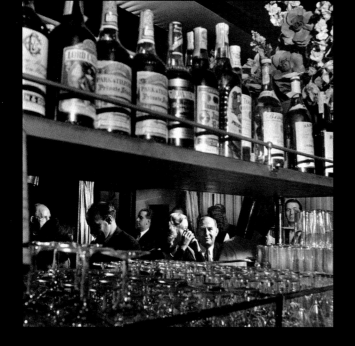

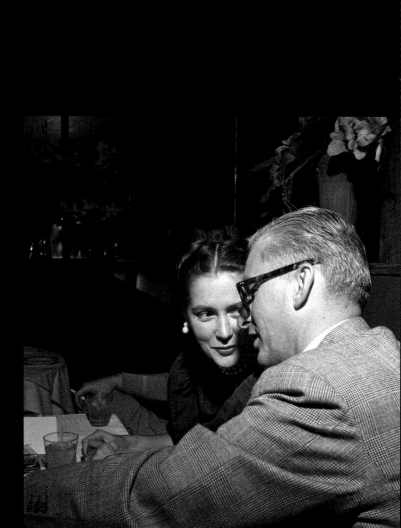

## THE STORK CLUB
**OCTOBER 1946 / PHOTOGRAPHER: BOB SANDBERG**

Gossip columnist Walter Winchell had once dubbed the Stork Club "New York's New Yorkiest spot." The exclusive nightclub was guarded by a bouncer who stood behind a golden rope and contained an even more selective venue, the Cub Room, waggishly referred to by some as the Snub Room.

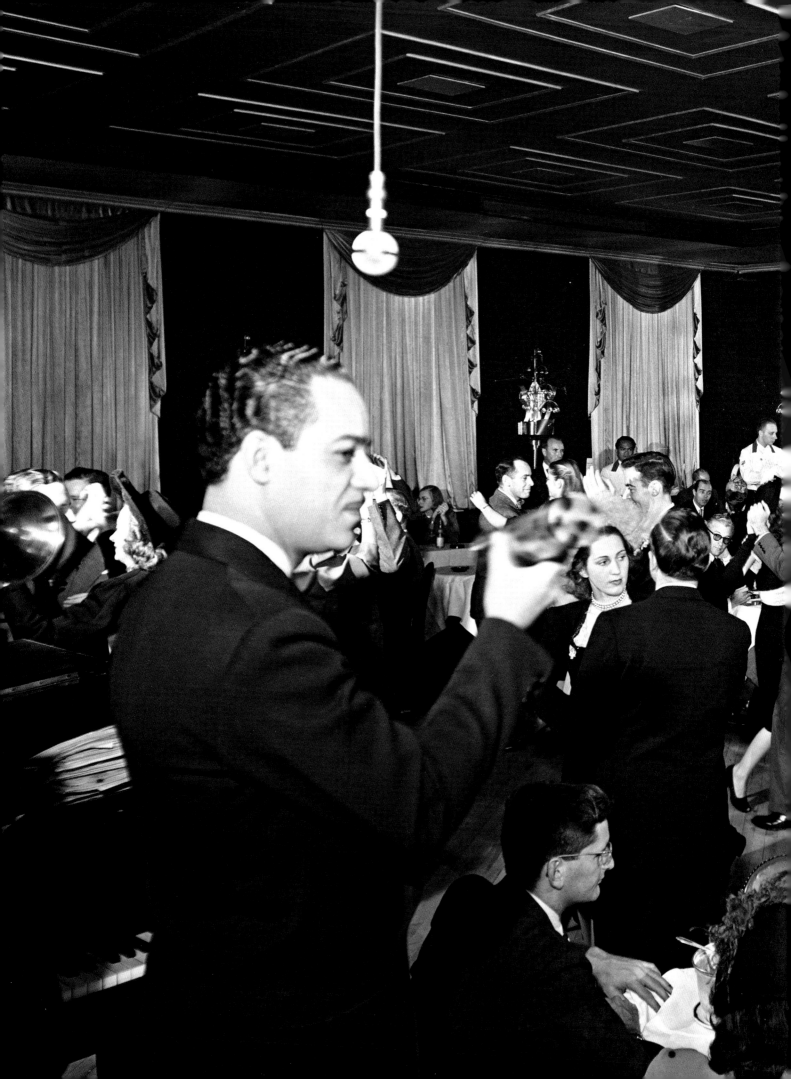

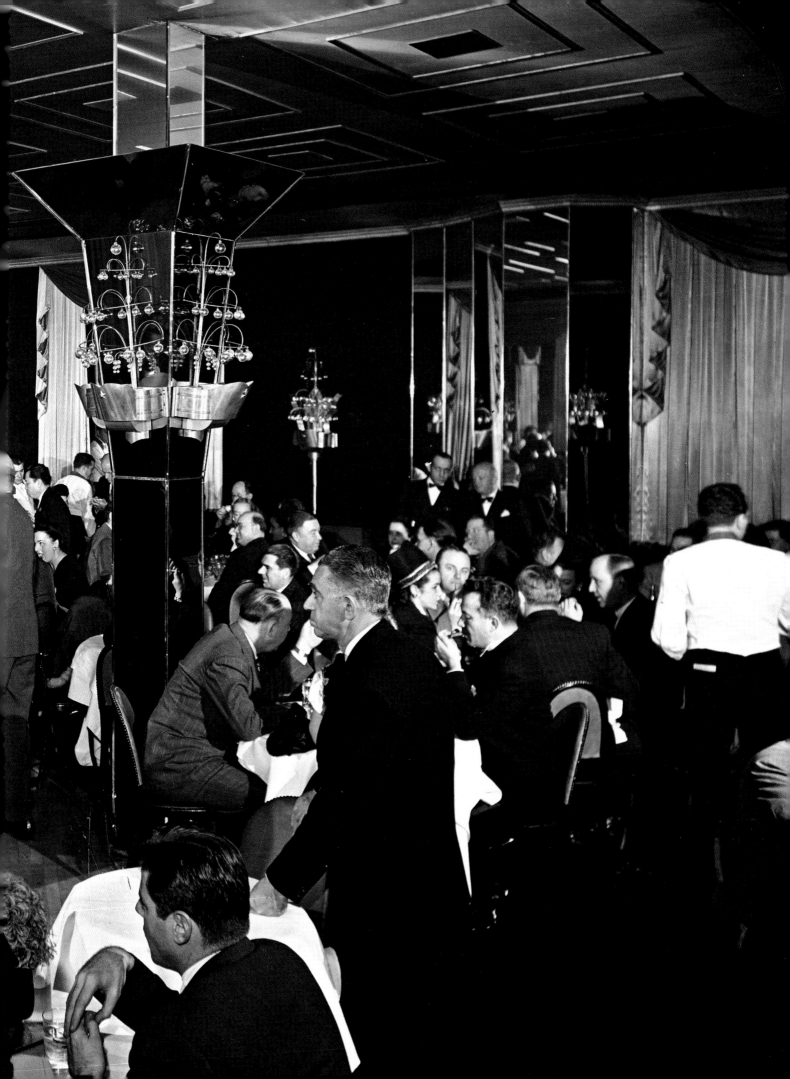

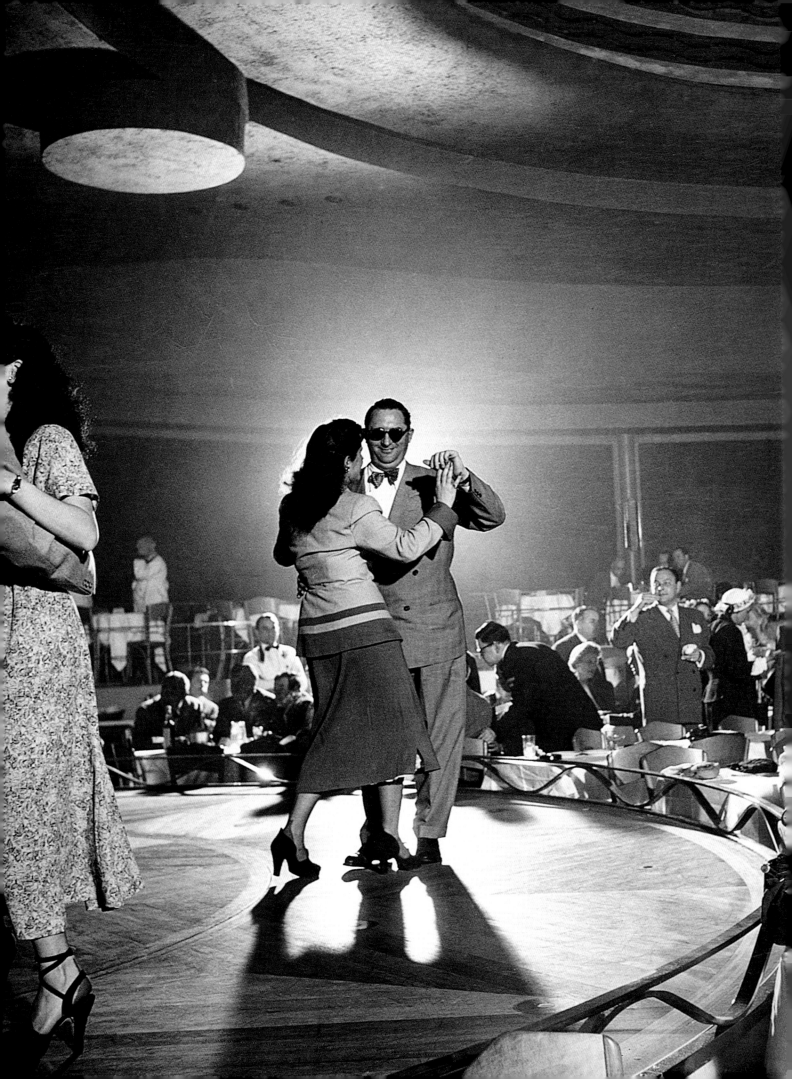

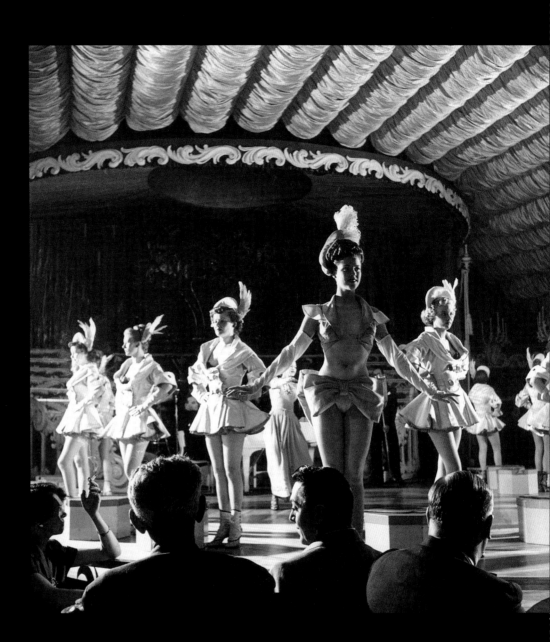

## COPACABANA

**DECEMBER 1948 / PHOTOGRAPHER: STANLEY KUBRICK**

The Copacabana, located at 10 East Sixtieth
Street, which introduced such celebrities as
Dean Martin and Jerry Lewis, epitomized
Manhattan sophistication in the popular
imagination. For Stanley Kubrick, however,
beneath its glittering surface lurked a sense
of alienation and menace, particularly as
seen in complex interactions between men
and women.

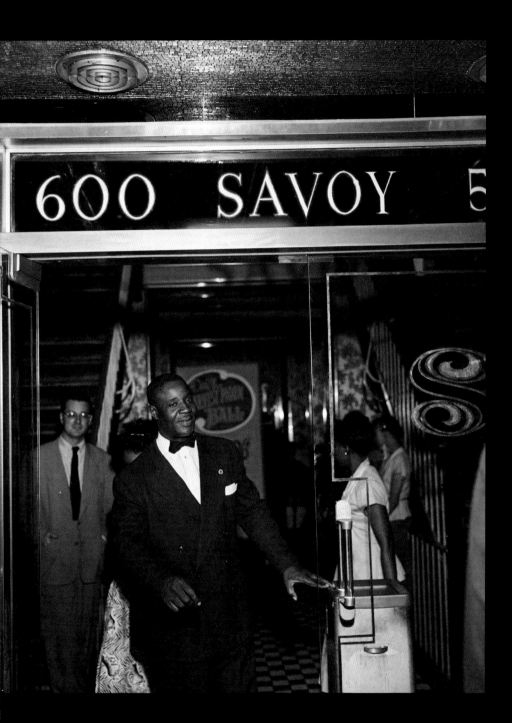

## SAVOY BALLROOM

**JULY–AUGUST 1949 / PHOTOGRAPHER: JOHN VACHON**

The Savoy Ballroom, located in Harlem
on Lenox Avenue and 140th Street and
known as the "Home of Happy Feet,"
was the nightspot where the Lindy Hop
was popularized. The club was racially
integrated, unlike its nearby rival, the
Cotton Club.

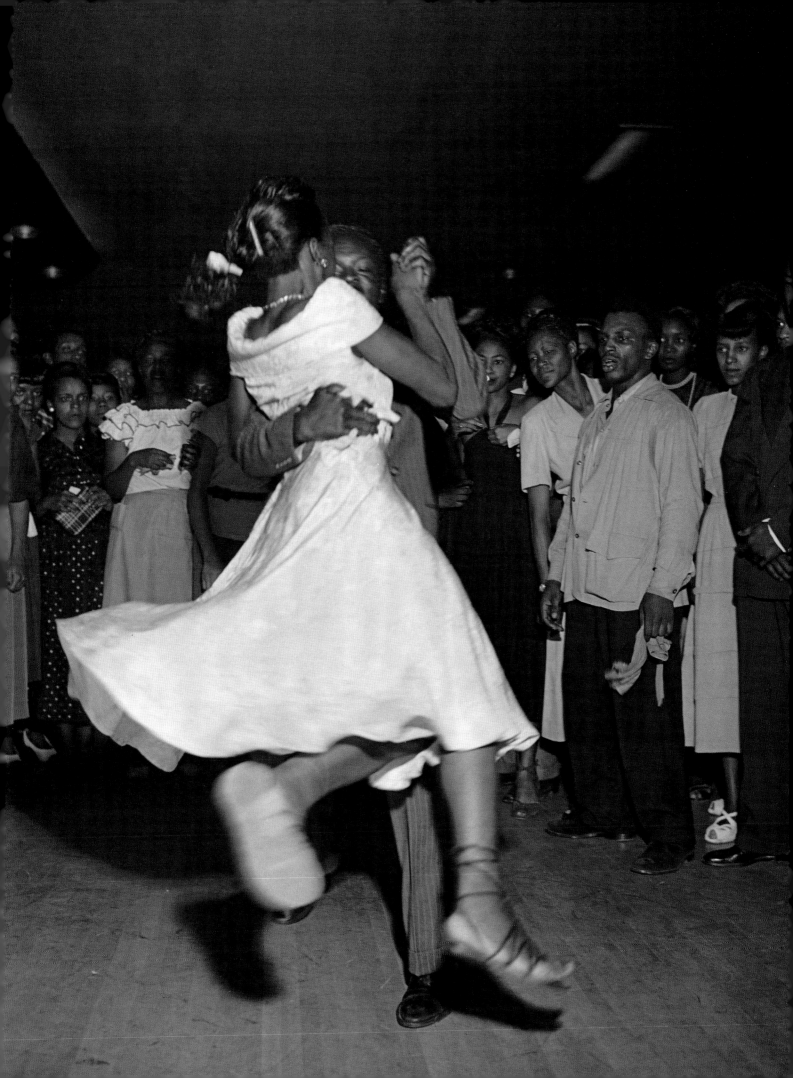

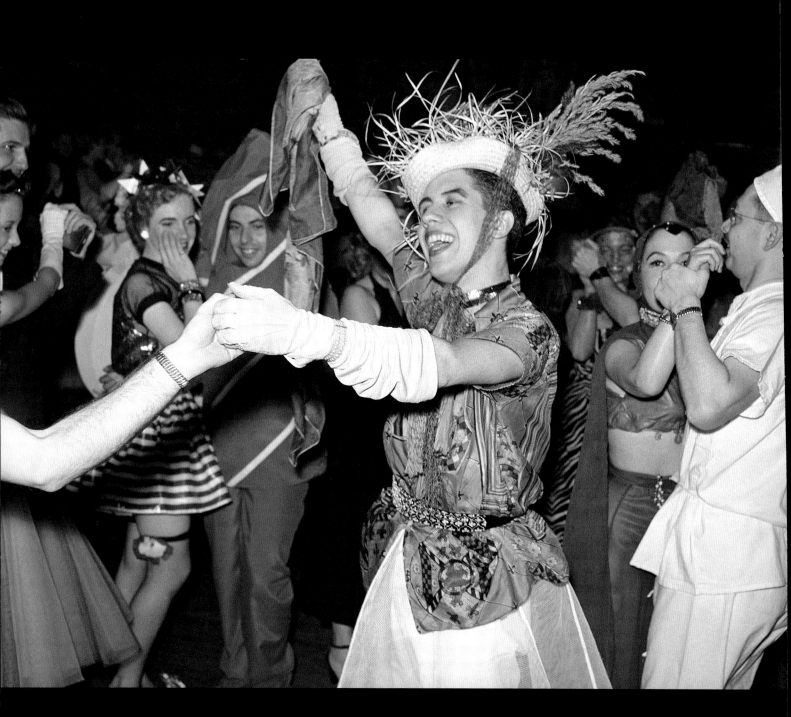

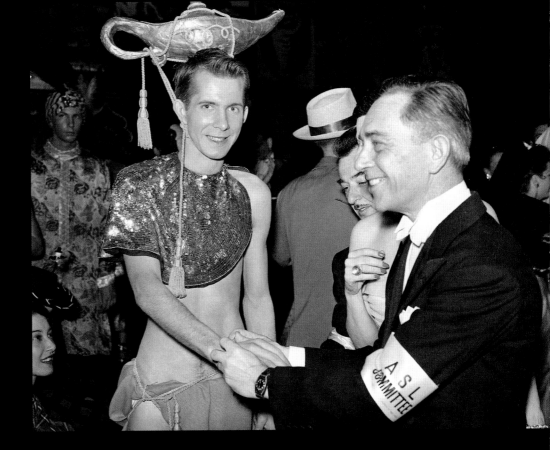

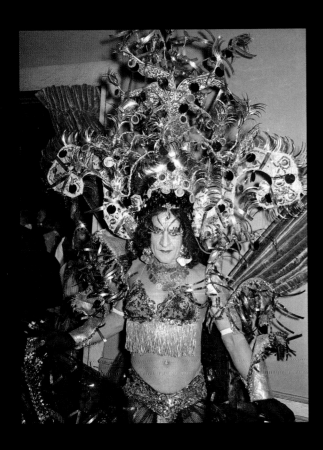

# ART STUDENTS LEAGUE

**APRIL 1952**
**PHOTOGRAPHERS: PHILLIP HARRINGTON AND
ARTHUR ROTHSTEIN**

The annual ball at the Art Students League
on Fifty-seventh Street was considered a
chic art world event and an invitation much
sought after. Seeking to express their urban
bohemianism, students entered a costume
contest, donning elaborate, sometimes
whimsical creations. The event capital-
ized on the sense of personal freedom and
opportunity for expression that New York
fostered.

*Note: Credit for the specific images of this assignment is not
identified in the* Look *collection.*

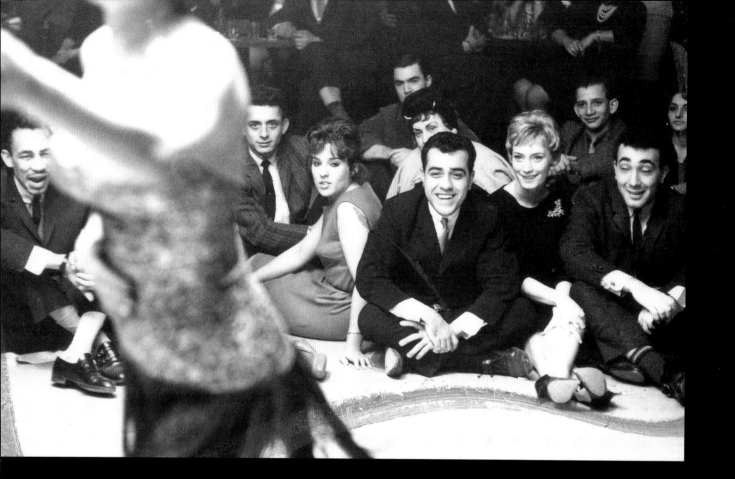

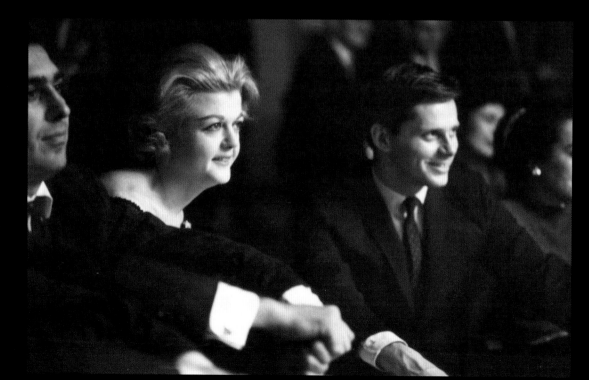

Actress Angela Lansbury
(b. 1925) and actor Robert
Morse (b. 1931)

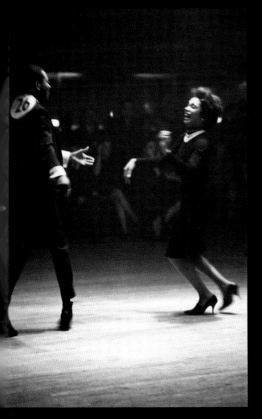
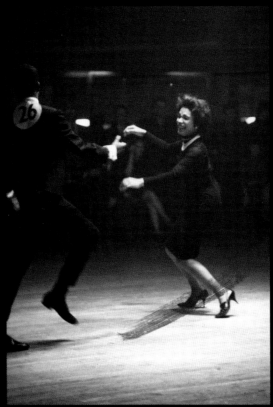
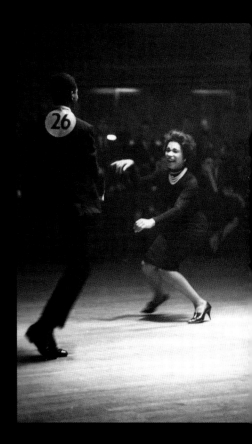

## PALLADIUM BALLROOM

**JANUARY 1961**
**PHOTOGRAPHERS: JAMES KARALES (OPPOSITE PAGE)**
**AND FRANK BAUMAN (THIS AND FOLLOWING PAGES)**

Located at Broadway and Fifty-third Street, the Palladium Ballroom, which had been an especially popular venue for Latin music starting in the late 1940s and launched the mambo craze in 1950, came by the early 1960s to reflect the new tastes and trends sweeping the city's cultural scene. The club not only attracted Hollywood and Broadway personalities, but also drew a racially diverse group of talented entrants to its weekly dance contests. Rules, regulations, and meticulously followed dance steps were out; youth, freedom, and self-expression were in. The 1960s were beginning, and New York would never be the same.

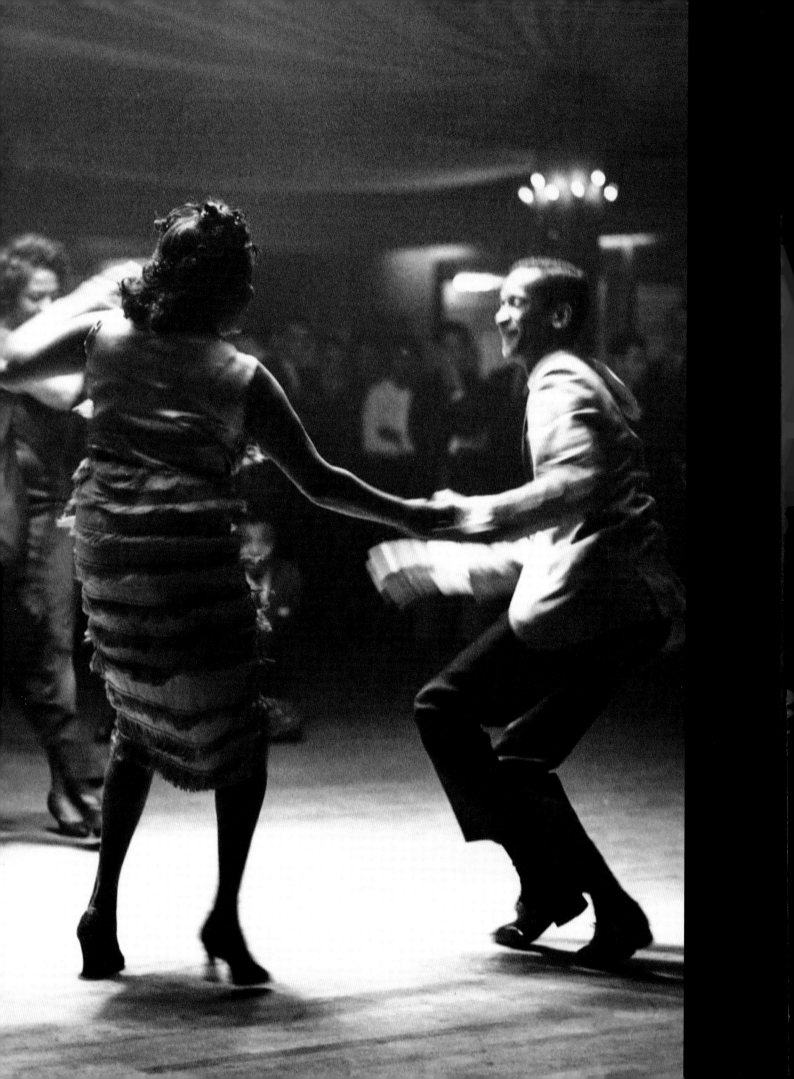

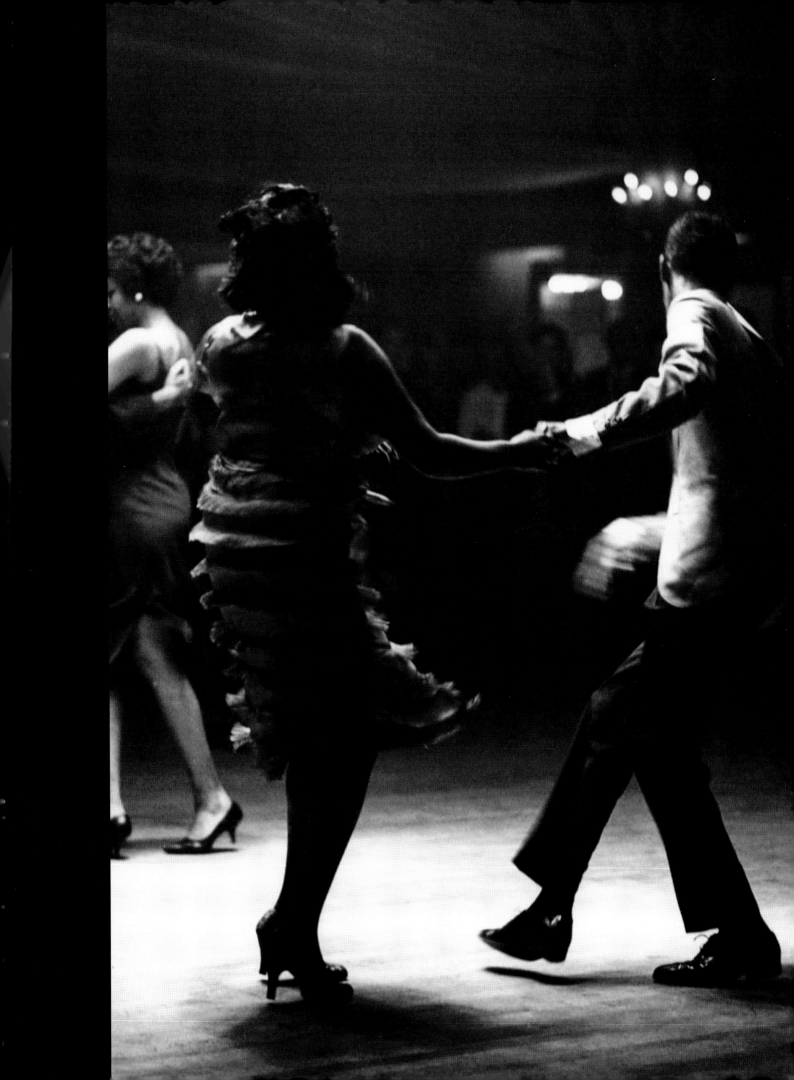

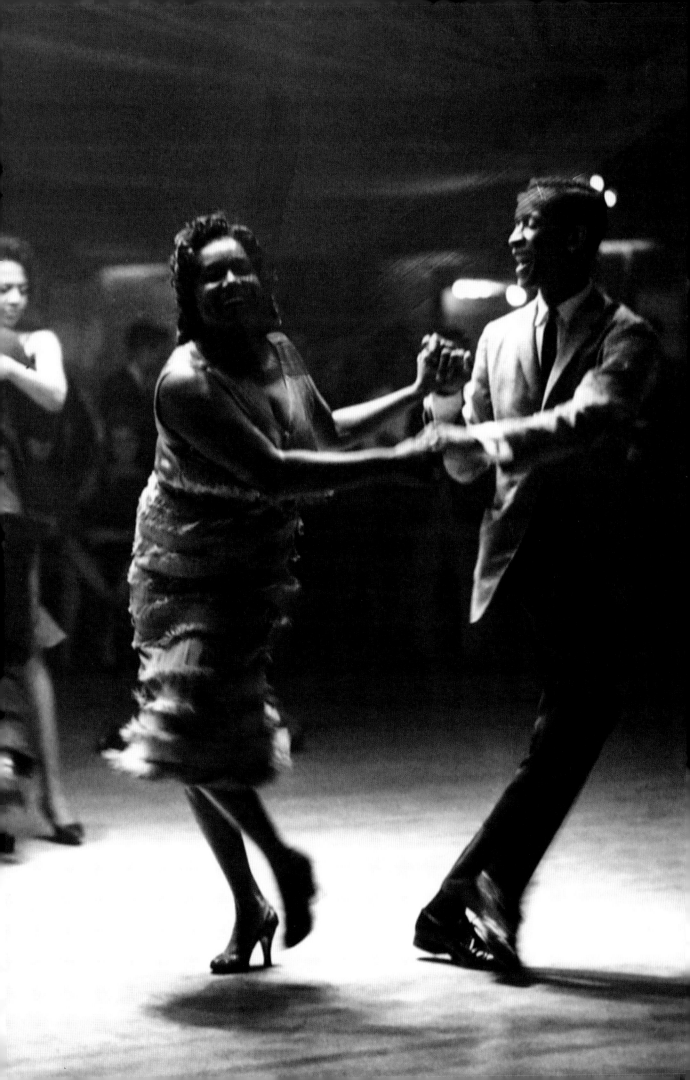

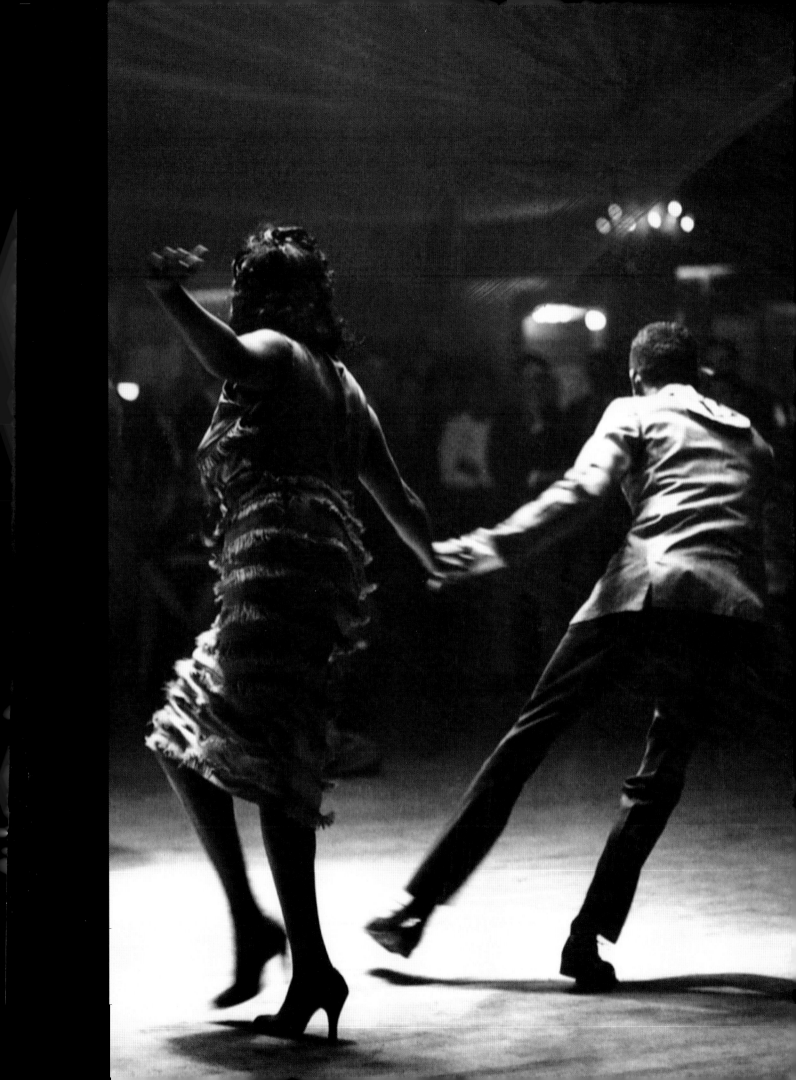

# INDEX

# PHOTOGRAPHY SOURCES

Arranged by the page numbers in this book, the following list provides the names and numbers of each photo assignment given by *Look* magazine and cataloged as such in the Museum's collection.

**Endpapers:** Art Students League Ball, 1061–52

**2:** Nightclubs — Copacabana Girl, 10583

**8:** T.W.A. Airline Hostesses, 11000

**10:** Gardner and Fleur Cowles, 12105

**14:** Nightclubs — Copacabana Girl, 10583

**16–17:** Bolger, Ray, 11040

**18–21:** Eric Victor — Broadway Dance Master, 11712

**22–23:** Bolger, Ray, 11040

**24–27:** Dunham, Katherine, 11161

**28:** Waldorf-Astoria — Entertainment, 10893

**29:** Knife Thrower, 11373

**30–31:** Salvador Dalí, 10211

**32–33:** Macy's Dogs, 3231–54

**34–35:** Marlon Brando, 11371

**36–37:** Puerto Ricans in New York Theatre, 11789

**38:** Night Clubs, 10863

**40–41:** Theatre — Stage-Struck Sisters (Struck Sisters), 12282

**42–47:** Williams, Rosemary — Showgirl, 11169

**48–57:** Times Square, N.Y., 12020

**58–59:** Todd, Mike, 11647

**60–61:** Stork Club and Sherman Billingsley, 10163

**62–63:** Elsa Maxwell, 10005

**64–67:** Todd, Mike, 11647

**68–69:** Lewis, Marlo — CBS Executive Television Producer, 11795

**70–71:** Rene d'Harnoncourt — Director of the Museum of Modern Art, 7563–57

**72–73:** Park Avenue, 7208–57

**74–79:** Changing New York, 7552–57

**80–85:** Models (Fashion) — Lisa Fonssagrives, 10246

**86–87:** Antoine — Hair Stylist in Fifth Avenue Apt., 10803

**88–95:** Charles James — Designer, 1129–52

**96–101:** International Ladies Garment Workers Union, 12242

**102–103:** Subway Story, 10292

**104–109:** Park Benches — Love is Everywhere, 10347

**110–111:** Subway Story, 10292

**112–117:** Advertising — Outdoor Advertising Sign Painters at Work, 12150

**118–127:** Subway Story, 10292

**128–135:** Harlem, 11813

**136–139:** Harlem, 7636–58

**140–147:** Puerto Ricans, 2200–53

**148–149:** Boxing — Graziano, Rocky, 12284

**150–153:** Cartier, Walter — Prizefighter of Greenwich Village, 11122

**154–155:** Boxing — Broadway Arena, 11162

**156–161:** Boxing — Graziano, Rocky, 12284

**163:** Baseball, Brooklyn Dodgers — Jackie Robinson, 12183

**164–165:** Sal Maglie, 6903–56

**166:** Yogi Berra, 7166–57

**167–169:** Sal Maglie, 6903–56

**170–177:** Brooklyn Nobody Knows, 10615

**178–181:** Brooklyn Thrill Killers, 3357–54

**182–187:** Tugboat Story, 10533

**188–189:** Harlem, 11813

**190–193:** Stork Club, 10291

**194–195:** Nightclubs — Copacabana Girl, 10583

**196–197:** Harlem, 11813

**198–199:** Art Students League Ball, 1061–52

**200–205:** Palladium Ballroom, 9103–61